Anyone
Who Had
a Heart

BURT BACHARACH

Anyone Who Had a Heart

My Life and Music

with Robert Greenfield

HARPER

NEW YORK • LONDON • TORONTO • SYDNEY

HARPER

A hardcover edition of this book was published in 2013 by HarperCollins Publishers.

HarperCollins books may be purchased for educational, business, or sales promotional use. For information, please e-mail the Special Markets Department at SPsales@harpercollins.com.

FIRST HARPER PAPERBACK EDITION PUBLISHED IN 2014.

All photographs are from Burt Bacharach's personal collection except where otherwise noted.

Library of Congress Cataloging-in-Publication Data has been applied for.

ISBN: 978-0-06-220607-7

HB 04.04.2023

For Jane, Cristopher,
Oliver, Raleigh,
and Nikki

I think that what you write is what you are. . . .

—*Burt*

I think that what you write is what you are

Contents

Anyone Who Had a Heart

Prologue
Nikki

I had only been married to Angie Dickinson for about nine months when I started thinking about getting a divorce. Our problems had nothing to do with the fact that she was a much bigger star than me. We just weren't really communicating with one another and part of that was my fault because I was still pretty immature at the time and so totally into my music that I could not have kept a real relationship going with anyone for an extended period of time.

When Angie told me she was pregnant, I was so surprised and overjoyed at the prospect of having a child that I completely forgot about all that and began doing everything I could to keep our marriage going. Angie had a difficult pregnancy, and while we were in New York together, she started having what looked like a miscarriage, so she went to see a doctor, who gave her some medication that was partly experimental.

Angie was just starting her sixth month when we went to a Dodgers game in Los Angeles. I had already written "Alfie" and recorded it with Cilla Black at the Abbey Road Studios in London, but the director of the movie decided he wanted Cher to cut the song so the picture could be distributed in America. I knew I wasn't going to have any input at the session but on our way home after

the game that night, Angie and I dropped in at Gold Star Studios, the magical room where Phil Spector had done all his incredible Wall of Sound records with the Ronettes, Darlene Love, and the Righteous Brothers.

Sonny Bono was producing the session. He had been heavily influenced by Spector so he had the same kind of setup, three percussion players and three guitars, and it was not at all the way I heard the song. By then I was used to controlling what was going on in the studio, but Sonny never once asked me, "Do you like the way it sounds?" It was not the way Cher was singing but what Sonny was doing to "Alfie" that I found so distressing.

I know it was just a coincidence, but as I remember it, Angie's water broke while we were in the studio that night, so we both got out of there as fast as we could and went right to the old Cedars-Sinai Hospital, on Beverly Boulevard in Silver Lake. Angie managed to hold on to the baby so they let her go home.

About a week later, an infection started. Her doctor told us she was losing the baby, so Angie went back into the hospital, where she was in labor for the next twenty-six hours. It was a Tuesday and there was no radio or TV in her room. The All-Star Game was being played in St. Louis so Angie kept asking everyone, "Who's ahead? Is the National League ahead?"

On July 12, 1966, our daughter was born, three months and twenty days prematurely. She weighed one pound, ten ounces and the doctors didn't think she would live through the night, but somehow she did. Because no one had any idea how long this child might live, Angie and I were told not to give her a name.

When a baby was born prematurely back then, their chances of survival were not very good. Three years earlier, Jacqueline Kennedy had given birth five and a half weeks early to a baby boy who weighed four pounds, ten and a half ounces. The doctors put him into a hyperbaric chamber so he could be given oxygen under high

pressure to keep his lungs clear, but he still died, thirty-nine hours after being born. If medical science could not keep the son of the President of United States alive, a baby who weighed four times as much as our daughter, how could Angie and I possibly think we would have any better luck?

Angie was in the hospital for five days before the doctors ever let her see our daughter. They didn't want her to have that memory of her if the baby died. Like clockwork, I would go to the hospital every day to see her by myself.

Even after Angie had come out of the hospital and could drive, I would still go there on my own because I thought that if I changed anything I was doing, something bad might happen to our daughter. It had to be my own private thing so I could commune with her through the window of the preemie ward, where incredible nurses were doing everything they could to keep our baby alive.

Day after day, I would stand in front of the preemie ward, looking at my tiny little doll of a daughter in her incubator. Even though I knew she couldn't hear me, I would start singing to her. You might think it would have been something I had written, but the song that got stuck in my head was "Hang On, Sloopy," by the McCoys.

I stood there and sang that song to my daughter every day because I was afraid that if I didn't, she wouldn't be there when I came back to visit her the next day. I also got into doing all kinds of other things I thought might keep her alive. Right across the street from where Angie and I were living, on North Bundy Drive, our neighbors had a pool where they would always let me swim. Whenever I went there after Nikki was born, I would try to save all the bees and insects that fell into the water. I was hoping and praying this act would somehow also help save my baby girl. For me, it became another ritual.

One day about eight weeks after our daughter was born, I was standing in front of the preemie ward singing "Hang On, Sloopy"

to her when two women who had been visiting someone in the maternity ward walked up. They began looking at all the preemies and one said to the other, "God, if I had one like that, I'd just throw it away." Completely losing it, I started to scream at them. Then I chased them all the way to the elevator.

Angie and I had wanted to name our daughter Lea, after Leon Krohn, the doctor who had delivered her. I really loved the nurses in the preemie ward, and since they had been calling the baby Nikki, we decided to name her that. Nikki's situation was so touch-and-go that she spent the first three months of her life in an incubator.

Because she stopped breathing a couple of times, they would sometimes have her on this little device that was kind of like a see-saw, to help clear the fluid from her lungs. The doctors had also instructed the nurses to give Nikki high doses of oxygen, which can sometimes be toxic to the eyes of premature babies. I had so much passion in wanting this child to make it that I said, "If she's blind, she's blind. Just let her live."

Having a child changed me in ways I didn't even really understand at the time. Despite all the hits I had already written and all the success I'd had in the music business, none of that seemed all that important to me anymore. So what if one of my songs went to number three or four on the charts? It didn't matter nearly as much as my daughter's life.

Chapter

1

The Story of My Life

When I was a kid, everyone in my family called me Happy. When I was born, my dad wanted to name me after himself so there would be a Big Bert and a Little Bert, but my mother didn't want to put me through the hassle of being called Bertram, as my dad had been when he was a boy, so they compromised on Burt. But even though our names were spelled differently, people would always ask my mother, "Oh, is your son Bert Junior?" and she would say, "No, he's not."

To lessen the confusion, my mother finally just said, "Let's call him Happy." I'm not sure where she came up with that name, because I don't think I was very happy as a kid. In fact, I was lonely most of the time. Since my dad was working as a buyer of men's clothing in Kansas City at the time, he probably never thought that either of our names would ever be known outside our neighborhood.

Neither set of my grandparents thought my parents were a very good match for each other, and I think my mom and dad moved to Kansas City to keep their marriage a secret. I was born in Kansas City on May 12, 1928, but my childhood memories don't begin until we moved to Forest Hills, Queens, where I grew up in an apartment on the second floor of a three-story building at 150 Burns Street, just a couple of blocks from Queens Boulevard.

No one in my family ever went to synagogue or paid much attention to being Jewish. We also didn't talk about being Jewish with other people, so I got the feeling this was something shameful that I needed to hide. I didn't have a lot of friends in Forest Hills but the kids I knew were Catholic, and most of them went to church at Our Lady Queen of Martyrs. Whenever we played football against a team with Jewish players, our captain would say, "Let's go and kick the shit out of these Jews," and I would say, 'Yeah, let's kick the shit out of these Jews!'" Because I wanted to be with them, I thought I had to talk that way, too.

As a teenager I was very short. At Forest Hills High School there were three thousand students, but not a single one of them, not even any of the girls, was smaller than me. So I already had enough problems without having to also admit I was Jewish.

I didn't read a lot as a kid, but one book I really loved and read over and over was *The Sun Also Rises*, by Ernest Hemingway. I really identified with the hero, Jake Barnes, who couldn't perform sexually because he was impotent. That was definitely not a problem for me. I was socially impotent because I was carrying around all this baggage, and I never felt like I fit in anywhere, not in school or in my neighborhood.

As a kid growing up in Forest Hills, I was Jewish but I didn't want anybody to know about it. I was too small for any girl to even notice I was alive. I was reading *The Sun Also Rises* and I was walking around with a name like Happy. And while I might have been able to find myself by really learning how to play the piano, there was nothing in the world I hated doing more than that.

I started taking piano lessons when I was eight years old. Every day when I came home from school in the afternoon, my mother would make me sit down at the upright piano in our living room and practice for half an hour. In my house, the push about music

always came from her. What I really wanted to do was be out in the street playing ball like everyone else I knew. Whenever my mother said I had to practice, there was always a fight and I would only do it because she didn't give me any other choice.

My mother played piano by ear, which I thought was remarkable, and I wondered, "Why can't she teach me to do this? It would be so much easier than sitting here doing scales over and over again." But whenever I argued this point with her, she'd say, "You have to learn to play properly." When she was young, my mother had wanted to be a singer. I don't know what happened to those dreams, but after the career in music didn't work out for her, she really leaned on me a lot.

My mother was born and raised in Atlantic City, New Jersey. Her father, Abe Freeman, owned a very successful cut-rate liquor store, until Prohibition put him out of business. Then he ran a pharmacy on the boardwalk, where he made enough money to send his three daughters—my mother, Irma, and her sisters, Dottie and Julia—to private school.

When the stock market crashed in 1929, Abe lost everything. Although he was president of Beth Israel, the Reform synagogue in Atlantic City founded by one of my Bacharach cousins, Abe could no longer afford to pay his dues so he went to the board to offer his resignation. When they accepted it, he never returned. Whatever connection my mother might have had with being Jewish also ended right then and there, which helps explain the way I was raised.

To the day she died, my mother had great taste in clothes and art and music. One of my cousins who used to visit us in Forest Hills still remembers our apartment as the most beautifully designed and decorated residence he had ever seen. It had high ceilings, wooden floors, and big windows that let in lots of light. At a time when

everyone else had white walls, ours were all different colors and decorated with framed original oil paintings, some of which my mother had painted herself.

By the time I was a teenager, my father had become a well-known newspaper columnist. He and my mother went out to dinner a lot, but they never had to pay for anything because my father might write an article about the restaurant. I never really felt comfortable with them in a restaurant, because even though we weren't going to be paying, my mother would still always ask the waiter, "Do you have orange juice?" And when he said, "Yes," she'd say, "Are you sure it's fresh?"

My dad was really driven and worked all the time but when it came to me he was the most gentle, no-pressure guy in the world. More than anything, I wanted to be like him. On Sunday mornings while I was waiting for him to wake up, I would go through all of his old scrapbooks, because he was definitely a hero to me. Like my mother, he'd grown up in Atlantic City, where he had worked delivering newspapers and then as a lifeguard on the beach during the summer.

A big guy who stood six feet tall and weighed about two hundred pounds, my dad looked a lot like his father, Max Bacharach, whom everyone called "Backy." Always immaculately dressed in a high-collar shirt and spats, my grandfather would get in his hand-cranked Model T Ford and drive through Pennsylvania to all the small towns where he sold men's clothing. Although Max made a good living as a salesman, his cousin Harry, who was the mayor of Atlantic City and after whom the Bacharach Giants, the local team in the Negro League, were named, and his cousin Isaac, who served eleven terms as a United States congressman, were a lot more successful than my grandfather.

When my dad was eighteen years old, he went off to college at the Virginia Military Institute, where he lettered in four sports. My

father played fullback on the football team and captained the All-Southern conference championship basketball team. During World War I, he left college for a year to enlist as a second lieutenant in the United States Marine Corps.

After graduating from VMI, my father went to work as a buyer of men's clothing for a department store in Baltimore where he earned twenty dollars a week. Since he had to pay twenty-five dollars a week for room and board, he began playing professional basketball and football as a sideline. Being a professional athlete back then was not nearly as lucrative as it is now, and to keep enough money coming in, my father once played on five different professional basketball teams at the same time. Whenever two of his teams played each other, he had to pick which one he wanted to be on.

After working for Saks Fifth Avenue in New York City, when that store first opened, and then as a buyer for Bamberger's in Newark, New Jersey, my father got a job at the Woolf Brothers department store in Kansas City. Shortly after I was born, we moved to Kew Gardens in Queens. After being out of work for six months, my dad started a small trade paper for the men's clothing business and then became an associate editor at *Collier's* magazine.

My father left that job to go into public relations and then co-hosted a radio quiz show on WJZ called *Suit Yourself.* He was also the host of the first sponsored television program in New York City. Eventually my dad began writing a column called "Stag Lines," which was syndicated in eighty-four newspapers, as well as a column called "Now See Here," which ran five times a week in the *Los Angeles Herald-Examiner,* the *San Francisco Examiner,* and the *Indianapolis Star.* For many years he also appeared in a segment called "For Men Only," which was shown in newsreels in movie theaters all over the country. He also wrote three books about men's fashion and grooming and household hints, and they sold pretty well.

Because my dad never had an unkind word to say about anyone

in what he wrote, he was always working and doing okay, and so I didn't feel the impact of the Depression while I was growing up in Forest Hills. On the other hand, I also never felt rich, because all the people my father knew in the clothing business had a lot more money than us.

I was thirteen years old when the Japanese bombed Pearl Harbor and I remember the day very clearly. I had gone with my parents to the Polo Grounds to see the New York football Giants play the Brooklyn Dodgers in the last regular-season game of the year. Tuffy Leemans, the star fullback for the Giants, was being honored that day.

Instead of sitting with my parents, I was watching the game from the press box with Dick Fishell, who was doing the radio play-by-play for WHN. Dick was a good friend of my parents and I really looked up to him because he was good-looking and had all the girls. It just seemed to me like he had it all. When the news came in to him just before halftime, Dick looked at me and said, "Shit, they bombed Pearl Harbor." I said, "Where's Pearl Harbor?"

At halftime, I went down to see my parents, who were sitting about ten or twelve rows back from the field, and I asked, "Where's Pearl Harbor? Because they just bombed it." My father said, "Who bombed it?" and I said, "The Japanese." So that's how my dad found out about our involvement in World War II. This was long before CNN and twenty-four-hour news, of course, so no one else at the Polo Grounds knew a thing about it until the game was over.

My father was forty-three years old when the war started. Even though he was too old to serve in the armed forces, he worked as a civilian consultant for the Air Force at Wright Field in Ohio. He also sold $5 million in war bonds at special events and helped bring entertainment to servicemen in hospitals. For me as a kid, World War II was something I read about in the newspapers and heard other people talk about. It really didn't affect me directly at all and

until the war was over I knew nothing about the millions of Jews who were killed in the Holocaust.

What I remember clearly from those years is coming home from watching the New York football Giants play the Chicago Bears at the Polo Grounds on November 14, 1943. When my dad and I walked into the house my mother was listening to the radio. Still really excited about the game, I started to tell her about it when she interrupted me. "I'm sorry you weren't here because you missed something unbelievable. Bruno Walter was supposed to conduct the New York Philharmonic but he got sick, so this young, unknown conductor took over and did a great job. His name is Leonard Bernstein." I went into my room and I thought, "Leonard Bernstein? Shit, I know this guy." And I did.

At that time, I had already begun taking piano lessons from a woman named Rose Raymond, who had studied with Leopold Godowsky at the Vienna Conservatory. She lived on Riverside Drive and Eighty-Sixth Street, in Manhattan. Once a week, I would sit with her for an hourlong lesson, and it was always brutal because she would make me do all these finger exercises at the keyboard without ever letting me play a single note. At one of her recitals I was supposed to play "Clair de Lune" but I forgot the music and really screwed it up good.

Even though I thought I had no talent and still hated to practice, I would ride the subway once a week from Forest Hills into Manhattan, get off the train at Fifty-Third Street, and then take a double-decker bus to Rose Raymond's apartment. No matter how cold it was, I would always ride on top because I really loved being up there. I was sitting on top of the bus one day with a couple of other brave people in the cold when this young guy who I thought was kind of weird came up the stairs and sat down next to me.

When I started whistling a tune, he said, "Is that 'Two O'Clock Jump'?" I said, "Yeah, how do you know that? Are you a musi-

cian?" He said he was, so I asked him if he played in any of the local bars. He said, "No, actually I'm a conductor." When I asked him what he conducted, he said, "The New York Philharmonic." I said, "Come on. I know who conducts the Philharmonic. Bruno Walter." And he said, "Well, I'm an assistant conductor."

After we had introduced ourselves to one another, I was getting off the bus at Eighty-Sixth and Riverside and the last thing I said to him was, "Well, I'll see ya on top someday, Lenny." What I meant was that I would probably see him again someday on top of the bus. Now he had made this sensational debut by stepping in at the last minute for Bruno Walter on a nationwide radio broadcast. The next day, the *New York Times* ran a front-page story about it, so I wrote him a letter, but I never got a response.

When I told my mother how I'd met Leonard Bernstein, she thought it was marvelous. Although I think she secretly hoped I would be conducting or composing for the Philharmonic some day, she always made a point of telling me, "Music is not a career I want you to have. I just want you to be able to play for your own pleasure, the way I do."

A couple of years later, I went to music camp at the Tanglewood Music Center in western Massachusetts. Before I left, Morton Gould, a well-known composer and conductor who was one of my parents' friends, told me, "Don't worry about the girls. Look out for the guys." I wasn't sure what he meant, but the first night I was there, this guy asked me to take off my shoes and socks so he could put his foot up against mine. I thought that was really weird so I refused. Even if I had taken off my shoe, I would have only gone as far as my sock.

I was at a Tanglewood faculty-student reception when I saw Lenny Bernstein, so I reintroduced myself. Lenny was with Felicia Montealegre, whom he later married, and when Lenny realized who I was, he said to her, "We have an amazing past." Because she

thought we must have done more than just run into one another on a crosstown bus, she said, "But he's so young, Lenny."

Lenny was brilliant, and I always had huge admiration for his work. He could be writing *West Side Story* in the morning and then go conduct Bach in the afternoon, but I didn't see him again until I was working to help Ted Kennedy win the New Hampshire Democratic presidential primary in 1980. I was attending a dinner party at his sister Jean Smith's house, and Lauren Bacall was also among the other guests, when Lenny came up to me and said he wanted to talk.

"Listen," he said, "have you been telling people that I once met you on a bus?" After I told him I had, he looked at me and said, "That never happened. You just dreamed it up. I wish you would stop telling this to people." And I said, "Holy shit!" Because I thought this made the story even better.

While I was going to Forest Hills High School, my parents would sometimes drive down on the weekend to Philadelphia to visit my aunt and her husband in Elkins Park. They had three sons, and the Binswanger boys were always roughhousing and having fun. Even though their family wasn't very Jewish, either, we would all play hide-the-matzoh at Passover.

I really liked being with the Binswangers, and I was always sorry when my mother and father and I would have to get back into my dad's Oldsmobile. On the drive home, we'd listen to the New York Philharmonic playing Brahms and Beethoven on the radio. The music was very dark and it would already be getting dark outside, and I really hated that ride because I knew I was going back home to where I had very few friends and was going to be alone again.

You know that book *Is There Life After High School?* To me, it didn't look like there was. For four terms in a row at Forest Hills High School, I was marked down for excessive lateness. The reason I never got to school on time was that I had trouble sleeping at night

because I kept hearing music in my head. I had real insomnia as a kid and I think it all started when I heard my mother say, "I only had four hours of sleep last night. If I don't get a nap today, I won't be able to function."

To me, that meant that if you didn't get enough sleep you would get sick or die. It was just a statement she made in passing but it really got into my head. My insomnia became so bad that I started taking sleeping pills when I was sixteen or seventeen. My mother was taking them, too, and I got one from her whenever I needed something to help me get some sleep. As an adult, this became a really bad habit I had to work very hard to break.

By this time in my life, my parents were going out almost every night. Whenever a new play or a nightclub opened in Manhattan, they would get an invitation so my dad could write about it in his column. They had a really active social life and whenever we would go to dinner at a place like Danny's Hideaway, a great joint on East Forty-Fifth Street where all the celebrities went back then, they would always see all these people they knew, like Earl Blackwell, Dorothy Kilgallen, and Louis Sobol, who were also newspaper columnists like my dad.

I would be sitting at the table talking to my parents about something really important to me and right in the middle of whatever I was saying, my mother or father would interrupt me by saying, "Oh, look, there's Louis Sobol. Hey, Louis!" Although I always wanted to say, "Hey, I'm talking here," I never did.

Even though I was in the general program at Forest Hills High School, which meant I did not have to take any state Regents exams, my grades were always really bad because I just didn't care about what they were teaching me. Mechanical drawing and Spanish had no relation whatsoever to what I cared about, so I never paid attention in class. Instead of listening to the teacher I'd read scores by Ravel underneath my desk.

One night when I was a sophomore or junior, my mother came into my bedroom and said, "You know, your dad and I have made a decision. We've bought you a Steinway grand and we push you all the time to practice, but it's obvious you don't want to play the piano. So we're giving you the choice. You can stop, if that is really what you want to do. You don't have to take lessons anymore, and you don't have to practice."

After my mother walked out of my room, I thought, "Man, this is great! Free at last." But later that night, the Jewish guilt started creeping in and I thought, "Jeez, I can't do this to my mother." So I kept right on taking lessons from Rose Raymond, and maybe even practicing a little harder than before. But I still had no real relationship to the music I was playing.

Although I still didn't have many friends, New Year's Eve always seemed like something special to me. It was the night when you were supposed to go out and celebrate and have a really good time. Because I wanted to be part of that as a teenager, I developed a routine on New Year's Eve that never varied.

Right after dinner I would go into my room to get dressed, always very warmly because I'd gotten that message pretty clearly from my mother. Then I would leave our apartment and walk about three blocks to the Seventy-First Street subway station and get on the train. I'm sure my parents must have been a little bit worried that some pervert might take advantage of me on the subway, but they never said a word about it. Since it was a safer time, nothing bad ever happened to me.

It would take me about half an hour to get to Times Square. When I came out onto the street, I would just go with the crowd. Even though all the lights on Broadway had been turned down because of the war, there would still be about four hundred thousand people there. Men in suits and coats and hats, and women in fancy dresses and fur coats, and lots of servicemen in uniform. Everybody

would be drinking but me. I was just part of this great mass of people, none of whom knew me. It was like I was invisible—I could see them but they couldn't see me.

At midnight, people would start blowing on little tin horns and throwing confetti in the air. Lots of people would be kissing each other but no girl ever kissed me. Why I chose to do this, not just once but year after year after year, I have no idea. I guess I just wanted to be part of something bigger than myself. I thought, "This is what you do on New Year's Eve. You go to Times Square and maybe something wonderful will happen." But it never did and then I would get on the subway and ride back home by myself. For me as a kid, New Year's Eve was all about expectations, but no matter how many times I went to Times Square, the night never lived up to any of mine.

In terms of music, my big breakthrough came when I was fifteen years old and started using a fake ID to sneak into little jazz clubs like the Three Deuces and the Spotlight on Fifty-Second Street in Manhattan. Sometimes there would be more people onstage than in the audience. Dizzy Gillespie was the guy I loved the most and he became my hero. I worshipped him because everything he did was so cool and I loved the way he looked onstage playing that funny-looking trumpet of his. One night I saw him standing out on the street with a monkey on his shoulder, so I went right home and asked my mother and father if I could get a monkey, too, but of course they said no.

It wasn't just Dizzy, either. I'd go to Birdland to watch the Count Basie Band, with Sonny Payne on drums, and they were just so incredibly exciting that all of a sudden, I got into music in a way I never had before. What I heard in those clubs really turned my head around—it was like a big breath of fresh air when somebody throws open a window. That was when I knew for the first time how much I loved music and wanted to be connected to it in some way.

Using the name Happy Baxter, which was as close as I could get to Bacharach without sounding Jewish, I formed a band with four other guys my age and we played a couple of high school dances in Forest Hills. What I liked best about playing in public was that I got to meet girls who would never have talked to me for any other reason. I remember playing a Saturday-night dance at a Catholic church in Forest Hills where there must have been twenty pretty girls hanging around the piano. As a teenager, I thought a lot about girls, so when it came to deciding to become a musician, that night definitely made an impression on me.

There wasn't much talent in the band but we did have a good drummer, Norman Feld, and a saxophone player named Jack Conn, whose father had cofounded the big music publishing company Bregman, Vocco, & Conn. Jack would get us arrangements for free. We would rehearse at his house and also go to the Nola rehearsal studio, right off Broadway on Fifty-Fourth Street, where the woman at the front desk would let us rehearse for free. Sometimes there would be jam sessions going on with the top names in jazz. One night when the piano player didn't show up, a great clarinet player named Eddie Barefield, who had worked with Bennie Moten and Fletcher Henderson, let me sit in with him and some top guys.

Even though I was now a lot more serious about music, I still got minimal action in high school. I thought I had gotten laid in Rego Park one night with a girl who went to school with me but it wasn't even close to going all the way. There was another girl I knew who had colossal tits and the two of us would go up on the roof of her building and I would dry-hump her and come just like that! I actually got laid for the first time during the summer after my junior year in high school when my father got me on this USO tour with a collection of vaudeville musicians who couldn't get work anywhere else.

It was a variety show, and the tap dancer Hal Le Roy was the

big star. Roy Smeck played banjo and I was the boogie-woogie pi-
ano player, as well as by far the youngest guy on the tour. We all
traveled together by bus and train to do shows in military wards
and hospitals in places like Martinsville, Virginia, where the audi-
ence consisted of guys who'd had half their faces shot off in the war.

Before I went on the road, I persuaded my mother to let me
take the braces off my teeth. She agreed on the condition that I put
them back on when I got home again, which of course I never did.
The one time I really needed my mother to tell me what to do, she
didn't, and as a result, I've had problems with my teeth throughout
my entire life.

The highlight of the tour for me took place one night when this
older woman who was a singer took me to bed. Even though I pre-
tended to know what I was doing, she knew the truth. But she was
very kind to me and that was the first time I ever got laid. I couldn't
wait to tell my few friends what had happened, but when I got back
to Forest Hills, none of them seemed all that interested. When I
showed my younger cousin the condom I was now carrying around
in my wallet, at least he was impressed.

In addition to the jazz I'd heard on Fifty-Second Street, I had
also started listening to the French Impressionists. I really liked De-
bussy, and Maurice Ravel's *Daphnis et Chloé*, Suite no. 2 was a big
favorite of mine. Even though I still wasn't a very good musician
and wasn't doing anything to advance my career, I did like listen-
ing to Freddy Robbins, a really good deejay my parents knew who
played jazz on WOV.

One day, I heard him announce a piano competition. The first
prize was fifteen lessons with Teddy Wilson, who had played with
Louis Armstrong, Benny Goodman, and Billie Holiday. The second
prize was fifteen lessons with either the great boogie-woogie piano
player Albert Ammons or with Joe Bushkin, who played jazz piano
in the hottest clubs in the city. So I decided to enter the contest.

Because there were a hundred and fifty contestants, I wasn't sure I would even get past the first round, so I didn't tell my parents about it. I just went in to the radio station by myself and played "Laura" and "How High the Moon." I was told they were going to pick fifteen of us to continue on into the next round.

When a telegram came to our house notifying me I had made the cut, I had to tell my parents what I'd done. When I went in to the radio station to play again, I made it to the finals along with two other kids. The three of us had to play onstage in Town Hall in front of an audience that included my parents, all of Freddy Robbins's radio listeners, and a panel of eight judges.

I was competing against a white kid from New Jersey and a really nice black kid named Warren Vaughan. When the judges came back to announce their decision, they said it was a tie between Vaughan and me and we would each have to play one more song to decide the winner.

By this time I was so nervous that I just kept licking my lips so I could get some saliva going in my mouth. While I was waiting to play, Joe Bushkin came over to me with his girlfriend Nellie, a hot-looking blonde who seemed kind of drunk. When she said, "Show Joe what you were doing to your lips," this made me even more nervous. But when I started talking to Joe, he turned out to be an enormously cool guy and a very free and wild spirit who was unlike anybody I had ever met before.

Just before I had to go out onstage again to play, Mary Lou Williams, the great jazz piano player who wrote and arranged for Duke Ellington and Benny Goodman, walked in. I don't know if Warren Vaughan played better than me, which he probably did, or whether the panel felt they had to vote for him because Mary Lou Williams was there, but he won and I came in second.

After they announced the decision, I picked Joe Bushkin to give me lessons. I probably would have learned a lot more about music

from Teddy Wilson, but Joe Bushkin taught me about life. A skinny Jewish guy who had grown up in a tough neighborhood in Manhattan, Joe was still in high school when he had started playing with Benny Goodman. When Joe got drafted into the Army in 1942, they sent him to Fort Hood in Texas, where he began growing weed behind the barracks. The commanding general knew what Joe was doing but looked the other way because he liked Joe's piano playing so much.

Whenever I would walk into Joe's apartment on the West Side of Manhattan after getting out of school in the middle of the afternoon, he would only just be getting out of bed. Although I never got high with him, Joe did show me how to roll a joint. He also told me how to go down on a girl. Whenever I would ask him about music, Joe would say, "What can I teach you? You gotta learn the music business yourself, man. Go out on the road with someone like Boyd Raeburn and travel all over the country with a band, in a band bus, because you're not going to be anything until you've had that experience."

A lawyer who owned a hotel in the Catskills who had either seen or heard me play in the competition offered me a job the following summer playing with a bunch of guys at the Shandaken Manor. We weren't going to make a lot of money but we could eat for free, and the guy who ran the place let us sleep across the road in an old converted chicken shack that still had feathers on the floor. There were five guys in one room, and I was the youngest, but I thought it was all great.

We started out making four hundred bucks a week, but because his mother was sick and we didn't want to lose him, we gave most of the money to Eddie Shaughnessy, a terrific drummer who later worked with Doc Severinsen on *The Tonight Show*. The hotel wasn't all that successful to start with and it became less and less successful as the summer went on, so the guy who owned the place kept

dropping our salary. Every week he'd say, "I'd love to keep you guys, but I can't afford you anymore." Pretty soon we were down to sixty bucks a week for the whole band.

Getting out of the city for the summer was a big deal back then, so I didn't want to go home. None of us did, because if you had a chance to work somewhere and came home early, that was a real loss of face. I was giving part of my salary away so my dad started sending me money, which I would use to buy Mounds and Almond Joys. I didn't need much because the food was free.

We were asleep in the chicken shack one night and at four in the morning we heard all this noise and then the sound of fire engines and sirens. We walked outside and looked across the road and saw the whole hotel was burning down. When we got over our shock, we realized we were free. Now we could all go back to the city and say, "You know, we had a really good job but the place burned down so we had to come home." I was okay with that, because I already knew I was not going to be living with my parents in Forest Hills much longer.

Chapter

2

Night Plane to Heaven

I have no idea how I ever actually managed to get out of Forest Hills High School. My grade average was 69.74, and in a class of 372 kids, I ranked 360th. What I do know for sure is that I didn't bother to attend graduation.

I really wanted to go to either the Eastman School of Music in Rochester, New York, or the Oberlin College Conservatory of Music in Ohio, but my grades were so bad that both schools rejected me. The way my dad liked to tell the story, he and my mother had heard glowing reports about the music conservatory at McGill University in Montreal, so they had me apply, only to learn there was just one opening left for the upcoming semester. We all flew up for my audition, and according to my dad, I was halfway through a piece by Debussy when the dean I was playing for stopped me and said they had to have me there.

The truth is that I went to McGill because I didn't know what else to do and I had nowhere else to go. The reason they welcomed me was that they were short of students. The music department at McGill is brilliant now, but back then there were just twenty-six students in an old broken-down conservatory with cold, dark rooms. My piano teacher was a German ball-buster named Helmut Blume,

who had never listened to jazz or even heard of Dizzy Gillespie. If I had known he'd studied with Paul Hindemith in Berlin, I might have respected him a little more.

When I went back to McGill in 1972 to receive an honorary doctorate in music, Helmut Blume told what he thought was this really funny story about a lesson in which I was supposed to have prepared the allegro finale of a Beethoven sonata. When I asked him if I could take it slow, he insisted I play the piece at the proper speed. After sitting there and looking at my fingers for a while, I finally shouted "They're off!" like an announcer at a racetrack, and started to play. At the time he was not amused.

During my first year at McGill, I lived in a rented room on Sherbrooke Street and took the bus to school. I thought it would be cool to have my own place, but all it did was make me less connected to campus life. I went to some football games at Molson Stadium but most of the time I was on my own. I used to envy the guys who were going to law school or medical school at McGill, because unlike me, they all looked like they knew what they were doing and had a real purpose in life.

In Forest Hills, I had gone to school with a light-skinned black football player who also wound up at McGill. Now that we were both away from home, he didn't want anyone to know he was really black and I didn't want anyone to know I was Jewish. Two weeks after I got there, the local chapter of the B'nai Brith sent me a letter inviting me to services for Jewish students, so that put an end to that.

Even though I could now do whatever I liked, I was still pretty weird in some ways, which I think had a lot to do with how I had been raised. I had always been scared of getting sick, so whenever it was snowing or raining and I was going out to Rockhead's Paradise or Café St. Michel to see Oscar Peterson or Maynard Ferguson, I would put on my rubbers and carry a bottle of Listerine with me to gargle with so I wouldn't catch cold.

When I went back to McGill for my second year, I moved into Douglas Hall, a dormitory overlooking the football stadium. I had two Norwegian roommates but I still pretty much lived by myself. Although I wasn't any kind of artist, I would while away the time in my room by drawing pictures of Lizabeth Scott, a great-looking blond actress I was crazy for. On the movie screen, she had this blend of the masculine and the feminine thing that really got it for me and I used to dream about meeting her someday.

Years later, when I was married to Angie Dickinson, I actually met Lizabeth at a party in Hollywood on New Year's Eve. She was in her mid-forties at the time but still looked great. I told her how I used to draw pictures of her when I was in college and how I had felt about her. Then I went up to her place in the Hollywood Hills to have lunch with her. We went swimming in her pool, and began a little affair. We got together only once or twice but I had fantasized about her for so long that it was really special for me.

At McGill, I wrote my first song, with a fellow student named Don Smith, who was a very intelligent and self-confident guy. The song was a ballad called "Night Plane to Heaven," and one of the verses goes, "On the night plane to heaven / On flight number seven / Along the milky way / In a world full of moon glow / Above where the stars go."

At the time I was so obsessed with Mel Tormé's "The Christmas Song" that I played nothing else for four straight months, but "Night Plane to Heaven" didn't sound like that at all. A friend of my father's published the song as a favor but it has never been recorded or performed because it wasn't very good. I mean, just look at those lyrics.

After my second year at McGill, I spent the summer in California, where I studied composition with Darius Milhaud at the Music Academy of the West, in Carpinteria. Milhaud was a wonderful man who was also a great teacher. A French Jew who had

been forced to flee for his life when Paris fell to the Nazis in 1940, Milhaud came to America and began teaching at Mills College in Oakland, where Dave Brubeck was one of his students.

There were just five of us in Milhaud's composition class and the other students were all writing a very extreme kind of twelve-tone music. At the time I was into Arnold Schoenberg, as well as Alban Berg and Anton Webern, both of whom had studied with Schoenberg. My first assignment was to write a sonatina for violin, oboe, and piano that consisted of three movements. The second adagio movement was a lot more melodic than I felt comfortable with and even though it seemed right to me, I was kind of embarrassed to play it for Milhaud on piano.

He must have sensed my discomfort, because after I finished playing, he said to me, "Never be ashamed to write a melody you can whistle." So he taught me a lesson I never forgot. And because he liked to take his students out to dinner on Sunday nights to a funky Mexican restaurant, Milhaud also taught me how to eat tacos.

After my third year at McGill, I decided I didn't want to go back to get my degree. Even though I was still always trying to do the right thing and make my parents proud of me, they didn't seem all that upset about it. Because I was twenty-one years old and the Korean War had just begun, I got a letter notifying me I was being drafted.

Unfortunately, I passed the Army physical with flying colors. I would have done anything I could have to get out of the Army because just the idea of having to learn how to shoot a rifle terrified me. Before I went to basic training, my parents took me on vacation to Florida, where we all went to the Hialeah racetrack, and then I reported to Fort Devens in Massachusetts.

Basic training was a total shock to me. I had always had trouble sleeping and now I had to be up at 6 a.m. every day. I knew

I couldn't give the drill sergeant a note from my mother saying I needed to sleep in so could you please cancel my KP duty? Instead, I had to learn how to survive sleeping in one room with eighteen other guys. I started out thinking I could buck the system by taking some poetry or the score to "Daphnis et Chloé" with me on marches so I would have something to read on the break and kind of stay above everybody else. After a while, I just tried to fit in as best I could with the other guys, most of whom didn't want to be there any more than I did.

In an article my father wrote for the *Saturday Evening Post* many years later, he said what while I was in basic training, they put me in charge of a platoon during drills one day. When I forgot to say "Company, halt!" everyone marched right into a stone wall. The truth is they would never have let me lead a march. I was such a terrible soldier that I used to pay another guy to clean my M-1 rifle.

One day when I was sweeping out the recreation hall on the base, I saw a piano and sat down and started to play. An officer walked in and before I could explain what I was doing, he told me he was in charge of putting together touring musical acts to entertain the troops. Instead of being shipped out to Korea or Germany like the other guys in basic, I began playing concerts on different bases in the First Army area. I would sit there at the piano pulling things out of my hat and improvising stuff that I passed off as unpublished works by Debussy. I was sure that sooner or later I was going to get busted for what I was doing, but it never happened.

One of the places I played was Fort Jay, on Governors Island, just off the southern tip of Manhattan. There were a lot of officers stationed there who had been called up from good civilian jobs because of the Korean War. One of them was a major who hated being back in the Army. They had put him in charge of the officers' club, so what he did every night was hang out at the bar and drink cognac with Women's Army Corps officers.

After he saw me perform, the major said, "I'm going to have you transferred from Fort Devens to Governors Island, and here's what you're going to do. You will no longer wear your private's uniform. You'll wear a tuxedo and play piano here in the officers' club, and you can live off the base."

By now my parents were living in an apartment in Manhattan, so I moved in with them. Every day before I had to report for duty, I would go to the major's apartment on Park Avenue to give piano lessons to his two kids. It was a real pain in the ass for me because I had no patience. After the lesson, I would drive my father's car to the Maritime Building on the Battery, take the ferry, and get to the base at around one o'clock in the afternoon.

Sometimes I'd be playing piano at night in the officers' club when some second lieutenant who'd already had a few drinks would put money in the jukebox while I was performing. What I really wanted to say was "What the fuck are you doing, man? Can't you see I'm playing here?" But because I wanted to stay there at all costs and I was just a private, I knew I couldn't make waves, so I would just stop playing, take a little break, and then start up again when the song was over.

After a while, I got to know every officer's favorite song. Whenever General Willis Crittenberger, who was in charge of the First Army, walked into the club, I would go right into "Back Home in Indiana" for him.

This went on for a while, until I got myself into some deep trouble by dating the daughter of Colonel Doubleday, the head of personnel for the First Army District. His daughter was cute but I guess she told him what was going on between us and he didn't like it, because, number one, I was Jewish and, number two, I was a private. So one day he called the major and said, "What does Private Bacharach do? What are his duties?"

The major said, "Well, he works in the officers' club."

"I know he plays piano in the officers' club but I have never seen a table of organization stating this. What else does he do?"

"He's in charge of the linen room," the major told him.

The next time I showed up at the base, the major said, "Go into the linen room in the officers' club and count all the napkins and tell me how many there are." There were four hundred napkins in the linen room. After I had counted them, I asked the major what else he wanted me to do. He said, "Go back in and count them again."

Even though I was now in charge of the linen room, the colonel still wanted me out of there so he had me transferred to Camp Kilmer in New Jersey, where soldiers would usually stay for three days before being shipped out to Korea or Germany. I remember standing in a long line, carrying my military records and my duffel bag. When I finally got to the sergeant at the desk, he pulled up my papers and said, "We have a request from General Crittenberger to hold you here." Every three days, a brand-new bunch of soldiers would arrive on the base and then get shipped out, but not me.

When I was allowed off the base I would take the train from New Brunswick, New Jersey, into the city to see my parents. I wasn't playing piano anymore. I was just being a soldier, doing nothing else, but it was a lot better than being in Korea. They kept me at Camp Kilmer for about five months, which probably saved my life. Finally somebody in personnel said, "What the hell is this? Ship this guy out!"

Instead of going to Korea, where I would have probably seen combat, I got lucky and was sent to Germany. I was stationed in Garmisch-Partenkirchen, a resort town in Bavaria at the base of the Zugspitze, the highest mountain in Germany. The Army had a very low-level Special Forces base there, with an entertainment center for soldiers on leave. I lived with three other guys in what had been an old German officers' club, so that was pretty nice.

My job was to write orchestrations for the band that played in Casa Carioca, a nightclub in the rec center that had an ice rink under a movable dance floor and a roof that opened to the sky. I had a great band to work with but when they asked me how many arrangements I could write for them, I said, "Maybe one every three weeks." I could have written two a week, and have really benefited from having that kind of a laboratory, but I didn't want to work that hard, so I just took the lazy way out.

Instead of really learning how to orchestrate, I was just biding my time. I began learning how to ski on wooden skis on the Zugspitze, which is a pretty terrifying mountain. I had never been that scared in my life. My parents came to visit while I was on furlough and we went to Paris and then Venice, where I met a girl who couldn't speak English but was spectacular. I arranged to meet her later that night.

After dinner with my folks, I told them I was going to take the boat from the Lido to meet a friend, but my mother said, "No. You can't go." I said, "If I'm old enough to be in the Army, I'm old enough to go." I went into town and looked for the girl, who was supposed to meet me by some canal, but I never found her, and then my mother wouldn't talk to me for the next couple of days.

I have a photograph of myself taken back then that says it all about my time in the Army. With one foot propped up on the edge of a fountain and my knapsack beside me, I'm standing in full uniform in front of some ancient ruin. In a lot of ways I look just like every young soldier. The only difference is that I'm holding a tennis racquet in my hand.

Chapter

3

I Married an Angel

After I was discharged from the Army, I went back to live with my parents in their apartment on East Fifty-Seventh Street in Manhattan. I had no idea what I wanted to do, so I hung around the city for a while and studied with the Czech composer Bohuslav Martinů at the Mannes College of Music on the Upper East Side. I also studied at the New School with Henry Cowell, the avant-garde composer who had been one of George Gershwin's music teachers when he was a boy.

I really liked Henry Cowell because he didn't take himself too seriously. He once played a piece in a concert in Paris by banging out clusters of notes on the piano with his fists that was reviewed in a French newspaper by their boxing writer. I also studied orchestration with Eric Simon, but I didn't really learn that much from him.

I went to a couple of John Cage concerts, one of which featured twenty-four musicians huddled around twelve portable radios. As Cage began conducting, the musicians turned the dials of the radios so the audience heard bits and pieces of music and speech mixed in with lots of static. I also saw a piece performed that Lou Harrison had written for Martha Graham. It was sixteen minutes long and thirteen of those minutes were complete silence. I was listening to

stuff that was pretty out there, but none of it helped me decide what I wanted to do as a musician.

It was then that I met Paula Stewart, a stage singer who also happened to be very good-looking. Paula was working as an understudy on Broadway when she ran into my dad at a press party. When she told him how hard it was to find an accompanist for her auditions, he said, "Boy, have I got a guy for you!" My parents invited Paula to a party at their apartment, and I was sitting at the piano playing background music when she came over and started talking to me.

Paula Stewart: I kind of sidled over to Burt but he was very cool to me and it was definitely not love at first sight. It was more like hate at first sight. I don't know why. Maybe he didn't like singers. But I've always been attracted to piano players. My father was a pianist and I dated Byron Janis for a while and Vladimir Horowitz was a great friend and then I met Burt. I told him I was looking for an accompanist and I asked how much he would charge to play at an audition for Richard Rodgers the following week. Burt said, "Five bucks," and I said, "Good. Sold!"

Whenever you performed Richard Rodgers's songs in a summer stock show back then, he insisted on hearing who would be singing them. Burt went with me to the audition for Richard Rodgers and he was a stickler. If you didn't play his music exactly as it was written, he got furious. In the middle of my audition, Richard Rodgers said, "Miss Stewart, will you please send your orchestra home?" I thought it was funny but Burt was crushed.

From then on Burt played all my auditions, and after each one we would go to the Horn & Hardart on Fifty-Seventh Street and have a cup of coffee to discuss how we had done. Gradually he got to know me a little better and we started going together. He was still living with his parents, which I think made him insecure, but then he moved into my one-room apartment at 140 East Fortieth Street.

Burt was a neat nut and he didn't like the way I kept house, so the first thing he did was clean up my kitchen.

Burt was also a germ freak. If he went out in cold weather, he would never leave the apartment without a bottle of Cepacol in his pocket. He got that from his mother. He was also a little bit obsessive-compulsive and would get out of bed to check the front door like twenty times at night. He would also be up all night playing the Wurlitzer spinet piano Vladimir Horowitz had bought for me, and that would annoy the shit out of me.

Paula could sing but she was not my kind of singer. However, even after we started living together, I would still get five dollars whenever I played an audition for her. The attraction between us was physical, because she was really good-looking and had great tits, which back then could not be prefabricated.

I began living with her. While I can't say it was wonderful, it was nice not to be living with my parents anymore. Paula and I were invited to a lot of fancy parties. I would walk in wearing black tie and we would be expected to perform. We were guests but we weren't really guests, which I thought was odd, and then Paula would sing "You Are Love" or some other song from *Show Boat* for all these really rich folks and debutantes.

I remember going to a party one night and being fascinated by the woman on my left at the dinner table. The next day, the phone rang and I picked it up, and this woman said we had met at the party the night before. She told me she had written her phone number down on the cuff of my shirt and wanted to know if I still had it. I was going right along with it until I realized it was my mother, who now knew I was not really being so faithful to Paula. It was a mess.

Paula Stewart: Burt and I used to be constantly invited to parties to perform for the Whitneys and the Duke and Duchess of Windsor.

We would perform and then sit and have dinner with the duke and duchess. Burt would be talking to her and I'd be talking to the duke, who at this point was a doddering, falling-down drunk. Wallis was very much the one in control and Burt and I performed for them so many times that she gave me this beautiful art deco jade and sapphire bracelet as a gift.

Paula and I were living together when one day she said, "Either we do it or we don't. Either we get married, or you have to move out." So I moved out. And I was miserable the first night. And miserable the second night. On the third day I woke up and told her, "I can't do this. Okay, Paula, we'll get married." I've since learned there really is a three-day cure, and I would recommend it to anyone. If you can get past the third day, you'll be over it and it will be finished just like a cold. By the fourth day you'll say, "What was I thinking?" But Paula wanted me to commit, so I did.

Paula Stewart: We had been living together for six months and my father was constantly pushing me to get married. Burt's mother, Irma, a teeny little lady who was very artistic, didn't like most of his girlfriends but she really loved me, and when she found out we were getting married, she told me, "You know, honey, he's really not marriage material." She tried to warn me but I still went right out and bought our engagement rings.

Then Burt began working for Vic Damone. Vic was not terribly well educated but he was good-looking and well endowed and the girls liked him. He would ask Burt all the time, "Tell me some big words. I want to impress this girl." So Burt would give him a couple of big words and I think Vic felt a little intimidated by that.

A well-known music publisher named Ivan Mogull, who lived in the same apartment building as my parents, suggested I go to work

conducting and playing piano for his good friend Vic Damone. I was very inexperienced as a conductor and didn't quite know what I was doing, but I auditioned for Vic and he hired me to go on the road with him. Vic had all the tools to be a great, great singer and could have become a huge star, but he was his own worst enemy.

Like me, Vic had also just gotten out of the Army, so we hit it off at first. I went to Palm Springs, California, where I lived with him and his managers, Marvin Cain and Nick Sevano, in a house Vic had rented in the desert so we could rehearse. But instead of working with him at the piano, I spent most of my time driving around with Vic in his car and watching him hit golf balls at the driving range.

One day as we were coming back from the range, Vic turned to me and said, "Burt, who's the best driver you've ever been with in a car?" I thought this was a really dumb question, so I said, "Uh, Marvin?" When we got back to the house, Marvin took me in the other room and said, "Listen, schmuck, you want to get ahead in this business? When Vic asks you who the best driver is, you say, 'You, Vic!'"

I was supposed to be getting paid fifty bucks a week for learning the act with Vic, but he didn't want to sign my check. So one day Marvin stood him up against the wall, took out a pen, wrote out the check beside Vic's ear, and made him sign it for me. I should have known right then and there that this was not going to last, but I was so happy to be working that I just went along with it.

Before we played at the Mocambo on the Sunset Strip in Los Angeles, Sammy Cahn wrote special lyrics to "The Lady Is a Tramp" for Vic to sing on opening night. Because Vic was too busy hitting golf balls and chasing girls to learn the words, he had to perform the song with a lyric sheet in his hand. Everybody in Hollywood was in the club that night so they all got to see Vic shooting himself in the foot.

Vic definitely had the singer's ego, and I soon learned that whenever I saw him coming toward me with a girl on his arm, I had to cross the street and walk on the other side. After we finished up at the Mocambo, we went to Las Vegas, where I met Slim Brandy, a beautiful girl from New York's Copacabana Club who had come to Vegas to dance at the opening of the Sands Hotel's Copa Room.

Slim Brandy: I had a lot of buddies in Las Vegas and one of them was Danny Stradella, who owned Danny's Hideaway in New York. Vic Damone was singing at the Thunderbird and Danny asked me what I thought of him. I said, "Well, he's terrific. Why?" And Danny said, "He needs someone to burst his balloon. He's screwed just about everyone in this town and you just got here so I'm going to make a reservation and we're going to sit ringside. Do you think you can flirt with him during the show and then brush him off when we go backstage afterwards?"

Vic had just absolutely destroyed one of my best girlfriends, who was a cocktail waitress there and had actually tried to commit suicide over him. So I was hot to trot. I got myself all dressed up and we went to this ringside table and for just about two minutes, my heart dropped because I thought, "Oh, he's so adorable! I'm never going to be able to do this." Then I got an elbow in the ribs from Danny, who said, "Hey, what's going on? You're not supposed to fall for the guy." As I was listening to Vic sing, I was going, "What is that countermelody? What am I hearing? I know the song, but I've never heard it sound like this before."

My eyes went to the right of the stage and Burt was playing piano and looking straight in my eyes, and it was kind of love at first sight. Danny and I went backstage and I gave Vic the brush-off. Two minutes later Burt said, "Let's get out of here." We went back to the Sands Hotel and we swam and we talked and we kissed and

we spent the next four or five days together. We did not go all the way because I was still a virgin.

I thought Slim was beautiful and after the show was over, I found a piano so I could play her favorite song, "I Married an Angel," by Rodgers and Hart. "Have you heard? / I married an angel / I'm sure the change'll be / Awf'lly good for me." Slim and I went to bed together in Las Vegas but she kept her bathing suit on.

Slim Brandy: Burt was very straightforward in Las Vegas. He said, "I've got a girlfriend back in New York and we're supposed to get married." And that was Paula. I was just a kid and I thought to myself, "Oh, I don't care about that. My mother would never allow me to bring a piano player home anyway." And I told him that.

After I had been working with Vic for about three and a half weeks, we were appearing at the Chicago Theatre on State Street when his manager took me aside and told me I was being fired. The reason he gave me was that whenever Vic and I were onstage together, he thought I was smiling at all the girls in the audience behind his back. It might have started with Slim in Las Vegas, but Vic would have fired me in any event because as I later learned, he fired a lot of people, like forty-three different keyboard players and drummers.

Still, this was the first real job I'd ever had and what really hurt was that Vic didn't even fire me himself. Instead, he had his manager do it, and I was totally crushed. The truth was I didn't really know how to conduct and none of the guys in the band wanted a young kid telling them what to play. But when I got fired, all my self-esteem and my self-worth went right out the window. I had no job, and how was I supposed to explain that to anyone?

I went back to New York, where I knew someone who knew Bill Ficks, the manager of the Ames Brothers, and he hired me to play with them. Joe, Gene, Vic, and Ed Ames were really good guys who were always on the road working in places like Tuscaloosa and Tulsa. Sometimes we all played basketball together before a show and I liked that. It was not a bad life by any means, but I knew it was a definite step down from what I had been doing with Vic.

Paula Stewart: Burt got a job with the Ames Brothers and went on the road with them. Even then he was the most incredible accompanist, and when he played piano, it sounded like an orchestra. But when he tried to write some songs for the Ames Brothers, they said, "Get out of here, Burt. Ah, please. Go listen to the radio." But they were very sweet guys and they were all at our wedding.

Burt and I got married on December 22, 1953, and I even bought my own wedding ring, for which I still have the receipt. We were married by a justice of the peace and I made my own wedding dress. My parents and Burt's parents were there, and we had the reception between shows, at the Versailles, a supper club on East Fiftieth Street between Third and Lexington where I was appearing at the time.

After we were married, Burt's father found us a one-bedroom apartment at 404 East Fifty-Fifth Street, not far from Sutton Place. The rent was maybe a hundred and twenty-five dollars a month and the apartment was just a block away from where Burt's parents lived, which of course they liked, and it didn't bother me because I loved them.

Hermione Gingold lived in the penthouse and Ben Gazzara and Janice Rule and Jack Cassidy and Shirley Jones all lived in our building, and we would see Jack and Shirley a lot. Our other friends there were Steve McQueen and Neile Adams, who hadn't gotten

married yet. Steve and Burt liked to sit together and watch games on television. I hated that.

I did a lot of traveling with the Ames Brothers, and whenever material came in that people wanted them to record, I would either play the songs for them on the piano or listen to the demos. They were all terribly simple and an awful lot of them were like a big hit at the time that went "I'm in love with you / You, you, you." That was when it occurred to me that I could go back to the Brill Building and write five of these a day. I also went back to New York to work on my marriage to Paula. For all the good that did me, I could have stayed out on the road for another six months.

Paula Stewart: One of my best friends was Wilson Stone, a well-known songwriter who was signed to Famous Music, where he was working for Eddie Wolpin. Burt couldn't find someone to write lyrics with him so I talked Wilson into writing a couple of songs with Burt. Wilson liked Burt's music and took him over to see Eddie Wolpin, who signed Burt to Famous Music, and that was how Burt got his first serious music contract.

Burt and I were separated a lot because he would be out on the road and I was working constantly in New York and doing summer stock. That was one of the reasons I kind of lost interest in the marriage. I started playing around a bit, which he didn't know. When you're in summer stock, some of those leading men can be pretty handsome.

The breakup happened in 1956 and I still have the letter Burt wrote me begging me to stay. It was really heartbreaking. He didn't want to give up the life we had, but it wasn't going anywhere. The divorce was simple. I said, "You're going to Vegas. Pick up a divorce while you're there." We were still friendly and he agreed to keep playing at all my auditions. That was part of our agreement

but I also had to give him half of the five-thousand-dollar dowry my father gave us when we had gotten married and custody of our dog, a beautiful boxer named Stewba, which stood for "Stewart-Bacharach."

While we were together, Burt never wrote a song that became memorable and he never wrote a song for me, which really pissed me off. But I never doubted his talent. In fact, I think I married his talent. That was how impressed I was by it. The other thing was that I never knew him as Burt. His family called him Happy and so did I. When he informed me that from now on he was to be known as Burt, I had a little bit of a hard time with that. But I did it to appease him. Although to me he will always be Happy.

To supplement the income I was getting trying to write songs, which was nothing at all, I played piano at one-night stands in Union City, New Jersey, with Steve Lawrence, who claims I once took him to a burlesque show in the middle of the afternoon because I liked listening to the music they were playing there. I also performed with Joel Grey in the Catskills, where we would do two shows on the same night at different hotels.

Back then, every hotel in the mountains had its own five-piece band, so we would leave the city in Joel's car in the morning and drive up to Kutsher's, to rehearse with their band. Then we would drive to Brown's Hotel and rehearse with their band. We'd go back to Kutsher's to do the first show, go to Brown's to do the second one, and then get in the car and drive all the way back home again. It was a pain in the ass and very hard work for not much money. Maybe I would make eighty dollars for the night, if that much.

I also worked with Georgia Gibbs, Imogene Coca, and Polly Bergen. I had a mad crush on Polly, and we were sort of together for about a minute and a half. She and I would do evening boat tours. We would drive down to Baltimore, get on the boat, leave the port,

rehearse the band, do the show, and come back at one in the morning. I also did a date in Florida with both Polly and Joel Grey, and although Joel also liked Polly, I liked her more. All of it was for very little money but I was learning how to conduct an orchestra.

I also did a USO tour in Libya with the Harlem Globetrotters and Abe Saperstein, the guy who owned the team. I was playing a lot of basketball at the Grand Central YMCA in the city and I was crazy about the game. On the scary old cargo plane going over there, I asked Abe if he would let me play for the Washington Generals, the opposing team of white guys who always lost every game. I told him all I wanted to do was take one jump shot from the corner and Abe said, "Yeah, sure, maybe we'll let you suit up some night," but he never did let me get in a game.

My roommate on the tour was Barney Ross, the former welterweight champion of the world. During World War II, Barney had won a Silver Star for single-handedly killing nearly two dozen Japanese soldiers on Guadalcanal and then carrying one of his fellow Marines to safety on his shoulders. While recovering from his injuries back in the States, he got strung out on morphine and became a full-blown heroin addict for a while.

One night when we were in Tripoli, the two of us went into a café and had a few drinks. Then Barney tried to pick a fight with a couple of Arabs. "Hey, you," he said to them, "we're Jews. You got a problem with that?" Somehow we both got out of there in one piece, rented two camels with drivers, and decided to have a race through the streets. I don't remember who won but it didn't matter because neither of us fell off.

Basically, I was doing anything I could to make ends meet, but when it came to writing songs, I had no idea how hard it was going to be, and the ones I wrote were so bad that I went close to a year and a half without getting one sold. In 1955, Patti Page recorded "Keep Me in Mind." I had composed the melody and a family

friend named Jack Wolf wrote the lyrics, but it wasn't a hit. Things were so bad that I had to borrow five thousand dollars from my dad. That was a lot of money back then and it would be like thirty-five thousand dollars today. It kept me going for a while, but what I really needed was to write a hit. No matter how hard I tried, it was something I couldn't seem to do.

Chapter

4

Warm and Tender

Even before I was signed by Famous Music, I had already started working out of a little office in the Brill Building, at 1619 Broadway. Everybody you needed to know in the music business was there but the offices were so small that there was just enough room for a desk, an old upright piano, and an air conditioner that didn't work in a window you could never open.

Downstairs was the Turf Restaurant, where a lot of songwriters who weren't broke went for lunch, and Jack Dempsey's Restaurant and Bar, where only people who really had money could afford to eat. Agents and performers looking for work would sit in the phone booths in the lobby making calls with dimes stacked in front of them. In the elevator going up to my office on the fifth floor, I would sometimes see Phil Spector, Jerry Leiber, Mike Stoller, and Jerry Moss, who later founded A&M Records with Herb Alpert.

Carole King and Gerry Goffin, Barry Mann and Cynthia Weil, and Jeff Barry and Ellie Greenwich were all right across the street at 1650 Broadway working for Donnie Kirshner, who had kind of an empire going at Aldon Music, with lots of office space and pianos and work rooms. Unlike them, I never got into writing the kind of songs you would call teen pop.

I don't know if it was my classical training or because I had fallen in love with jazz as a kid but the kind of music Bill Haley and His Comets were making also never did much for me. A lot of those songs consisted of just three chords, C to F to G. If they had thrown in a C major seventh that would have been a lot more interesting, but the plain C major chord just seemed so vanilla to me.

The way it worked in the Brill Building for a songwriter was that when you finished a song, you would take it to a publisher and play it. If the publisher liked it, he would say, "Go make a demo." The publisher would pay for the demo and then it would be up to him to peddle the song to an artist who would record it. Some publishers knew a good song when they heard one, and some had no idea.

My first year and a half in the Brill Building was very hard and I got a lot of rejections. After I had come up with a few songs that were recorded, someone arranged for me to see Connie Francis. She'd already had a huge hit with "Who's Sorry Now?" and was a big star, but when I went in to play a song for her, she took the needle off the demo after eight bars.

Pretty much the same thing happened when I went to see Carolyn Leigh, a well-known lyricist who wrote hits like "Witchcraft" and "The Best Is Yet to Come" with Cy Coleman. I played her some of my music and asked if she would be interested in writing with me but she turned me down flat. So it was not as though people were knocked out by what I was doing.

While both Connie Francis and Carolyn Leigh might have been right about the songs I played for them, I've always thought that if a lot of the people who were trying to write hits back then had been able to stick it out and have the stomach to be repeatedly rejected, they might have eventually become very successful.

After I had written some songs with Jack Wolf, Eddie Wolpin hired me to write for Famous Music, a division of Paramount Pictures. A classy guy in his fifties who always dressed very sharply and

was related in some way to the Gershwin family, Eddie had better taste in music than most of the publishers in the Brill Building. The two of us would sometimes go out to the racetrack at Jamaica and Belmont, and Eddie kind of liked having me around, which made it easier for me to get an office at Famous Music. I got paid fifty dollars a week for working there but since my salary was charged as an advance against future earnings, this meant that every week I went without writing a hit just put me in a deeper hole in terms of what I owed the company.

Eddie Wolpin thought it would be a good idea for me to write with Hal David, but we were both also working with other people at the same time. Hal might write three days a week with Mort Garson in the morning and then with me in the afternoon, and I also wrote with Bob Hilliard and Hal's older brother Mack.

When I first met Hal, I was twenty-seven, single, and living with my dog Stewba in a nice little apartment with a tiny terrace overlooking Bloomingdale's at 166 East Sixty-First Street. Hal was thirty-five, married, and living in Roslyn, Long Island. Along with his two older brothers and his sister, Hal had grown up in Brooklyn in an apartment over a delicatessen run by their parents. During World War II, Hal had served in a Special Services unit in the Pacific, where he had written songs and sketches for people like Carl Reiner and Howard Morris.

After the war, Hal followed his brother Mack into the songwriting business and went to work at the Brill Building. By the time I met him, Hal had already written the lyrics to "The Four Winds and the Seven Seas," a hit for Guy Lombardo that Vic Damone also recorded. Hal had also worked with Frank Sinatra and Teresa Brewer.

The best way I can describe Hal is to say that he was a regular guy. Sammy Cahn once said I was the only songwriter who didn't look like a dentist, and if you had met Hal at a party back then, that

was exactly what you would have said he did for a living. Like me, Hal was a perfectionist but he didn't have a lot of personal eccentricities and he didn't dress like a guy in the music business. When it came to writing a song, he always had the ability to unleash some extraordinary lyrics. I really believe that what you write is what you are, and the deeper core of Hal's being always came through in his craft.

Hal was also pretty structured. I remember him telling me, "I work between ten and five and then I get on the train and go home." Hal and I were never able to write a song together in a minute and a half, and we couldn't be in the Brill Building after six at night because they would lock the front door and neither of us had a key. So there was no such thing as an all-night session.

Unlike a lot of the other guys I wrote with, Hal was flexible. Sometimes he would bring me a song title or some lyrics he had written, sometimes I would play him the opening strains of a phrase or a chorus I had come up with, and sometimes we would actually sit in the office at Famous Music and write together. At the end of the day, Hal would go home to do his work and I would go home to do mine. The next day we'd come back to the office and work together on whatever we had come up with overnight.

Our office was so narrow that Hal had to squeeze by me to get to his desk, where he would chain-smoke one Chesterfield cigarette after another as I sat at the piano. The room was always filled with smoke, and although I hated the smell, I never asked him to stop or told him how much it bothered me. At some point, thank God, he finally broke the habit.

Hal and I wrote some really bad songs together, like "Peggy's in the Pantry" and "Underneath the Overpass." Then Syd Shaw and I came up with "Warm and Tender" in 1956, which became the B-side of Johnny Mathis's first big hit, "It's Not for Me to Say." At the time, Johnny was not a well-known artist. He had done a jazz

album at Columbia and then Mitch Miller decided to record him and change Johnny's image by having him do romantic ballads, with Ray Conniff conducting the orchestra.

Since Syd and I got paid as much for writing the B-side as whoever had come up with the hit, "Warm and Tender" was really important for me. The money I earned from it pulled me out of the financial hole I was in with Famous Music. "It's Not for Me to Say" went to number one on the pop chart and Johnny became a big star. Both songs were used in the movie *Lizzie*, the story about a girl with three personalities, starring Eleanor Parker and Richard Boone, and then ended up on Johnny's *Greatest Hits* album.

Syd Shaw was a very funny gay guy, and every time we wrote a song that Johnny Mathis recorded, Syd wanted to celebrate by giving me head. Quoting the A-side of "Warm and Tender," I would tell him, "It's not for me to say but thank you very much, I don't want that."

A year later, Hal and I came up with "Magic Moments" and "The Story of My Life" at about the same time. After Perry Como recorded "Magic Moments" and sang it on his television show, the song became a hit and I made enough money from it to pay my father back the five thousand dollars he had loaned me. Perry Como would never have recorded most of the pop material that was coming out of 1650 Broadway, but "Magic Moments" was a lot more adult and mainstream than what I started writing later on.

I don't know how Hal and I did it, but "The Story of My Life" definitely sounded country, so it was sent to Nashville. Marty Robbins recorded the song and it went to number one on the country-and-western chart. I remember being in Las Vegas conducting for Marlene Dietrich around that time and there was a chorus line at the Sands called the Texas Copa Girls, all of whom were beauty contest winners. "The Story of My Life" was being played like crazy in Houston and none of the girls in the line at the Sands believed a

New Yorker like me could have written it. I had a copy of the sheet music sent out so I could prove to them that I had.

I still wasn't doing that well, but I wanted to get out of the city for the summer, so I took a house in Ocean Beach on Fire Island. I split the $3,000 rent for the season with four other people, one of whom was Merv Griffin, who back then had a game show on local television in New York. A friend of mine named Charlie Herman, whom I had met playing basketball at the YMCA in the city and who later became my road manager, was also out there for the summer.

Charlie was a Brandeis graduate who liked to hang out at the Bayview Club because it was so quiet. Even on a Saturday night, there would be no more than ten or twelve people there. Among his other talents, Charlie could drink eleven martinis and not fall off the bar stool, and he got to know Billy Kohler, who owned the place.

I was in there one night when Billy came over to me and said, "Charlie says you play piano. Are you any good?" I said, "Yeah, I am." We made a deal for me to play on Friday, Saturday, and Sunday nights and Billy said, "You've got a choice. I can give you a percentage if we do well or I could just give you forty dollars a weekend and you can have all the food and drink you want." I said, "I'll take the forty and food and the drink, yeah."

After I started playing there, a guy who wrote for *Variety* or the *New York Post* came in and had a couple of drinks and wrote a rave review about me. The next weekend, you couldn't get into the fucking joint. The Bayview Club became the place to be on Fire Island on weekends, and there were so many people trying to get in that Charlie became the bouncer. In order to get into the club, you had to go through him. The place got so jammed that it wouldn't have mattered if Charlie had been playing piano.

By the first week in July, so many girls had spilled their drinks

on my piano while I was playing that they had to set up a white picket fence to keep them away from me. If I had taken the percentage I would have been making a fortune, but to make up for that I was eating as much lobster as I could and also drinking a lot.

I was playing there on a Sunday night when Tracy Fisher walked in. She was a great-looking California girl with beautiful hips, sun-streaked blond hair, a dark tan, and blue eyes. At the time, she was married to Marvin Fisher, who had written the lyrics to "When Sunny Gets Blue." Tracy was older than me and after we left the club together, she said, "When I came in to have a drink tonight, I had a choice. I was either going to fuck you or the guy at the end of the bar, who's a fisherman."

I didn't know if she was serious or making a joke, but I thought she was incredible. Tracy had been a showgirl and had great legs and I was just crazy about her, so we started an affair that lasted all summer long. When I went back to the city, she left Marvin and moved in with me in my fourth-floor walk-up on East Sixty-First Street, where we lived with Stewba and Tracy's dog, a poodle named Killer.

If Tracy and I had stayed together, I would never have had a career. I would also probably be long since dead. Every night when I came home from the Brill Building, Tracy and I would start the evening by drinking martinis before dinner. After the fifth martini, we would go out and walk our dogs on Park Avenue. Then we'd come back home and go to bed and I would never get any writing done.

Our relationship started to come apart after a few months because I started wondering, "How much can you drink? And then not write?" We finally broke up when she gave me the crabs after sleeping over at a friend's apartment. Tracy just kept right on living the same way and eventually wound up with some low-level hood, who killed her on a boat.

Despite "Magic Moments" and "The Story of My Life," I still hadn't found my own voice as a writer, and I wasn't doing all that well with the assignments I got from Famous Music. Without being given credit for it, I wrote the instrumental theme for *The Blob*, a Paramount picture starring Steve McQueen. I got five hundred dollars for the song. Mack David put words to it and the song was recorded as "Beware of the Blob," by the Five Blobs. Bernie Knee, a demo singer and musician at Associated Recording Studios in Times Square, where everyone cut their demos back then, sang all five parts on the song and it became a moderate hit.

During the next four years I wrote eighty songs with Hal, Wilson Stone, Syd Shaw, and Bob Hilliard, including one called "Happy and His One Man Band." None of them were hits, and most were never even recorded. Even though it bothered me a lot that my songwriting career was going nowhere, I kept myself busy by touring the world with Marlene Dietrich.

Chapter

5

The Blue Angel

I was about to go to Los Angeles to learn something about scoring films at Paramount Pictures and see this actress named Norma Crane, whom I had met in New York, when I heard myself being paged at the airport. I went to the front desk of the TWA terminal to take the call, and it was Peter Matz, a brilliant conductor, arranger, and classically trained pianist who had worked with Harold Arlen on Broadway. After Arlen had recommended Peter to Marlene Dietrich, he had started working as her accompanist before she loaned him to Noël Coward for an engagement in Las Vegas.

I always liked Peter because we had so much in common, and when I picked up the phone, he said, "Look, I'm in a real jam here. Dietrich is playing in Vegas at the same time as Noël Coward and he wants me to work with him, so do you think you could fill in for me and do the date with her?" Although I was definitely interested, the idea of meeting Marlene Dietrich seemed really intimidating to me. I had no idea if I could even pass the audition, but Peter said he would let Dietrich know I would be calling her at the Beverly Hills Hotel.

After I had put my stuff away in Norma Crane's apartment on Sweetzer Avenue in West Hollywood, I called Marlene Dietrich

and went over to see her in a bungalow at the Beverly Hills Hotel. Marlene was fifty-six years old at the time but she was still beautiful and as famous as ever. We talked a little and she was very nice and got me something to eat, but I was still really nervous because she was a very powerful presence and had the aura of a huge star.

When we started to work together at the piano, she said, "Do you write?" I said, "Yeah, I'm trying to be a songwriter." She asked to hear something I had written so I played her "Warm and Tender." Marlene had never heard the song before but when I finished, she told me how much she loved it. Marlene wasn't going to sing the song herself but she wanted Frank Sinatra to hear it. I gave her the demo I had brought with me and she got it to Frank. When he turned the song down, Marlene got really angry with him and told him he was making a big mistake because I was going to become a really well-known songwriter. "One day you'll see!" she told him. "You'll see!"

I asked her what song she wanted to open her show with and Marlene handed me the sheet music for a song Mitch Miller had written for her, called "Look Me Over Closely." I looked at it and said, "You don't want to open with this kind of arrangement, do you?" When she asked me how I pictured the song, I began playing it at a different tempo. I got her to try it that way and told her to let herself get carried away by the feeling. I also convinced her to open with "My Blue Heaven." Then she had me play one song after another.

I began coaching her a little bit because Marlene had a tendency to rush and get ahead of the beat. "Sit back," I told her. "Just sit back." I was still a little tentative because Marlene could have just told me to get the fuck out of there, but she soon became very comfortable with me and began getting a strong hold on how to sing these songs. When I was done writing corrections on the lead sheets and orchestrations, we agreed I would come back to see her at ten

the next morning. and we spent the next two weeks rehearsing to-
gether in Los Angeles.

As a singer, Marlene had a vocal range of not much more than
an octave and a note or two. Since I knew we were going to be
working with a pretty large orchestra, with what I hoped would be
a tight rhythm section, bass, drums, and guitar, with me playing pi-
ano, I thought I could get her to swing a little. I kept some songs she
had been doing forever, like "Lola," "Lili Marlene," and "The Boys
in the Back Room," but added standards like "You're the Cream
in My Coffee," "My Blue Heaven," "One for My Baby," "Makin'
Whoopee," "I've Grown Accustomed to Her Face," and of course,
"Falling in Love Again," which Marlene had first sung in Josef von
Sternberg's classic film *The Blue Angel* in 1930.

We opened in Las Vegas at the Sahara Hotel and the show went
really well. Marlene was a smash. It was a wonderful time for me
because Marlene always insisted that I go out with her after the
show. One night we would have dinner with Judy Garland and the
next it would be Maureen Stapleton. I didn't really like the music I
was playing for Marlene all that much but it seemed like a terrific
life to me, because I was conducting, getting paid, and meeting all
these really famous stars.

After the fifth or sixth night, I realized I was kind of trapped in a
web with Marlene. I was single and every casino had great-looking
girls in the chorus line and I wanted to hang out, but I couldn't do
that if I was having dinner with Marlene. Don Rickles was playing
the lounge at the Sahara and whenever I would go in there with
Marlene, he would lay all this stuff on her about me like "There he
goes, looking for broads. Any broad will do. Look out for him, girls.
He's heading to the front door." I loved Rickles and thought he was
hysterical, but Marlene took it seriously and would get really angry
at him.

The first time Marlene and I worked together in Vegas, I didn't

stay at the Sahara. I was at the Bali Hai Motel, and one day while I was playing tennis there, I saw Marlene walking by with a big bag of groceries. I hadn't known her very long at this point but she got the key from the front desk and let herself into my apartment. When I came off the court, she had had the juice from six steaks condensed for me to drink.

It was summertime and I was sweating like crazy, so I threw my tennis clothes on the floor and went to take a shower. When I came back out, she was washing my clothes for me. The amazing thing about Marlene was that despite all the fame and stardom, she was still a German hausfrau at heart and always did everything she could to take care of me.

Marlene and I got a little drunk together one night in Vegas and as I was taking her back to her room, she tried to kiss me and said, "Let's go inside." But I just didn't want to go there with her. Maybe I was smart enough by then to know I couldn't conduct the orchestra every night behind a woman I was sleeping with, even if I had wanted to sleep with her, which I didn't. It would have been like falling in love with fire.

After we finished the engagement in Vegas, I stayed on at the Bali Hai so I could get a divorce from Paula. Back then, you could only get a divorce in Nevada if you were there for six weeks but it was a fun city to be in. There were showgirls in every hotel, and a lot of them were real beauties.

Marlene and I then went on tour to South America. In Rio de Janeiro, the two of us would walk in the hills at night and listen to the drumbeats coming up from the city. That was the first time I heard the baion beat, where the one is followed by a one-beat pause and then two half beats. Phil Spector used it in "Be My Baby," and it's in Jerry Leiber and Mike Stoller's "There Goes My Baby" by the Drifters. You also can hear it at the start of "Any Day Now," a song Bob Hilliard and I wrote and Chuck Jackson recorded.

Whenever Marlene and I flew into a city in South America, there would be a big press conference and Marlene always insisted I be there with her. Sooner or later, the question would come up about whether we were together. Marlene, who could speak French and Spanish as well as English and German and I think Italian, would always say, "Oh, no, there is nothing between us because he is so busy and such a ladies' man, he has women all the time."

In places like Chile and Argentina, it was always very difficult for me to get a girl past the front desk of our hotel. Since no one thought anything about two women going upstairs together, Marlene would sometimes do me the great favor of bringing the girl to her room so I could pick her up and take her to mine. The funny thing is that most of them were dogs.

The real romance between Marlene and me took place when we were onstage together. There would be a scrim in front of me to help with the lighting effects, but for the last three numbers, they would open the scrim, and lo and behold—a Jewish piano player would be sitting there. Even though it always scared the shit out of me, Marlene would introduce me to the audience every night by saying the exact same thing: "I would like you to meet the man, he's my arranger, he's my accompanist, he's my conductor, and I wish I could say he's my composer, but that isn't true. He's everybody's composer . . . Burt Bacharach!"

The most amazing tour I ever did with Marlene was in the spring of 1960, when she went back to Germany for the first time since the end of World War II. As soon as the tour was announced, the German newspapers were filled with letters from people denouncing Marlene as a traitor for having fought with the enemy in the war. What Marlene had really done was put on a U.S. Army uniform while entertaining the troops. She had hated Hitler and the Nazis and gotten as many of her Jewish artist friends out of there as she could before the war began.

The outcry against her returning to Germany was so loud that Norman Granz, the promoter, had to cancel our concert in Essen. In Berlin, we went from doing five nights to three and what began as a seventeen-city tour became twelve. Before we opened in Berlin, Marlene held a press conference and told a reporter that since all her former friends in Germany had either left the country or died in the concentration camps, there was no one left there for her to see except for Hildegard Knef, the actress and singer.

On May 3, 1960, we opened at the Titania Palast in Berlin. Because the ticket prices were so expensive, there were five hundred empty seats in the house. Marlene started the show by singing "Falling in Love Again" in German and then she did "The Boys in the Back Room" and "One for My Baby." She sang in English, German, and French and dedicated one of her songs to Richard Tauber, the great operatic tenor, and Friedrich Hollaender, who had composed the music for *The Blue Angel*. Both of them had been forced to leave Germany because they were Jews.

Her last number was "I Still Have a Valise in Berlin," which she sang in a white tuxedo. When she was done, Mayor Willy Brandt led the standing ovation and Marlene took eighteen curtain calls. The reviews were all very positive, and the audience loved her so much in Munich that she had to take thirty-six curtain calls. They liked her a lot less in the Ruhr, and as we were walking through the lobby of the Park Hotel in Dusseldorf, a hysterical young girl who hadn't even been born during the war ran up to Marlene and spat right in her face while screaming how much she hated Marlene for betraying Germany. Marlene's response was to tell a press conference that she would never perform in Germany again.

When we got to Wiesbaden we were greeted by bomb threats. The French string section we were traveling with freaked out and wanted to leave the tour, but somehow we managed to get them onstage. At one point during the show I would play a "Blue Angel"

medley while Marlene went off to change into tails. When she was ready to come back out, I would cut the orchestra and she'd walk to a chair at the edge of the stage, sit down in a spotlight, and sing the Harold Arlen song, "Vun more for my baby, vun more for the road."

With Marlene, every move was precisely calculated and she would always smoke a cigarette and move away from the chair at a certain point in the song. When she stood up and moved to the left at this show, she misjudged the edge of the stage and fell off it, landing right at the feet of Josef von Sternberg, the man who had discovered her years before. She had her left hand stuck in her pants pocket and hit the floor with her shoulder.

Marlene didn't know it at the time but she had broken her shoulder and was in shock from the pain. Somehow I realized she was about to start singing the same song she had just done, so I began hitting the same note on the piano again and again to bring her back and it worked. She went out to dinner with von Sternberg and his son that night, but the next morning I insisted she let me take her to the American Air Force Hospital, where the doctor told her she had fractured her humerus.

Marlene refused to take anything for the pain. Instead she tied the belt of her raincoat around her arm and off we went to the next city. She walked onstage that night with her left arm tied to her body with a bandage that she hid with sequins and rhinestones, and I did what I could to help her learn how to sing without moving her arms. She never missed a show. In every way imaginable, she was a warrior.

It took Marlene about three weeks to heal from the injury and then we flew to Israel. On the plane to Tel Aviv, Marlene got a stewardess to sing her a song in Hebrew over and over again so she could learn the words while I took notes so we could do it onstage. When we got off the plane, the promoter met us and said, "Miss

Dietrich, of course you are not going to sing any songs in German here because as you know, the language is forbidden in this country and no German films are shown and German cannot be spoken on the stage."

The promoter also told her that a couple of weeks earlier, Sir John Barbirolli had conducted Mahler's Second Symphony in Israel. Even though Mahler himself was a Jew, the public outcry was so intense that Barbirolli had been forced to conduct the choral parts in English. Marlene looked at the promoter for a while and then she said, "I will not sing one song in German. I will sing *nine* songs in German."

He thought she was joking, but Marlene was brilliant when it came to things like this. When she got onstage in Tel Aviv the first night, she opened with "My Blue Heaven" and then "You're the Cream in My Coffee," both of which she sang in English. Then she said, "I would like to sing you a song as a mother sings a lullaby to a child, and the name of the song is 'Mein Blondes Baby.' "

There was a huge gasp from the audience and then a hush fell over the entire hall as Marlene started to sing in German. People were crying and so was I, and so was most of the orchestra. Marlene did nine German songs that night and it was one of the most emotional experiences of my life because the dam broke. Even though Israel was already selling machine guns to Germany and Israelis were driving around in Volkswagens, Marlene broke the barrier against the German language being spoken in the country while also making everyone realize how deep the connection between those two countries really was.

When we worked together in Madrid, Francisco Franco was in the audience. Marlene was offstage trying to get out of her gown so she could change into her white tie and tails as quickly as possible and I was conducting "The Blue Angel" medley. Half the Spanish musicians were playing it and half were playing something else. I

started screaming " 'Blue Angel Medley'!" at them, and I threw the pencil I was using to conduct with at the drummer.

After the show was over, I gathered all the musicians around me. I was still furious and I kept saying, "We rehearsed it. We *re-hearsed* it!" The problem was that they had been drinking sangria all day and getting loaded. As if none of this was their fault, they started screaming at me. "Why you no speak Spanish? Why you no speak Spanish?"

Whenever Marlene and I went out on tour, she would always make me rehearse the orchestra for eight days before the first show. After the first two days, I wouldn't know what to do with them anymore and it would all go downhill, but that was just how obsessive she was about every aspect of her performance.

Marlene and I toured all over Russia, with a different opening act every night—a juggler, a dog act, a magician, and a pas-de-deux team of dancers. Right before our last show in Leningrad, Marlene and I were coming back from another terrible dinner to do our final show in Russia. As we were walking across the stage to go to the dressing room, the opening acts were warming up. The juggler was throwing his balls up into the air and one of them came down and hit Marlene right on the head, and she said, "Oooh!"

I said, "Marlene, are you okay?" And she said, "Yes." As we were walking to her dressing room, I said, "Are you sure?" She said, "Yes." I left her in the dressing room and said, "I'll be back in fifteen minutes to check on you."

Marlene always opened the show with "You're the Cream in My Coffee." When I came back into her dressing room, she said, "Burt," and started to sing to me. She went, "You're the cream in my *vaht*?" She had a really puzzled look on her face and I thought she might have been pulling my leg, but I didn't think she had that kind of sense of humor so I was worried. I asked Marlene if she wanted to see a doctor but she said no. When I came back ten min-

utes later, I asked her how she was and Marlene said, "Okay." Then she said, "Burt," and started to sing "Just Molly and me and baby makes *vaht?*" Now I was very worried.

We got onstage and I hit an E major seventh on the piano to start the opening number. I didn't know what to expect and she sang, "You're the cream in my . . . la-la-la-la," and never came back to any of the lyrics. The same thing happened with "My Blue Heaven" and "Go See What the Boys in the Backroom Will Have." And every song for the entire show was just like that. The title of the song and then "la, la, la, la-la-la-la" because she could not remember any of the words.

After the show, we got on the midnight train to Moscow. I went to see Marlene in her compartment and said, "You've got me scared out of my mind because I don't know who to call or what to do." Then she said, "Look, if I die on this train, you call my daughter Maria. She's got the A-list and the B-list for my funeral and she'll work it all out." I didn't know what to think but when we got to Moscow the next morning, she was just fine.

In Russia, the food was awful and the hotels were worse. Between shows, I would walk around looking for a girl who didn't have gold teeth. By our third week in Russia even the cows were starting to look good to me. I couldn't wait to get out of there.

I once flew to meet Marlene for a show in Warsaw. After we landed, I walked down the steps of the airplane in a driving snowstorm and Marlene was waiting for me with a huge mohair scarf from Dior, which she wrapped around my neck, and a flask of vodka. I had a couple of shots and I was drunk before I got into the terminal, but that was the way Marlene always took care of me when we were out on the road together. In Poland, she arranged for me to stay in a room where the great Polish pianist Jan Paderewski had slept, but there were so many ghosts and so much history in there and the drapes smelled so bad that I could not sleep at all.

After I'd had some R&B hits, Marlene and I were doing two weeks at the Olympia Theater in Paris and Quincy Jones came backstage after one of the shows. Quincy was a friend of mine and said, "Why are you doing this? You write good music. You gotta get back to it." I said, "Well, Q, I'm seeing the world." It was an answer I knew he would understand but I was also doing it for Marlene, because I felt like I couldn't let her down. Whatever else I had going on, I always said yes whenever she asked me to go back out on the road with her.

There was always a duality with Marlene because she never wanted me to leave her. She always wanted me to be there conducting for her but the more famous and successful I became, the more likely it was that she would lose me. Marlene knew this but she was so proud of having been right about me as a songwriter that whenever I got good reviews, she would cut them out of the newspapers and send them to people all over the world.

On November 4, 1963, Marlene headlined the Royal Command Performance at the Prince of Wales Theater in London. There were nineteen acts on the bill and the Beatles came on seventh. At the end of their set, John Lennon stepped to the microphone and said, "For our last number, I'd like to ask your help. The people in the cheaper seats, clap your hands. And the rest of you, just rattle your jewelry," and then they went into "Twist and Shout."

Queen Elizabeth was giving birth to Prince Edward, so she couldn't be there that night, but the Queen Mother came back after the show to say hello to everyone. Marlene bowed to her and the Queen Mother spent a lot more time talking to her than she did to the Beatles.

Elvis Costello: The annual big show of the year in England back then was the Royal Command Performance. It began in 1912 and benefits the Entertainers and Artists Benevolent Fund, founded by

George V, so over the years it had a history of being a concert party for the royal family, and everybody from shows in the West End to comedians, jugglers, and ventriloquists would be on the bill, along with one or two big American or international stars.

This particular edition of the show is still remembered because the Beatles were on it and John Lennon said the thing about "rattle your jewelry." When you watch the footage now, it was obviously a rehearsed remark, but at the time it seemed like he had done something incredibly cheeky and it was in all the papers the next day.

The curious thing about this is that Burt was on the bill with Marlene Dietrich. So were the Joe Loss Orchestra, the band my dad, Ross MacManus, sang with. When I finally met Burt many years later, I told him, "My dad was on the bill with you in sixty-three." I've written a bunch of songs with different people but my two big cowriting collaborations are twelve songs with Burt and twelve songs with Paul McCartney and they were both on the bill that night with my dad. How strange and spooky is that?

Long after I had stopped working for Marlene, I agreed to conduct for her for six weeks on Broadway at the Lunt-Fontanne Theatre. She was sixty-seven years old but still looked great and the show sold out for the entire run. On opening night, there were so many fans on the street outside the theater that they stopped traffic and a couple of cops had to hoist Marlene on top of a limousine so she could sign autographs and pose for photographs.

During the last five years of her life, Marlene became a recluse and would never leave her apartment on the Avenue Montaigne in Paris. She wasn't working anymore and she wasn't going out, and sometimes when I would call her, she would pretend to be the maid answering the phone and I would have to say, "Marlene, cut the shit. It's me, Burt."

Other times when I called her, Marlene would say, "Burt, I vant

to make one more record." She wanted to sing "Any Day Now" and had already worked out how she wanted to do it and how the timpani would sound. She would say, "Burt, I vant to sing it for you," and then she would go right into "Any day now / I vill hear you say / 'Goodbye my love. . . .'"

I knew there was no way I could ever get her into a studio, so I would say, "Well, Marlene, why don't we do it? I could make an orchestra track and slip a microphone through your door and you wouldn't even have to see anybody. You could just put earphones on and sing if you really do want to make one more record." And she would always say, "Ja, Burt. I do."

It would have been impossible to do but I kept talking to Marlene about it because I think the idea gave her a little glimmer of hope. Like "Wouldn't it be nice if we could work together again?" We never did record the song, but I really wish we had because it would have been truly memorable.

What I learned from Marlene was that if you wanted something done, you had to do it yourself. If Marlene had to stand onstage for an hour during rehearsal while they adjusted a light on her, she stood there. No stand-in, just Marlene right there for as long as it took. Then during the show, the pin light would be on her just the way it was supposed to be. She also taught me to never give less than 100 percent onstage because her attitude was to always go for it all.

Marlene Dietrich: Most of the time while I was with Bacharach, I was in seventh heaven. Up to now, I've spoken of the artist. Burt Bacharach, as a man, embodied everything a woman could wish for. He was considerate and tender, gallant and courageous, strong and sincere; but, above all, he was admirable, enormously delicate, and loving. And he was reliable. His loyalty knew no bounds. How many such men are there? For me he was the only one.

When he became famous, he could no longer accompany me on

tour around the world. I understood that very well and have never reproached him in any way.

From that fateful day on, I have worked like a robot, trying to recapture the wonderful woman he helped make out of me. I even succeeded in this effort for years, because I always thought of him, always longed for him, always looked for him in the wings, and always fought against self-pity. Whenever he had the time, he still worked on the arrangements for my songs, but as director and pianist, he had become so indispensable to me that, without him, I no longer took much joy in singing.

When he left me, I felt like giving everything up. I had lost my director, my support, my teacher, my maestro. I was not bitter, nor am I today, but I was wounded. I don't think he was ever aware of how much I needed him. He was too modest for that. Our separation broke my heart; I can only hope that he didn't feel the same way. We were like a true small family when we traveled together, and laughed at everything together. He misses that, perhaps.

After Marlene died of renal failure in Paris in 1992, at the age of ninety, a writer called to interview me about her. I had never read her autobiography, so he started quoting what Marlene had written in it about me. It was so overwhelming that I broke down and began to cry.

Chapter

6

Baby, It's You

Even during the period when I was spending a lot of time out on the road with Marlene, I would always come back to New York as soon as the tour was over and start writing songs again in the Brill Building with Hal, his older brother Mack, and Bob Hilliard. I wrote a lot of songs and I thought some of them were pretty good, so I would make demos and send them to the A&R men at different record companies. The response I would usually get from them was "You've got a three-bar phrase in this song that should really be a four-bar phrase."

It was like getting an order from a second lieutenant in the Army telling me to charge up a hill in battle so I would probably have gotten killed. Did it make any sense? No. But if the second lieutenant said it, he had to be right, and so I tended to think the A&R men knew what they were talking about.

Most pop songs have two verses and then a bridge that leads to the final verse, and are written in either four/four time, which is four beats to a bar, or three/four, which is also waltz time. In the beginning, I wrote in that format because I thought it was the correct way to do it, but then without really intending to do so, I began breaking the rules and writing in more complicated time signatures like six/eight and twelve/eight.

I remember a song Hal and I wrote called "That Kind of Woman." We sent it to an A&R guy who said that if I changed a phrase from three bars to four bars, he would give it to Joe Williams. I did what he asked and Williams recorded the song but it went nowhere. The truth is that I ruined a lot of songs by not believing in myself enough to tell these guys they were wrong.

By now, I had gotten to know Luther Dixon at Scepter Records, the label Florence Greenberg had founded to record the Shirelles, a girl group her daughter had seen perform at her high school assembly in New Jersey. Florence was an overweight white housewife from New Jersey and Luther Dixon was a black singer, songwriter, and record producer who had cowritten "16 Candles" for the Crests. The two of them wound up becoming a couple and formed three labels, called Tiara, Scepter, and Wand Records.

In the spring of 1961, Hal and I wrote a slow ballad called "I Wake Up Crying," which Chuck Jackson, who had been in the Del-Vikings, one of the first interracial doo-wop groups, cut for Wand Records. I wrote the arrangement and played piano on the track, and the song went to number thirteen on the R&B chart. Even though I had never written music that sounded like this before, I think the R&B structures were already in me because I had gone to a couple of recording dates that Jerry Leiber and Mike Stoller had done at Bell Sound in New York and I really liked their music.

In October, Gene McDaniels recorded "Tower of Strength," a song I had written with Bob Hilliard, and it went to number five on both the pop and R&B charts. The song opened with a trombone solo, which was something you didn't hear on R&B records back then. It was recorded by Snuff Garrett at the Liberty Records studio in Los Angeles, and I didn't like it because I thought they had made the tempo too fast. Bob Hilliard and I came up with a kind of answer song to it, called "(You Don't Have to Be) A Tower of Strength," by Gloria Lynne on Everest Records, that went nowhere.

Mack David and I then wrote a song called "I'll Cherish You."
I was cutting all my demos at Associated Recording Studio and I
would try to make them sound the way I felt the song should go, but
what I could do there was very limited. Maybe I could bring in a
sax or a trumpet and a guitar and sometimes a violin if I could find
a violinist who would work for little money. I would write for the
violins in two parts and this way I could get three violins playing on
one part and three violins playing on another. But it would be the
same guy and I would just keep overdubbing.

We didn't have multitrack boards back then so I would be over-
dubbing on tape and there was a limit to how far I could go with
that. I cut "I'll Cherish You" as a demo at Associated with me on
piano, an organ player, a stand-up double bass, and a drum set so
faint you can barely hear it because I always worked there with a
minimum of microphones. I had girls singing the background vo-
cals and because they had this great large reverb plate there, all of
it was smothered in echoes.

Luther Dixon loved the song but he wanted Mack to rewrite the
lyrics to make it darker. Luther came up with the "cheat, cheat"
part and took a co-songwriting credit for himself under the name
Barney Williams. I think he was one who changed the title to
"Baby, It's You."

When we recorded the song, Luther had Shirley Owens, the lead
singer of the Shirelles, come into the studio by herself to put a new
lead vocal on the track. In every other way, the finished record is ex-
actly the same as my demo, with everything I put on it still there. If
you listen carefully right before she starts her lead vocal on the intro
and the "sha-la-la-las" come up in the background, you can hear me
shouting them out and sounding so bad and really loud.

"Baby, It's You" was supposed to be the B-side of the single but it
went to number eight on the pop chart. When I was in London with
Marlene for the Royal Command Performance and she was sing-

ing songs that were as far removed from the Shirelles and what was happening in R&B as you can imagine, one of the Beatles came up to me and said, "Oh, we just recorded a song of yours, 'Baby, It's You.'"

Marlene and I had just come from Sweden, where I had seen posters with the Beatles on them, but at the time, I had no idea who any of these guys even were. I didn't listen to their version of "Baby, It's You" for a long time, because by the time the Beatles cut it that song was already in my past and I was thinking, "What's next? What do I do now?"

In the spring of 1961, Bob Hilliard had taken Jerry Leiber and Mike Stoller a song he and I had written together called "(Don't Go) Please Stay," which the Drifters recorded. I wrote the song in triplets, and that was how I recorded the demo, but Jerry and Mike had a completely different concept of how it should sound. They changed the tempo so that it had more flow and was better than what I had done. The song opens with Bill Pinkney singing "Don't go" in a really low bass voice, and then Rudy Lewis, who had just replaced Ben E. King as the lead singer in the group, takes over.

By this time, I knew Jerry and Mike well enough to go to them and say, "Anytime you're doing a date, I'd love to come and watch you guys." On a regular basis, I began going to Bell Sound so I could watch them work with Ben E. King and the Drifters. Jerry seemed to like me and I knew him much better than Mike, but we all became friends and they agreed to take me under their wing.

Jerry and Mike came up with the idea for Hal and me to form a publishing company with them called U.S. Songs, which gave us a split copyright on everything we did together. The problem was that the only songs they contributed to the company were by a country-and-western artist named Billy Edd Wheeler, while Mike and Jerry got a lot of good songs Hal and I had written. Hal, who was always much smarter than me at business, was against it from

the start and he was right, because it was a total mistake and I shouldn't have done it, friends or not.

I was five years older than Jerry and Mike, but they had been at it longer than me and I really learned a lot about making records from them. Jerry was a lot more forward than Mike, and in another life he had definitely been African-American. Jerry could talk like he was black to the Coasters and write songs like "Yakety Yak" and "Charlie Brown." In the studio, he was the best I ever saw.

At Bell Sound, where Jerry and Mike liked to work in New York, all the microphones were live and there were no baffles or partitions. There was a vocal booth but there was so much leakage in the room that the drums would bleed into the microphones recording the string section. Everybody would be playing live, so the singer would hear the drums and be influenced by them, and the way the singer phrased the song would influence the drummer and the whole rhythm section as well.

When everybody in the room was feeding off each other, you would get the kind of interaction that made working this way a completely different ball game from what came later, when people began making records by cutting separate tracks on different days. When you layer a record, you bring in the guitarist one day and the percussion player the next day and a couple of months later they meet each other and say, "Are we on that record together? Oh yeah." For me, to have everyone playing everything at the same time was the best way to cut a record.

Jerry would have four guitars, three percussion players, drums, a string section, background singers, and the Drifters all going at the same time. Whenever I watched him work, all I could say was "Wow!" Jerry would get in that room with the musicians and the singers and set the groove and the feel, and you can hear that on the records he and Mike made there. Jerry was also very big on the baion beat, so that was something else we had in common.

My initial connection to Jerry and Mike had come through Bob Hilliard. Even in the Brill Building, Bob was always looked on as kind of an oddball because he was a wild man with a wild sense of humor. He'd written the lyrics for "Dear Hearts and Gentle People," a song that was a hit for Dinah Shore, and a novelty number called "The Coffee Song (They've Got an Awful Lot of Coffee in Brazil)," which Frank Sinatra cut. Bob also wrote the words for "In the Wee Small Hours of the Morning," which is a really great Sinatra record. Although Bob and I didn't write a lot of songs together, whenever we did, we did well.

In the spring of 1962, Bob Hilliard came up with a great lyric for "Any Day Now." When we took it to Scepter Records, they wanted to give it to Tommy Hunt, the former lead singer of the Flamingos. We threatened to pull the song if they didn't let Chuck Jackson record it, and when we did the session, the cellos, violins, horns, and backup singers were all playing live behind him. The record went to number twenty-three on the pop chart and number two on the R&B chart and was covered by people like Dee Dee Sharp, the Drifters, Tom Jones, Ronnie Milsap, Aaron Neville, James Brown, and Elvis Presley.

Even though I was now writing a lot of R&B material, Hal and I were still working for Famous Music. They asked us to come up with a song for a movie Paramount Pictures was about to release, called *The Man Who Shot Liberty Valance*, starring John Wayne and James Stewart and directed by John Ford. It was a very hard song for me to write and it took me a long time to finish it. Hal wrote the lyrics first, so I had to come up with music to fit the words and figure out where to put the hook.

The song has an odd structure because there are two verses before the hook comes in and the hook itself is "The man who shot Liberty Valance / He shot Liberty Valance / He was the bravest of them all." I finally finished writing it while I was hanging out on

the beach for a couple of days in Montauk, Long Island. I had a girl with me but I couldn't enjoy being there with her because my mind was on the song rather than her.

I didn't actually produce the record but I did have a lot of say about how Gene Pitney cut it. Jerry Leiber happened to be in the studio with me that night, and he was the one who came up with the violin solo that starts the song, because I had written it for a different instrument.

What I remember doing at that session was something I did a lot back then whenever I was having a problem in the studio. Instead of staying in the control room, I would break the orchestra for ten minutes and go into a stall in the men's room and lock the door behind me. That way there was no music coming at me and I could just try to sort it all out in my mind. Was the problem the string voicing in the first eight bars? Was that it? Should the strings even be there?

More times than not, I would come out of there and have the problem solved. But for me it was always by thinking it through in my head rather than going to the piano, because if I did that, my hands would just automatically go to all the old familiar places and I would never be able to work through it at all. By sitting at the piano and going through the song bar by bar, I was staying horizontal instead of trying to see the whole vertical plane of the music and where it should go. In order to fix whatever was wrong, I always had to hear the song and the arrangement in my head.

Even though "The Man Who Shot Liberty Valance" went to number four on the pop chart, the song was not in the movie. The music in the film itself came from *Young Mr. Lincoln*, a movie John Ford had directed in 1939.

Right around this time, Slim Brandy came back into my life and we kind of picked up where we had left off after I had met her

in Las Vegas when I had been working there with Marlene for the first time.

Slim Brandy: I had gotten married to a very wealthy man, and while we were vacationing at the Fontainebleau Hotel in Miami Beach, Burt was working there with Marlene so I went to see him. He was in a cabana by the pool with Marlene and he introduced me to her and the sparks were still flying between us, but it was just, "Hi. I'm here and hello, and it's great to see you."

Three years later, after I divorced my husband, I was at Basin Street East with this very young man I was dating. We were sitting right up front and the place was jam-packed and there was this one empty table and I thought, "Who's going to take that table? It's got to be a celebrity." When the lights dimmed, Burt walked in with his mom and dad and sat down right next to me. So this whole thing was kismet.

By then, Burt was divorced and so was I and he called me the next day. I was leaving my house in Great Neck, Long Island, so I moved into his building. I had two kids and this way we could be together because my apartment was right across from him. We went together for about two months and I knew it was premature, but I wondered why he wasn't asking me to marry him. For me, two months was a long time but there was never a word about commitment from him.

Even then Burt was really dedicated to his music and would wake up in the middle of the night and write. We used to walk his dog Stewba to P. J. Clarke's and Burt would sit at the bar and feed him beer. The beer would be in the air and the dog would lick up every single drop without missing any of it. Burt also loved to go to this famous steak place on First Avenue, Billy's, and we also used to go to Rocky Lee's, an Italian joint where Frank Sinatra used to

hang out. Burt loved going out for dinner and we went out all the time.

I had to go to Mexico to get a divorce so I figured Burt would say something before I left, but he didn't. We went out to dinner and I said, "I have a problem. You never talk about us getting married." And he said, "Whoa, whoa, baby. We've only been seeing each other a few months." I said, "I know, Burt. But how do you feel about it?" He said, "Let's not go there," and I said, "Fine. I've got to go get my divorce and I may go see Jack Entratter at the Sands Hotel and take a little vacation in Las Vegas." He said, "Well, you know I want you to come back, but I'm not going to tell you what to do." He was always like that. Very noncommittal.

That wasn't good for me, so I went to Las Vegas, and while I was there, I met Paul Anka and wound up having a big love affair with him. I was so confused. How was this possible? I had been waiting for Burt all my life but I really fell hard for Paul and we had about a three-month relationship. I remember when I came back home, the doorman of our building said, "Mr. Bacharach has been calling. He has been waiting every day for you to come in." I called Burt and we went to dinner and I said, "I've got to tell you. I've fallen in love with someone else."

I kept running into Burt in the building and we got to talking about Paul. Then Burt put his arms around me and kissed me and we were back together again. That was the start of our real love affair because this time he did make a commitment to get married. We were together for almost two years and from my point of view, the relationship was wonderful. He wasn't singing at the time but when he used to sing to me, I'd say, "You're nuts not to make a record by yourself."

We got engaged and Burt bought me a ring from Buccellati on Fifth Avenue. Then I got pregnant and he was fine with it because we were going to get married anyway and Burt loved children. But

then he started to get a little edgy and we began to bicker. He was drinking a little bit more than usual, and I think he felt trapped. I knew in my heart that if I married Burt and had his baby, this man was going to leave me and I would never get over him.

Without Burt knowing it, I aborted the baby. He was very upset when he found out what I had done, especially because I had never discussed it with him. And that was it. We stayed together for maybe another month but the abortion really pulled us apart. Burt and I broke up shortly before John F. Kennedy was killed in 1963.

I went to California to meet some people who wanted me to become an actress. I made a little movie called *The Pleasure Seekers* with Gardner McKay and I started to have a little thing with him. Burt called me one night at two in the morning and said, "You're not alone." When I said, "No, I'm not," he hung up on me, and it was two years before we talked to one another again.

Chapter
7

Make It Easy on Yourself

Bob Hilliard and I wrote a song for the Drifters called "Mexican Divorce," which came out in February 1962 as the flip side of a record that never even made it on to the charts. Jerry Leiber and Mike Stoller really liked the song but they were so busy running Redbird Records that they asked me to rehearse the background singers for them in my office. There were four girls there, and they all sounded so great that I couldn't tell which one was the best singer.

The four girls were Cissy Houston, her nieces Dee Dee and Dionne Warwick, and their cousin Myrna Smith. Right from the first time I ever saw Dionne, I thought she had a very special kind of grace and elegance that made her stand out. She had really high cheekbones and long legs, and she was wearing sneakers and her hair was in pigtails. There was just something in the way she carried herself that caught my eye. To me, Dionne looked like she could be a star.

About six weeks after we cut "Mexican Divorce," Dionne got in touch with me and asked if she could come in and make some demos with Hal and me. We took Dionne into the studio and had her cut "It's Love That Really Counts" and "Make It Easy on Yourself." When we took the demos to Florence Greenberg, she liked

"It's Love That Really Counts" enough to let me record it with the Shirelles, but she had no interest in "Make It Easy on Yourself."

An A&R man named Calvin Carter, whose sister Vivian and brother-in-law James Bracken ran Vee-Jay Records in Chicago, one of the first black-owned and -operated labels, came to the Brill Building one day to look for material and someone gave him "Make It Easy on Yourself." Calvin took the demo back to Chicago and played it for Jerry Butler, who thought it was a hit just the way Dionne was singing it. When Calvin told him Scepter was not going to put it out, they decided to cut the song on Vee-Jay.

Unlike Luther Dixon at Scepter, Calvin Carter and Jerry Butler told me, "You get the musicians, you conduct, you make the record." Vee-Jay put up the money for the date and Calvin Carter and Jerry Butler flew into New York for the session. For the first time ever in the studio, I had maximum control, and it all went pretty well. Jerry Butler always liked to lay back and sing behind the beat so I had to push him a little to get what I wanted on the lead vocal.

Slim Brandy had come with me to the studio that night. She had a great suntan and was wearing an incredible orange dress. She looked so drop-dead gorgeous that Jerry couldn't stop staring at her. Calvin Carter finally said over the intercom, "Hey, Jerry, keep your mind on the song, man!" Everybody cracked up, and although we only cut one song that night, "Make It Easy on Yourself" went to number twenty on the pop chart.

By saying, "Make the record yourself," Calvin Carter gave me my first big break After I did that session, I knew I never wanted to work any other way again, because by actually being in the studio while the record was being cut, I could protect my material and make the song sound the way I had heard it in my head and then played it. I could start with a framework and then evolve from that as the musicians heard the song and then played it.

That was always the moment of truth for me, because the song

lived or died with making the record. If I didn't get it right, I only had myself to blame. Sometimes after a recording date I would wake up at four o'clock in the morning and realize I didn't want the strings playing that early in the record and leaking into every microphone in the studio but I couldn't go back in and fix it. I was stuck with it and that always drove me crazy.

By trying to get everything right before the song went onto tape, I thought I could avoid waking up at four o'clock in the morning, but that never worked for me, either. No matter how hard I tried, nothing was ever perfect. There was always a pimple somewhere. Years later, I finally realized that if everything else felt good, I just had to let it go. Which may be the definition of maturity.

What I also learned by cutting "Make It Easy on Yourself" was that I could not control what happened once the record was pressed. When I heard the song on the radio for the first time, I couldn't believe how bad it sounded. I called Ewart Abner, who was the head of Vee-Jay at the time, and told him I thought the record sounded like garbage. He said, "What are you talking about, man? We sold seven thousand copies in Philadelphia today." And I said, "Yeah, but if you had pressed it right, you could have sold eleven thousand records in Philadelphia today." I think I even threatened to buy back every copy so I could have it re-pressed myself.

There were a couple of different methods of pressing records back then, and one was a lot better than the other. The sound on any given 45 also had a lot to do with the quality of the raw materials used to make it, but a lot of record companies would do whatever they could to save as much money as possible when it came to the actual manufacturing process. For the label, it was strictly about economics.

Whenever one of my records came out back then, I would get totally freaked out when I heard it on the radio for the first time. It was almost as if I didn't want to hear it because I knew it was never going to sound as good as I wanted it to. More than once, I said I

was going to the pressing plant myself so I could see what they were doing wrong. I never actually went but I did start getting pressings from two different plants for every record I made so I could decide which one sounded better.

Many years later, when I was recording as a solo artist, I cut an album for A&M Records that Herb Alpert and Jerry Moss wanted to release in conjunction with a TV special I had done with Barbra Streisand, Tom Jones, and Rudolf Nureyev. Herb and Jerry were both great friends of mine and I was driving them crazy because I just couldn't get the record mastered the way I wanted. I mastered it and remastered it and we kept getting closer and closer to the deadline but it still didn't sound right to me. I had to go to Japan to do some concerts, and Jerry Moss said, "Just let it go, Burt. You'll come back and work on it and we'll miss the release date." That was what we wound up doing, and it was really stupid of me because the TV show won an Emmy Award and I really hurt Herb and Jerry in terms of sales by not being able to let go of the album.

When I was cutting a record back then, I would hear a song maybe four hundred and fifty times while I was writing and rehearsing it with the artist and then maybe another eighty times as I worked out the arrangement in my apartment. In the studio, I would do as many as twenty or thirty takes, listen compulsively to all the playbacks and mixes as many times as I could, and then play the acetate over and over again. Before a record was ever released, I would have heard it about a thousand times and I was still never satisfied with the way it sounded on the radio.

The way I felt about "Make It Easy on Yourself" was nothing compared to the way Dionne reacted to it. She was already possessive about what Hal and I wrote and got really upset with us because she felt we had given her song away to someone else, which was definitely not the way it happened. Hal and I wanted to work with her, so we signed Dionne to a production deal with a company

we formed, and then we went to Florence Greenberg, who agreed to let Dionne record with us on Scepter.

The story Dionne likes to tell is that while we were arguing with her about Jerry Butler having done "Make It Easy on Yourself," she said, "Don't make me over, man!" and a week later, the two of us brought her a song with that title. Hal never bothered to correct her version of the story, but if you had asked him about it, he would have told you Dionne never said that to him.

What made Dionne different from a lot of the artists we worked with was that she had minored in piano in college and could read music, which was a big plus for me. The more Hal and I worked with her, the more we saw what she could do. In "Don't Make Me Over," a song that goes from twelve/eight to six/eight, I had her sing an octave and a sixth and she did it with her eyes closed.

Dionne could sing that high and she could sing that low. She could sing that strong and she could sing that loud, yet she could also be soft and delicate. As our musical relationship evolved, I began to see her potential and realized I could take more risks and chances. To me, her voice had all the delicacy and mystery of sailing ships in bottles.

Dionne Warwick: "Don't Make Me Over" was my very first recording and I still remember it vividly because we literally did thirty-two takes. Burt kept saying, "Can you give me one more? I think you've got one more in you." And it was not as if he was fixing one or two notes or a couple of words. It was the entire song each time, full out. Can a singer do thirty-two takes? I don't know about anyone else but I certainly did. Everybody was in the studio at the same time so all the musicians and backup singers were doing this as well and Burt wound up using the second take.

We cut the song at Bell Sound, and when Hal and I brought it to Florence Greenberg, she cried. Not because of how much she

liked the record. Florence cried because of how much she *didn't* like it. Both of us were really taken aback by her reaction but there was nothing we could do or say to make her change her mind. She wound up putting out "Don't Make Me Over" as the B-side of "I Smiled Yesterday," a song we had cut at the same session.

Fortunately for us all, disc jockeys flipped the record over and began playing "Don't Make Me Over," which went to number twenty-one on the pop chart and number five on the R&B chart. My first name was misspelled as "Bert" three different times on the label and because Scepter mistakenly put a *w* into Dionne's last name, which was Warrick, she became Dionne Warwick from then on. Eventually, even Florence Greenberg came around. Not because she liked the record. Not at all. Florence started loving it because she saw it go up the charts.

A month before all this happened, Hal and I had actually had the biggest hit we had ever written with "Only Love Can Break a Heart," by Gene Pitney, a song that went to number two on the pop chart. Gene was a lovely guy who had an almost freakishly high voice. Gene was also a pretty good songwriter and had already had hits with "Hello, Mary Lou" for Ricky Nelson, "Rubber Ball" for Bobby Vee, and "He's a Rebel" for the Crystals, which Phil Spector produced.

Hal and I wrote "Only Love Can Break a Heart" specifically for Gene. The melody doesn't sound like something I would have written without having first seen the lyrics, and the song has a very odd structure. Hal must have given me the line "Last night I hurt you / But darling remember this," because the hook, which is almost like the chorus, comes in four bars after the song starts. It's an unusual form but that never bothered me so long as it made sense.

Instead of making a demo of it, Hal and I went over to 1650 Broadway so I could play the song for Gene on the piano. Then I wrote the arrangement, and you can hear Gene whistling over the

opening section. The thing about Gene was that he always came to the studio prepared, so this wasn't one of my "beat up the singer" sessions. The song didn't take long to do and I walked out of the studio feeling good, thinking, "Wow, this sounds like a hit." "Only Love Can Break a Heart" went to number two on the pop chart for a week, and the funny thing was that "He's a Rebel" was number one. I've always wondered why nobody has ever cut "Only Love Can Break a Heart" again, particularly a country artist.

Hal and I then came up with a song called "I Just Don't Know What to Do with Myself." Tommy Hunt, the former lead singer of the Flamingos, a really terrific doo-wop group, had just had a big hit on Scepter with "Human," so the label decided to let him cut this as a follow-up. I did the arrangement and conducted the orchestra, and Jerry Leiber and Mike Stoller produced the session.

I thought it was a terrific record, but because Florence Greenberg didn't like the fact that Tommy Hunt was dating one of the Shirelles while also being kept by some other woman, she did nothing to promote it and the song went nowhere. It didn't become a hit until Dusty Springfield covered it two years later. Elvis Costello did a live version of the song with the Attractions in 1977 and performed it onstage when we toured together in 1999.

In the spring of 1963, I took a song Hal and I had written, called "Blue on Blue," to Bobby Vinton, who had started out as a trumpet player and a bandleader with Dick Clark's Caravan of Stars. "Roses Are Red (My Love)" had been a number-one song for him, but after four of his singles in a row failed to hit the charts, he was looking for a hit. I played the song for Bobby, but when he told me he wanted half the publishing on it, I turned around and started to walk out of his office. Bobby ran after me and said, "Hey, Burt. I'm just joking. It's a great song. Let's record it."

I didn't produce "Blue on Blue," but I did the orchestration, and wound up playing piano on the session as well as conducting the

orchestra. The record made it to number three on the pop chart. The real significance of "Blue on Blue" is that after Hal and I wrote it, we stopped working with other people. After spending eleven years together, we decided to get married as songwriters and only work with one another.

Chapter

8

Land of Make Believe

Hal and I were really starting to hit our stride with the R&B material we were writing, but we also kept coming up with songs like "Wives and Lovers," a three/four jazz waltz that Jack Jones recorded. I never liked the way he cut it because that wasn't how I thought the song should sound orchestrally, but Jack did win a Grammy for Best Pop Performance for the song. "Wives and Lovers" was covered by people like Frank Sinatra with the Count Basie Band, Stan Getz, Nancy Wilson, Lena Horne, and Ella Fitzgerald, who cut it with Duke Ellington.

When I heard the version Sinatra had done with Count Basie, I called Quincy Jones, who had produced the session, and said, "Q, how come it's in four/four? It's a waltz." And he said to me, "Burt, the Basie band doesn't know how to play in three/four." Some years later, I actually went into the studio and cut the song with Vic Damone and the record was terrible.

In October 1963, Gene Pitney had a hit with "Twenty-Four Hours from Tulsa," a song I really liked because as it was getting born and coming together, it became a miniature movie. Hal and I didn't write a lot of songs together that told stories but whenever we did, it was always an adventure.

Hal David: In the early days, around the time we did "Twenty Four Hours from Tulsa," I would sometimes write short stories in a black-and-white high school composition notebook and then write lyrics from that. Doing this really helped me because in the beginning, I used to wander all over the place with my work, especially when I was telling a story, and doing this enabled me to keep myself on track.

Hal started out the song with the line "Dearest darling / I had to write / To say / That I won't be home anymore." The first note is an A with a G underneath it and I used it to give the opening a sense of dissonance and urgency and pain and anguish so we could tell the story of a guy who meets somebody on the way home and then never gets there. "Twenty Four Hours from Tulsa" opens with trumpets with a bit of dissonance and then a dobro slide guitar comes in against the baion beat. A couple of years later, Billy Joe Royal used the same opening almost note for note on "Down in the Boondocks," which I guess you could call the highest form of flattery.

While Hal and I were writing the song together, I visualized all the various parts. Where the trumpets would come in, where the drums would become more pronounced, where the rhythm section would generate a different kind of intensity, and then the really powerful climax where Gene sings, "And I can never, never, never / Go home again." I loved orchestrating the song because the story was so dramatic and the orchestration propelled it forward.

Hal and I were also trying to come up with new material for Dionne. While the three of us were rehearsing in my apartment one day for an upcoming recording session, I played her a song that kept changing time signatures, going from four/four to five/four and then with a seven/eight bar at the end on the turnaround. It seemed really natural to me that way and the last thing on my mind was to ever make a song that would be difficult for musicians to play or for an audience to understand.

I played Dionne a little of the song and told her Hal had not yet finished writing the lyrics. She said, "What are you waiting for? Go finish it off!" Hal went into my bedroom while she and I rehearsed another song, and when he came back out, he gave us the finished lyrics for "Anyone Who Had a Heart."

Before we recorded it, I spent a week working with Dionne and the background singers. We rehearsed every day so everyone would be prepared. For me that was essential because I wanted to leave as little as possible to chance once we actually got into the studio. At night I would go back to my apartment and play mind games with myself by pretending the copyist was coming in the morning so I had to get the arrangement done right away.

In those days if you were sick, there was a forty-eight-hour window during which you could cancel a session without having to pay for the studio time. I had a bad cold but I still wanted to keep the date. Even as we were cutting "Anyone Who Had a Heart" at Bell Sound in the fall of 1963, Hal was still driving himself crazy about the way the accent fell on a word in one of the lines.

Hal David: I had it almost the way I wanted it and until we went into the recording studio that night, I was trying to change it. The song starts, "Anyone who had a heart could look at me and know that I love you / Anyone who ever dreamed could look at me and know I dream of you." The accent should not be "dream of you." The accent should be "dream of *you*." But I had to have the accent on "of" because that's where the melody was. I tried to find a way to make the "of" do something but I never could. And maybe it just couldn't be done. But I worked on that until it was recorded. Then I had to let it go.

Along with Cissy Houston, Dee Dee Warwick, and Myrna Smith, I brought in three white girl singers who were making a lot

more money at the time doing jingles than any of us were ever going to see from a record. One of them was Linda November, who could sing all the way up into the stratosphere. She and the other two white girls would walk into the studio, hang up their mink coats, and be ready to go to work. On "Don't Make Me Over," I had Cissy, Dee Dee, and Myrna singing in the lower register, with the white girls singing on top of them. If you listen to the record, you can hear the soul on the bottom and the altitude coming from the white girls.

Hal and I cut Dionne doing "Walk on By" and "Anyone Who Had a Heart" at the same session, and then argued about which song we should release first. We decided to go with "Anyone Who Had a Heart," which went to number eight on the pop chart.

A couple of months later, I went to see Dionne perform at the Apollo Theater in Harlem. When she did "Anyone Who Had a Heart," I could tell the band was struggling. When I went backstage to say hello to her after the show, the band surrounded me and they were all kind of hostile. One of the horn players said, "Why do you make it so difficult for us, man? Why do you have a seven/eight bar in this song?" I said, "Listen, there must be people who understand this music the way it is. Otherwise, it wouldn't be a hit. They get it. So instead of counting, just try to feel it. Sing the lyric on your horn."

Although I had no idea how it happened at the time, Brian Epstein, the manager of the Beatles, bought a copy of Dionne's record of "Anyone Who Had a Heart" while he was in New York and took it back with him to London. He gave it to George Martin, who thought the song would be perfect for Shirley Bassey. Instead, he wound up cutting it at Abbey Road Studios with Cilla Black. The song became a hit in England, and Dionne got really bent out of shape about that.

Dionne Warwick: I say frequently if the organ player had made a mistake or if I had coughed during the middle of the song, Cilla would have coughed and the organ player would have played a wrong note. That was how verbatim they copied exactly what we had recorded.

Although I knew how Dionne felt about what Cilla had done, neither Hal nor I had any control over who covered what we wrote so there was really nothing either of us could have done about it.

Elvis Costello: The way music was set up in England back then meant that there were two things that conditioned hearing it differently than in America. One was the needle time restriction, which put a strict limit on the amount of recorded music that could be played per week on the BBC, which was the main source of music other than Radio Luxembourg. This meant that a lot of what was played on the air in England was heard transposed or filtered through dance bands and ensembles that played live on the BBC, including the one my dad sang with.

The second factor was that there were no global releases in those days, so there was a delay of up to six weeks between the release of the record in America and its release in England. A record had time to be a hit in America and then it would be picked up by people in the U.K. who had their ears tuned to the American charts.

I've heard Dionne on this subject a lot, and it is true that English artists back then did very consciously go in and copy American recordings note for note. But of course the timbres of the players and in some cases the rhythm sections weren't quite as groovy. The English brass tone is also very distinctly different, and of course the recording studios were different as well.

I definitely heard "Anyone Who Had a Heart" by Cilla first, and it became a number-one hit in England before Dionne's ver-

sion was ever heard there and then I think both versions were in the charts. And then I heard Dusty Springfield's version after that. In England back then, Burt sometimes had two and even three versions of the same song in the charts at the same time.

They weren't really like what we would later call soul records, although the original versions were sung by African-American singers. The covers in England were sung predominantly by white singers. But people like Dusty and Cilla were great on those early records. I still really love Cilla's version of "Anyone Who Had a Heart" because she sounds so desperate in a great way and that's a very profound song.

At that same session, Dionne also cut "Land of Make Believe," and her version of it was released early in 1964. Within weeks, the Drifters put it out as the flip side of a single but the song never became a hit for either of them. In April, Hal and I finally got Scepter to put out "Walk on By." Hal and I were always trying to come up with material for Dionne to record. Like tailors in the apparel business, we were making goods for her to sing.

While I was writing "Walk on By," I was hearing the whole arrangement. I love flugelhorns and they're on there and I heard the piano figure being played by two different pianos. We cut "Walk on By" first that night and I had Paul Griffin and Artie Butler playing the same figure on two pianos at the same time. Because they were never exactly in synch with one another, that gave the song a very different, jagged kind of feeling. I let the rhythm section have a certain kind of freedom and they got it really quick because they all knew me and they could read where I was going.

Then we cut "Anyone Who Had a Heart." The song was challenging but they got it, too, and it was kind of like, "Wow! What have we got here?" Florence Greenberg, who by now really had a track record when it came to *not* knowing when Hal and I had writ-

ten a hit, put out "Walk on By" as the B-side of a song called "Any Old Time of Day." Murray the K played both sides on his radio show in New York and then asked his listeners to vote on which one they liked better. They picked "Walk on By," which went to number six on the pop chart.

Isaac Hayes did an incredible twelve-minute version of the song that I loved, and many years later I got to tell him so when he performed it on one of my television specials. On YouTube you can see President Obama doing about eight seconds of "Walk on By" as a tribute to Dionne during a campaign appearance he made with her in New Jersey. The great thing about it is that he can really sing.

A few months after Hal and I wrote "Walk on By," Famous Music offered us five thousand dollars to come up with the theme song for the movie *A House Is Not a Home*, starring Shelley Winters. It was based on the life of Polly Adler, who had been a famous madam in New York City during the 1920s. Hal came up with a brilliant lyric that never let you know the song was about a brothel.

I wrote the music for the song in my apartment on East Sixty-First Street and I was so excited about it that I called Hal and played it for him over the phone. Paramount Pictures wanted Brook Benton, who'd already had several number-one hits, to record the song, so I sat down with him in our office to teach it to him. Benton was really difficult to work with because he kept singing the wrong notes in the ascending melody line that goes up chromatically in thirds with the lyric "A chair is just a chair / Even when there's no one sittin' there." There is also a bar change from four/four to three/four in the bridge, so it's not the easiest song to sing.

Dionne just happened to drop by while I was working with him and watched the whole thing going down. Benton was being a real pain in the ass and at one point he uttered this great line: "I could read music but I don't want to spoil my soul." Because the people at Mercury Records knew there had already been a good deal of

friction between the two of us, they kept me out of the studio when he cut the song. Alan Lorber, who did the arrangement, wound up producing the session. I thought it was a good record but Benton was still singing the wrong notes.

In self-defense, I took Dionne into the studio and cut "A House Is Not a Home" with her. Two weeks after the Benton version was released, her version came out as the B-side of "You'll Never Get to Heaven (If You Break My Heart)." The two versions compromised one another so neither one went very high on the charts.

"A House Is Not a Home" is still one of my favorite songs, and when Dusty Springfield performed it on one of my television specials, she was great. Ella Fitzgerald and Stevie Wonder have also cut it, but the person who really made it a standard was Luther Vandross, who I think did the best version ever.

A month after "A House Is Not a Home" came out, an independent record company called Big Hill released a song Hal and I had written called "(There's) Always Something There to Remind Me," sung by Lou Johnson. I was really impressed with Lou's talent and I thought I had made a great record with him, but it just hung around on the charts in America. Then Sandie Shaw wound up having a number-one hit with it in England.

Another song I cut with Lou Johnson in 1964 that never became a hit for him was "Kentucky Bluebird." The original title of the song, for which Hal wrote some incredible lyrics, was "Message to Martha." I recorded it first with Marlene Dietrich on a four-song EP we did for the German market in 1962 as "Kleine Treue Nachtigall," which means "Faithful Little Nightingale."

Four years later, Dionne decided she wanted to record "Message to Martha," but Hal and I tried to discourage her from doing so because we felt it was a man's song. At some point, Hal told her the only name that would work as a substitute for "Martha" was "Michael." Even though Hal also told her he didn't really like that

name, she went ahead and cut it as "Message to Michael" and it became a top-ten hit for her on both the pop and R&B charts.

Slim Brandy: The only contact I had with Burt during this period was when he called me in Rome. I had started to do some acting and I was there with Frank Sinatra while he was making *Von Ryan's Express* and I had a brief affair with him. It was a funny scene because Burt called me while I was at dinner with Frank and Glenn Ford and Prince Romanoff and Sammy Davis Jr. and *Madame Butterfly* was playing over the hills of Rome. Frank was drunk and he was talking to Ava Gardner and I was drunk and talking to Burt and I knew we were not getting back together.

It was just the leg that was kicking was still there. Frank was pissed off at me and he said, "Who are you on the phone with all this time?" And I said, "My ex-boyfriend, Burt Bacharach." And Frank said, "Ah, he's a lousy writer." And I looked at him and said, "Yeah? Well, why don't you try to hum a few bars for me?" We were fighting and I said, "You couldn't hum any of his music, never mind sing it. It's so complicated." While he and I were together in Rome, somebody took a picture of us and Frank broke the guy's arm. I heard the crack.

What I also remember about that session when we cut "Walk on By" was that I was seeing Lee Grant at the time and she wanted to come to the record date, so I put her in the booth. I was always intrigued by Lee because she had been blacklisted for twelve years for refusing to testify against her husband, the playwright Arnold Manoff, before the House Un-American Activities Committee. Lee was a brilliant actress who won an Academy Award and then became a really good director, but she suffered for her political beliefs for a long time, because that was such a terrible period in the history of our country.

Lee Grant: Burt said, "I'm recording tonight. Would you like to come?" I remember literally feeling my blood drain right through the floor as I watched him, because Burt was producing and conducting and playing and his talent literally stunned me and so it was a real gift to be there.

Burt was not single and unattached, but we had a little thing and it was a really lovely summer. Then I remember him telling me, "You know, I met Angie Dickinson and there's something about her I really, really dig and I'm going to go back and try it out," and it was like that with us too. When I started to get some secret serious feelings about Burt, I called Norma Crane, who was a friend of mine, and asked her, "Can he be there for anybody?" She said, "No," and I said, "Thank you."

We were passersby in each other's lives but I had a baby grand piano at my house and Burt would sit down and play. I love talent, and he was gorgeous. Gorgeous and electric and obsessed, and there is nothing as attractive as a person who is thankfully not obsessed with you but their own talent and work.

My mother and father already knew Angie Dickinson from a press junket, so when I went out to Los Angeles again in the fall of 1964 to try to learn how to score films, I met her in a coffee shop outside Paramount. We talked about baseball and she was very nice. The thing Marlene always used to say about Angie was "She's terribly nice," but the truth was that Angie was nice to the world. She always had a smile for everyone on the crew of any movie she was in and they all adored her. I used to think there had to be a flip side to that, but it was genuine and just who she was.

As I was leaving, Angie gave me her number and said, "The next time you're out here, give me a call," and I thought, "Wow! A real movie star!"

Angie Dickinson: I first met Burt's parents on a press junket in New York when I was promoting *Captain Newman, M.D.*, with Gregory Peck in 1963. I was standing on the corner of Fifty-Seventh and Fifth and a tall man said, "Excuse me, aren't you Angie Dickinson?" I said, "Yes," and he said, "I'm meeting you at three o'clock this afternoon for an interview. I'm Bert Bacharach." And I said, "Oh, great. Well, I'll look forward to that."

We got along just great. I loved his wife and we saw each other for dinner whenever they came to L.A. and whenever I went to New York. This went on for about a year and a half before I even met Burt. Bert kept telling me about his great son and I said, "Sure, sure, sure, sure."

I think they were pushing me on him as well, so I finally met Burt for a drink at Paramount in September 1964. We went to Nickodell's, which was not a coffee shop but a bar. I absolutely did not know who he was beyond his parents and I had no sense of his music at all, except that his dad told me he had written "Wives and Lovers." After that meeting at Nickodell's, Burt said, "If you're in New York, give me a call." At that point, there were no tom-toms going.

In late February 1965, Burt called me and said, "I'm coming out to L.A. Can we have dinner?" I said, "I can make it Monday or Wednesday," and he said, "How about Monday *and* Wednesday?" Charm all the way. I laughed and said, "So, Monday." And on Monday, we went to Chianti, a great restaurant on Melrose in West Hollywood, for dinner. And then on Friday night, we went to Chez Jay, and that was the crucial night because he was leaving the next day.

Angie loved Chez Jay and she knew Jay Fiondella, the former actor who ran the place and was a good friend of Frank Sinatra.

It was all kind of funny because Marlene had sent Sinatra "Warm and Tender" thinking he would love the song, but as it turned out, Frank didn't love it. When I met Angie she was one of the few women in the Rat Pack and had known Frank for years.

Angie Dickinson: On our first date, Burt came to pick me up and as usual, I wasn't quite ready. I was standing in my bathroom and finishing my hair at the mirror with the door open and I had the radio on and Diana Ross and the Supremes were doing "Stop! In the Name of Love," and I said, "Oh, God, did you write that?" And Burt said, "I wish I had." I still didn't know who he was and I didn't even know he had written "Don't Make Me Over," which was one of my favorite songs.

After our first date, there were flowers the next day with a note that said, "It was a wonderful evening. From one penicillin sufferer to another," because I can't take it, either. Burt was a gentleman and he knew how to stroke the right spot. He oozed charm and he knew it, and it was a seduction. We went out three times that week and by Friday night, I was pretty hooked. I knew he had been living with Norma Crane but at the time I think he was in love with an actress named Ena Hartman. That was who he was talking about and since she was black, it was even more interesting.

After that visit, Burt went back to New York. Within the month, I was asked to do *Password* on television. I called him and said, "I'm coming to New York," and he said, "So, good. Let's see each other." On our second date, Burt said, "I have to go to London. They're doing this special on me and I'm opening Marlene Dietrich at the Savoy. Why don't you come with me?"

I got someone to send me my passport and we went. Within six weeks, we had gone out in L.A. three times and gone out in New

York three times and we were on our way. That was just that way it happened and it was one of the most romantic courtships ever.

An independent label named Kapp Records offered to put up the money for me to do an album of instrumental versions of songs like "Don't Make Me Over," "Walk on By," "Anyone Who Had a Heart," "Wives and Lovers," and "Twenty Four Hours from Tulsa." The album was going to be called *The Hitmaker*. Even though it had never been a hit I decided to also cut a song called "Trains and Boats and Planes," which Hal and I had written for Gene Pitney but he hadn't liked enough to record.

I went to London to make the album because it was a lot cheaper to record over there and I'd heard the English musicians were great. I was in coach on the flight over there and a beautiful black actress named Ena Hartman was in first class on her way to London to audition for the new James Bond film. I had a lot of work to do in London and I was busy writing arrangements in my little room in the Dorchester. Ena and I got together a little but she didn't get the role and had to go back to Los Angeles.

I recorded the album as quickly as I could but I didn't sing on it. Instead, I had three girls called the Breakaways—who later backed up Jimi Hendrix on "Hey Joe"—do all the vocals. I was just playing piano, and when somebody else was doing that, I was producing in the booth. I was working with some incredible musicians, like Jimmy Page and John Paul Jones, who later went on to form Led Zeppelin; Big Jim Sullivan; and about half of the Ted Heath band.

I guess because I'd had a string of hits in England, the word had gotten out that I was something special and the control room was always crowded. I remember being at the console trying to give signals to the bass player and the drummer to play louder or softer and this one guy kept taking pictures of me. He was really bothering me so I finally said, "Get the fuck out of the way." The guy turned out

to be Antony Armstrong-Jones, who was then married to Princess Margaret, and was also known as Lord Snowdon. I didn't know any of this at the time but he was very understanding.

The album sold only five thousand copies in the States but it went into the top ten in England. The single "Trains and Boats and Planes" got to number four on the charts and did better over there than the cover version by Billy J. Kramer and the Dakotas, which George Martin produced. Back then in England if you got a record on the BBC, everyone would hear it, so I actually got discovered over there long before that happened in the States, and that was the reason Granada Television decided to do a special on me.

When I went back to Los Angeles I brought the album with me and played it for Angie, who was ecstatic over every cut. She thought it was all very beautiful, and to get that kind of adulation from a woman like her was really something. There was an intense physical attraction between us but I was also really in love with Angie. At the time, I think I was too insecure to believe that this gorgeous movie star could fall in love with me.

Angie Dickinson: I did love *The Hitmaker* album and I often wonder if I was in love with Burt or his music. One of the titles I'm thinking about for my book is "I Think It Was the Freesias" because when we were together in London, Burt would always come back to our flat with a handful of freesias. Between the music and the freesias, I was a dead duck.

Chapter

9

What's New Pussycat?

Angie and I flew to London together and she was with me when I started shooting a special called *The Bacharach Sound* for Granada Television. Angie knew all about camera angles and lighting and had been with Howard Hawks while she was making *Rio Bravo*, so she really had an eye for the camera and did everything she could to protect me in this completely new environment.

Angie and I were staying at the Dorchester Hotel, and that was where she ran into Charlie Feldman, who was producing a new movie, *What's New Pussycat?*

Angie Dickinson: Charlie Feldman had been a great agent and then he became a producer. He was an enchanting guy and everybody who knew Charlie adored him, including me, and we dated for quite a long time. He was always trying to get me to marry him but I wasn't in love with him. I just loved him. Charlie really knew how to live, and year-round, he always had the Audley Suite at the Dorchester. One day while Burt was out, I called Charlie and said, "Come down and see me."

I had some of the stills Burt had given me that were used for the *Hitmaker* album, so I put one of them up and Charlie said, "Who's

that?" I said, "That's the guy I came over with." He said, "What does he do?" And I said, "He's a songwriter." Charlie said, "What has he written?" I said, "Oh, 'Walk on By,' and 'Anyone Who Had a Heart,' and 'Don't Make Me Over.'" Charlie said, "He wrote those? Can he score a movie?" And I said, "Sure."

Burt had never scored a movie but I was sure he was capable of it because he was already a genius in my mind. And the proof was in those songs I had just mentioned. Charlie told me he had a deadline to get the movie into the theaters and the guy who was going to do the music had dropped out. Charlie had someone waiting in L.A. to come over and start but the deadline was only about three weeks away. The guy who had dropped out was Dudley Moore, who was a great pianist, and the other composer he had waiting to come over was a young newcomer named John Williams, who had done the music for *The Killers*, a movie I had done just the year before.

Burt met with Charlie, who said, "I'd like you to look at the picture and see if you want to do it." Burt asked me if I would go with him, and I said, "Sure." It was a rough cut and I laughed my head off because it was hysterical. Burt had never seen a rough cut and he said, "Is it any good?" I said, "It's great," and Burt said, "I'll do it if you'll stay." Because he knew he needed help.

Even after having seen *What's New Pussycat?* I'm not sure I could really say what it was about. The script was written by Woody Allen, and the movie is set in Paris, where Peter O'Toole works for a fashion magazine. Every woman he meets, all of whom he calls "Pussycat," immediately falls in love with him, so he goes to a psychoanalyst for help so he can marry the girl he loves.

Speaking in a heavy German accent while wearing a black Beatles wig and thick black-framed glasses, Peter Sellers plays the psychoanalyst. A lot crazier than O'Toole, he is desperately in love with one of his female patients, who also happens to be after

O'Toole. The film is filled with beautiful women like Romy Schnei-der, Capucine, Paula Prentiss, and Ursula Andress, and a lot of it is just completely wacky, pure Marx Brothers slapstick.

After I told Charlie Feldman I would score the movie, Angie and I found a flat on Wilton Row, off Belgrave Square right across from a great pub called the Grenadier, about two blocks from Hyde Park. Even though I had never scored a film before, my instinct was to not work from the sheets of music cues written out by the music editor. The cues themselves had been selected by the director, who would say, "I want the music to start here and I want it to come out here."

I decided the only way I could really learn how to time the music cues was by watching the film over and over until I knew it by heart. I had no idea how to run a Moviola so Angie learned how to do it. I'd be working when Angie went to bed and she would say, "Okay, wake me up when you need the reels changed," or "Are you hungry? I'll make you some supper, or we can make love. . . ." Whenever the film broke in the middle of the night, she would splice it for me.

I was under tremendous pressure to write the score and I had no idea how to deal with a rough cut that was full of dead sound. Angie would say, "Well, they'll redo the voices in the places where you can't hear them now." I didn't understand the medium at all so I needed a translator, and Angie was the one who explained it all to me.

At one point she had to go back to Los Angeles to do the Acad-emy Awards show with Bob Hope. Then she spent twelve hours on the red-eye so she could be with me in London. I still had not written a single note and what I would do is walk in Hyde Park and try to hear something, but I just could not get started. Paralysis was setting in.

Angie was gone for three days, and when she came back, I fi-nally broke through and came up with the melody for "What's New Pussycat?" by watching how bizarre and brilliantly weird Peter

Sellers's character was in the movie. The music was a direct trans-
fer of what I saw him doing on the screen. I went to the piano and
played these kind of Kurt Weill–ish, angular off-center chords that
just felt so right for what I was seeing.

By then, Hal had come over to London so he could write lyrics
for the music I had started coming up with. Hal was staying at the
Dorchester but he would come to our flat so we could work together.
Whenever there was a pickup for the mailman, he would ring the
bell. One day Angie, who was paying most of the bills, handed Hal
some envelopes and said, "Do you mind taking these with you? It's
one less bell to answer." The phrase must have stuck in his head
because a couple of years later, Hal used it as the title for a song we
wrote that later became a big hit for the Fifth Dimension.

Angie Dickinson: "What's New Pussycat?" was not the first
song Burt wrote for the film. "My Little Red Book," "Here I Am,"
and some Russian thing came first. He didn't write "What's New
Pussycat" until Easter Sunday because we went out that night and
celebrated at Trader Vic's. Burt said to me, "The waiters don't
know they just watched a proposal." It was a hint I don't remember
that well because I was trying not to get hooked on Burt and I did
not have marriage in my plans at all.

When Burt finished scoring the movie, they gave me a very nice
jewelry travel bag to thank me for my help. As the editor handed it
to me, he said, "This is for you. None of us are safe." They didn't
need to use their editor to splice the film and feed the Moviola be-
cause I did all that for Burt. That was a murderous three weeks, I
can tell you. And for Burt, it had to be crippling.

Tom Jones had covered a song Hal and I had written called "To
Wait for Love," as the flip side of his first hit single, "It's Not Un-
usual." Tom and his manager, Gordon Mills, came to the flat where

Angie and I were staying to hear "What's New Pussycat?" They were both looking for another really hard-core R&B song as a follow-up to "It's Not Unusual," so when I played them this waltz, Tom was reluctant to record it. I had so much more music to write for the film that I couldn't wait for them to leave so I could get back to work.

I thought Tom wasn't going to record the song, but Gordon Mills told him the movie was going to be a hit so Tom agreed to do it. When we did the record date, I ran the session and did something I had never done before. I put five pianos in the room, all uprights, and two of them were tack pianos, which have tacks or nails on the hammers so they make a honky-tonk sound when they hit the strings.

When Tom walked into the studio and saw five pianos, he thought I was crazy, but by having them all play the same thing at the same time it was a little out of synch, and that was the sound I wanted. Tom said I got him to sing better than he ever had before and "What's New Pussycat?" became an even bigger hit for him than "It's Not Unusual."

The first time I played "What's New Pussycat?" for the movie people, one of them said, "This is in three/four. It's a waltz. How is somebody in a disco in Paris going to dance to it?" I said, "It feels right the way it is, so they'll find a way to move to it." I never bothered counting bars or seeing whether or not there were eight bars in the first section. Sometimes there'd be nine bars and sometimes twelve but I never paid any attention to a changed time signature.

The song I had actually written for the sequence where Peter O'Toole starts taking off his clothes as he dances with Paula Prentiss in a Paris disco was "My Little Red Book." It's an odd song that doesn't sound like anything I had ever done before, and I recorded two versions of it with Manfred Mann and his group. Paul Jones, who later became an actor in movies and on British television, sang the lead vocal on both of them.

Paul Jones: For that scene, I was told they had originally intended to use an existing record. A Motown record at that, because lots of things at the time had that very insistent four/four beat. And somewhere along the line, either because the existing song's publishers wanted *x* million dollars for it or because Burt said, "If I'm doing the music for this movie, I'm doing all the music for this movie," they had to scrap it. Since the scene had already been shot, Burt was subbing for whatever Peter O'Toole had danced to when they had filmed it.

Can I just put in a quick word here for Hal David? I mean, the lyric is so good. I got really excited about it because of that word "thumbed" in the second line. "I got out my little red book the minute you said goodbye / I thumbed right through my little red book." A lesser writer would have written "I looked right through" or "I went right through" or "I searched right through," but "thumbed." I could actually see the slightly discolored corners of the pages where the thumb went. Hal is just so precise and concrete.

The version that appears in the movie was done after the Manfred Mann version. We were told, "If you guys know what's good for you, you'll come to the studio in Abbey Road and Burt and Angie and Hal will be there and you'll record this song that Burt's written." And I went, "Yeah! Okay! I'll be there early!"

Burt was producing and really working me quite hard. I'd literally sing a phrase and he'd say, "No, let's go back over that." I was singing whole takes and then going back and redoing this line or that line again. When we finally got to take nineteen I said, "Burt, I'm really sorry." He said, "What are you sorry about?" I said, "Take nineteen. I'm so sorry I couldn't nail it in one." And he said, "Don't worry about that. I've gone past thirty takes with Dionne Warwick." I think nineteen was the end, but it may have been a couple more after that as well.

Manfred Mann could read music and he was a jazz piano player

and a jazz fan and wrote a fortnightly column in *Jazz News*, but he still couldn't play Burt's stuff. The story about Burt having to move Manfred off the piano bench during the session is absolutely true. In fact, it was slightly more subtle than that. Burt said to Manfred, "Look, I tell you what. You play the left hand and I'll do the right hand." Then they switched and Manfred did the right hand and Burt did the left hand and eventually Burt was sitting at the piano alone. Manfred didn't hold it against Burt for a moment, and has actually said he admired the tactful way he had been edged out.

It wasn't that easy for the rest of us to get the music, either. Mike Vickers, who played both guitar and flute on it, couldn't get one particular chord at all. Burt was at the piano and Mike was looking over and seeing what Burt's fingers were doing and he said, "Well, right, okay. There's an F, there's also a G-sharp, there is a C, and there's a B-flat or an A-sharp, and a D-sharp as well." That's really complicated and Mike was trying to get this chord string by string. Eventually, Mike, or Tom McGuinness the bass player, said, "I think I know how you do that chord. It's just a straightforward bar right across the first fret." It is in fact E-A-D-G-B-E up a semitone. It's the pounding beat, up a semitone, and then back down again.

The Manfred Mann version did nothing in either the States or the U.K. and the song never became a hit until Arthur Lee and Love performed it. They may have played the wrong chords but that's not difficult, is it? Bacharach and David haven't written anything else that sounds like "My Little Red Book" but it was Burt's version of what you would hear in a disco back then and that's why it's genius.

Over the years, I've had to learn to get used to people making radical changes on my songs and stand back so I can look objectively at what they've done to see if I like it. Arthur Lee came along

and cut "My Little Red Book" with Love and although I didn't like their version because they were playing the wrong chords, it was nice to have a hit that gave me some credibility in the world of rock and roll. Like, "Oh, man, he wrote 'My Little Red Book'?"

I've always been very grateful to Charlie Feldman for letting me score *What's New Pussycat?* but I felt the same way about what he did to my music before the movie came out. After I was through working, Charlie fell in love with the cue I had written while watching Peter Sellers. Charlie took many of the cues I had written and threw them out and took this one cue I had done with the musette, and maybe a violin and a clarinet, and copied it and dropped it in everywhere throughout the movie.

Angie couldn't come with me to the premiere in New York because she had to go off to shoot *The Chase* with Marlon Brando, so I went with my parents. After I heard what Charlie had done, I called Angie and said, "I want my name off this film! I don't want to be connected with it in any way!" She said, "Don't be crazy! Don't be crazy!" The picture came out and it was a huge hit and "What's New Pussycat?" was nominated for an Academy Award for Best Original Song in 1965. So I really learned a lot from Angie.

Angie Dickinson: Burt saw the premiere and wanted to take his name off the credits because he just hated the movie. It was not my music so I could be more objective. On the film, Burt had his credit as "Burt F. Bacharach." I said, "Why not Burt Bacharach? It's so young and hip," and he said, "I don't want people to confuse me with my father." Maybe he really meant it sounded more elegant but I said, "After this movie, nobody is going to confuse you with your father."

Chapter

10

Love, Sweet Love

It was 1965 and the war in Vietnam was really starting to heat up, but I was not yet in touch with my own political feelings. Hal had written the chorus for "What the World Needs Now Is Love" but then spent two years trying to find the first line of the opening verse until he came up with "Lord, we don't need another mountain." I wrote the music and the song sounded really good to me even though I thought, "Is this preaching?"

We had been doing all these R&B songs for Dionne, so I wondered if this one would be soulful enough for her. When Hal and I finished the song, I played it for Dionne because she was our artist and our flagship and always our first choice to record our stuff. She said, "Okay, it's not my favorite song that you guys have written," which meant she didn't want to do it. I valued her opinion so highly that I just put the song in a drawer and forgot about it for almost a year. I figured, "Well, if she doesn't like this, it can't be any good."

Ten months later, Timi Yuro, who had cut a song Hal and I had written called "The Love of a Boy," which was a minor hit, opened at the Copa in New York. I had her come to my office so I could play her the song Dionne had turned down. When Timi started to

sing, I began beating my hands on a table so she could hear how I wanted her to accent the lyrics. She said, "Oh, go fuck yourself," and walked out the door. So it wasn't as though I now thought Dionne had been wrong.

Hal and I were scheduled to record a couple of songs with Jackie DeShannon, who'd had a hit with "Needles and Pins" and written "When You Walk in the Room." When she came to our office, Hal said, "Take out that song 'What the World Needs Now Is Love' and play it for Jackie," and I said, "Really?" So I played the song and Jackie started to sing it and I said, "Holy shit, she sounds like the song was made for her."

The way Jackie DeShannon could sing killed me, because she had that rough kind of imperfect voice that was absolutely perfect. Hal and I booked a session at Bell Sound and we cut "What the World Needs Now Is Love" with Cissy Houston, Dee Warwick, and Myrna Smith on background vocals. The record went to number seven on the pop chart at the same time that "What's New Pussycat?" was at number three. Since then, "What the World Needs Now Is Love" has been covered by more than a hundred different artists.

Dionne definitely let Hal and me both know she was not happy we had given the song to someone else, but the truth was that she had turned the song down when we offered it to her first. Even though my relationship with Dionne was always strictly professional, she also wasn't crazy about me being with Angie. While we were in London, the two of us went to see Dionne at the Savoy and she walked out onstage wearing a blond wig and I thought, "What the fuck?" I was speechless.

Angie Dickinson: Dionne didn't walk onstage that night in a blond wig because of me. She's even blond on the cover of one of her albums. I think it was just a coincidence and I didn't take it person-

ally. I knew she didn't like me but she wouldn't have gone that far, I don't think.

The way Dionne felt about Angie was nothing compared to what I had to go through with Marlene. Before I ever met Angie, I was conducting for Marlene at the Colonial Theater in Boston and Angie was in town, so she came backstage to say hello to Marlene. All the press guys wanted to get a picture of them because they both had great legs—Angie had gotten hers insured for a million dollars—so they had their photograph taken together.

After I stopped conducting for Marlene, I wrote some arrangements for her before she went off on a tour of South Africa. By now it was getting serious with Angie and me, and that was a big threat for Marlene, because she didn't want me to marry anybody. Not just Angie. Nobody! While Marlene was in South Africa, she had voodoo dolls made up to look like Angie and put pins in them.

Angie Dickinson: Burt and I were driving on the freeway in L.A. one day and he had just asked me to marry him and I didn't answer him. He said, "I asked you a question and you haven't answered it." And I said, "Yeah, I know." And he said, "You want to give me a nice birthday present?" And I said, "I'll try." And he said, "Marry me."

I laughed but I still didn't answer him. As we were driving, we saw this billboard for the opening of Hollywood Park and Burt said, "You know, the problem with getting married on my birthday is I wouldn't be able to go to the track." It was so funny and adorable and who wouldn't say yes to that?

I was still working on *The Chase* and Burt said, "Let's go to Vegas on Friday and get married." He went to the track on his birthday, which was Wednesday, May 12, and on Friday I called the set around four in the afternoon and found out I was on standby and

didn't have to be there again until Tuesday. I told Burt, "I don't have to work. Let's go."

Back then you could use anybody's name to make a reservation a few hours before a flight was scheduled to leave and just go to the airport and find a parking place and get on the plane. Burt and I got seats on a seven or eight o'clock flight. We checked in at the Sands and I made two calls. One was to my mother in Burbank. She had met Burt, and I guess she liked him, but it didn't matter. And then I called my best girlfriend June, who was married to Ricky Nelson's older brother David, and I said, "I just wanted to tell you I'm in Vegas and I'm going to get married." She said, "Oh good, we'll come." I said, "No, no, no, no. We just want to make it simple." And she said, "No, we'll come. You missed my wedding. I'm not going to miss yours," and I didn't have the guts to say no.

June and David had to get their children taken care of and got to Vegas at about 11 p.m. By then, Burt and I were already drunk but not stopping yet. While we were waiting for the Nelsons, we were having drinks with Chuck Barris, but we still had to get a license and have blood tests and all that crap.

Angie and I were both drunk and I didn't know if David and June Nelson were ever going to get there. It was getting later and later and we had to get married and then I ran into a friend of mine in the casino. Chuck Barris, the game show guy, who I used to play basketball with in New York. I always liked Chuck and he was married to Lynn Levy, whose father was one of the founders of CBS. He was very drunk that night and I said, "Would you and Lynn stand in with us tonight? We're going to get married." And he said yes.

Angie Dickinson: It was 3:45 in the morning by the time we got married. If you want to call it a wedding. I mean, it was in a chapel that was also a grocery store. Oh, God, yes. The Silver Bell Chapel.

I think that was the night Burt fell out of love with me, because here we were sitting and waiting in a casino lounge and it just took the boom off of it. I didn't feel it then but I think Burt felt it showed a weakness in me that I didn't tell June and David not to come. If I had, we would have been married by ten o'clock. Subconsciously, I don't think he liked that we had to kill time and it broke the spell.

That's the whole story, except when it came to "Do you promise to love, honor, and obey?" Burt started laughing and almost couldn't say that because it was just so hysterical to him. I think it was the "obey" that got him. You obey your parents and your teachers but you don't obey your wife. It's a terrible phrase and it shouldn't be in there and I think that's why many people write their own vows. It was ludicrous and Burt just laughed his head off. And we were drunk enough that I ended up laughing, too.

I think they offered us a recording of the ceremony to buy and we didn't want it. Isn't that awful? Because we could probably sell it now on eBay. We were just so tired by then. Burt and I were married on May 15, 1965, and the next day we went back to L.A. and got my Chrysler convertible, which was on loan to me from Universal, and we drove to Palm Springs for a two-day honeymoon. Then Burt had to go to New York and I went back to filming *The Chase*.

Angie and I had been married for maybe five days and she went off to shoot *The Chase*. I wound up in London. I went to see Marlene at the Dorchester and what I saw was the other side of her, the not-smart side. She still wanted me in her life to write arrangements and conduct for her whenever I could, but when I went up to her suite to play her some new arrangements so we could see what they sounded like, she just let loose.

"You married that cunt! That slut! How could you have done such a thing!"

As Marlene kept raving at me, I started backing out of the suite thinking, "It's over between the two of us." I was really puzzled. I had always thought Marlene was too smart to ever do anything like this. I mean, she had just crucified Angie in every possible way.

Angie Dickinson: I knew Marlene didn't like me for sure, but I didn't know about the voodoo dolls. Burt told me she once said about me, "She has slept in so many barns." He also told me she said, "Burt, nobody smiles that much." And the problem with that was Burt felt the same way. He found me a bit naïve and thought nobody could love the sunset so much and I think he rather enjoyed telling me that story.

We got married in May and then I got a job in Rome to do *Cast a Giant Shadow* with Kirk Douglas. I said, "I'm going to take this job and two tickets to Rome come with it." Burt, who was always so considerate of Marlene, said, "Great. Then I can let Marlene off the hook for my ticket." So we went to Rome and his folks joined us. They used to go around the world on press junkets in those days and I think they were nearby.

I finished the picture and Burt had to do four or five shows with Marlene at the Edinburgh Film Festival. When we came backstage to pick her up after the first show, I was already in the car and Marlene and Burt got in. I said to her, "Oh my God. You were fantastic!" And she said, "Well, of course I was. I had to be. You were there." I laughed. It was a cute remark.

What I remember about that show in Edinburgh is that after it was over, Marlene and I came out of the stage door together and just like always when she performed, all these people were waiting to get her autograph. Marlene saw them and pointed at me and said, "No, you vant him." And they all looked at me and said, "Who's he?"

The amazing thing about Marlene was that right from the start she believed in me and was always really supportive.

Angie Dickinson: After we got married, Burt moved into my house on North Bundy in Brentwood. It was not just kind of small. They don't get any smaller. The house was so small that I put in a half bath for him as a gift. Oh, I wanted it, too. You've got to have two bathrooms. It's one thing to go to a hotel for a couple of days with only one bathroom, and Burt's place in New York had only one bathroom. But I mean, "Oy vey."

After a while, Marlene and I got over what had happened at the Dorchester that night, and whenever she would come over to the house where Angie I were living for dinner, which was usually Kentucky Fried Chicken, potatoes, and coleslaw, the dance the two them would do was unbelievable. They either really adored one another or they fucking hated each other.

I would see that going on and I would say to myself, "How do I get out of this?" Even though I probably should never have told Angie what Marlene had said about her at the Dorchester, I had already done that. But Angie never came from the position of "I don't want this fucking broad in my house." Angie never did that. But the performances that went on when these two actresses got together were really something to see.

Angie Dickinson: Marlene was nice to me at dinner but I knew it was a performance on her part. She was a mature lady who understood that if you can't fight them, join them. For her, it was a no-brainer. Burt was delicious and Marlene adored him as a guy and enjoyed his company and wanted to be with him. She also simply could not function without him. He was her Svengali.

About a year after we were married, Burt and I were in New

York and about to meet Marlene for dinner at a restaurant called Le Steak. It was only a couple of blocks away on Fifty-Seventh Street but we were late and I was nervous, of course, for all the right reasons. Burt led me in because he knew where she was seated. All the way at the back in a gorgeous fur turban, Marlene Dietrich was sitting at a table alone.

We walked in at least twenty, if not thirty, minutes late and Marlene just looked at Burt and simply said, "Hello, darling." That was all. She didn't even look at her watch and say, "Thank you," which I would have done. I think it says so much about Marlene and her relationship with Burt. For her, he could do no wrong.

After Burt had stopped conducting for Marlene, I ran into her in Beverly Hills one day. I chased after her and said, "Marlene!" And then I said, "Burt would love to hear from you," or "I'm so sorry things aren't working out." And she said, "*Finita la commedia.*" That was the last I ever saw or heard from Marlene. A love affair that had been so good for so long ended so sadly.

As I became more well known as a songwriter, I knew it was coming close to the time when I wasn't going to be able to work with Marlene anymore. Still, I tried to come through for her on certain dates. I even groomed Stan Freeman, a brilliant piano player, to take over as her conductor, but she didn't like him. Then I got her another conductor. I don't think anyone is irreplaceable, but it finally became apparent to me that where Marlene was concerned, it was always going to be "No vun can replace Burt."

Gary Smith: The first time I ever met Burt was in 1965, when I created a television show called *Hullabaloo.* Burt walked into the office with Paul Anka, who was a good friend of mine at the time, and they said, "We've got a theme song for you." I said, "Oh, that's great." They played me a little demo tape they had done and it was

a good up-tempo song. Paul had done the lyrics and Burt had written the melody.

Unfortunately, our theme song had already been written by Peter Matz, our musical conductor, and as much as I would have liked the prestige of having a song written by Paul and Burt, I said, "Guys, it's just too late. I can't pull it away from him." Paul was a hustler and he had probably pushed Burt by saying, "I know Gary Smith. Here's my lyric. I can get an appointment with him in ten seconds."

At the end of every show on *Hullabaloo*, we would cut out the letters for the finale from the *Billboard* magazine charts and spell out something like "Motown" or "Lennon-McCartney" and all the guests would do their songs. One week when Dionne Warwick was on the show, it said "Bacharach" and all the guests performed Burt's songs. The next morning, my assistant said, "There's somebody here to see you. His name is Hal David." And I went, "Oh God. I know what this is about."

Hal walked in and he looked like an accountant or a guy who worked in a drugstore and he said, "Look, Gary, I'm not going to make a federal case about this but I will tell you this. I was sitting at home with my kids last night watching *Hullabaloo* and they said to me, 'Daddy, why isn't your name up there? Why doesn't it say Bacharach and David?'"

I said, "Oh shit, Hal, I have to be honest with you. I don't have an answer for that. Except to say that your partner in music has a cachet that is unbelievable. You know that. He's a handsome guy and he could be hosting TV shows someday. I urge you to go out and get a PR person. Because you have to be more visible. It's not that Burt's doing it on his own. It's just that everyone in the business always thinks of what the two of you have written as a Bacharach song. Nobody says Bacharach-David like they say Lennon-McCartney." And he left the office, thanking me for the advice.

Hal David: After I saw *Hullabaloo*, I called Lee Eastman, our attorney, and he had his son John give the *Hullabaloo* people an earful about what they had done and I think I did hire a publicist then.

During this period, Hal was the one who did most of the business stuff and he was the one who brought in Lee Eastman to help us set up our own publishing company. Hal would talk to Florence Greenberg at Scepter Records and send in our accountants to find the money whenever we were given a royalty statement that seemed wrong, and he would call *Cashbox* magazine to complain about the chart standings when our new record didn't get a bullet. I never wanted to do any of that because I was still kind of shy at the time and always afraid of bad news.

Angie Dickinson: Personality-wise, Hal was one hundred percent different from Burt, and you never would have thought they would jell at all. Hal was not show business. He was old-fashioned and Burt was forever young in the way he walked, the way he dressed, the way he talked, and the way he looked. Maybe the fact that Hal was old-fashioned let him write so many of those lyrics from what seems like a woman's point of view. The old-fashioned way people loved and lived, they kissed, they fell in love, they got married, they had babies. It was pure romance. Unlike Burt, Hal had to create his own importance because the public made Burt important, and not Burt and Hal.

When Burt married me, no one outside the Brill Building knew who he was. They knew the songs but not the man. Most songwriters had the same problem. But Burt backed it up with his own thing. I was just the cover of his book and we became a very exciting team. Kind of like Brad Pitt and Angelina Jolie are now because an appealing couple always attracts attention. We were equally exciting people in different fields and it's just normal to look at pretty people.

Once things started happening for me, there was definitely resentment from Hal. I think I did kind of take him for granted because even though he was delivering brilliant lyrics, I wasn't paying much attention to them. I just wanted Hal to give me great-sounding open words that would be easy to sing on the notes I was looking for so the music would shine through.

Now I understand that Hal was being neglected, but in all truthfulness, did I feel like that then? No. It was definitely a certain kind of ego thing. If people wanted to do these things for me that I hadn't asked them to, great. You know what a very famous songwriter once told me? "Hey, nobody whistles lyrics, you know?" Cruel, huh?

Chapter

11

What's It All About?

I have never had a song come to me fully formed, in a blinding flash of inspiration. What I do is tinker. I fiddle. If a melody comes too easily to me, I don't think it's any good, so I turn it upside down and look at it in the middle of the night. A pop song is a short form so everything counts. You can get away with murder in a forty-five-minute piece but not in a three-and-a-half-minute song.

Some songs just beat you up because they seem to have too many notes or too many words or are just too much. So what I do is play with the melody, explore it, question it, and see if I can keep making it better. Sometimes a song can overwhelm the listener and make them sick of it after loving it for days. So I have to take on the role of the listener as well as the composer. If a song is starting to beat me up while I'm working on it, I know it's wrong.

I also have great difficulty letting things go if I get stuck while I'm writing, and that was what happened while I was working on "Alfie." Howard Koch, who was running Paramount Pictures at the time, asked Hal and me to come up with a song for a film that had already been shot in England and the studio was going to release in America. I read the script in New York, as did Hal, and then I called Koch to tell him how much we liked it.

The song had to tell people what the picture was about, and when Hal called me up from Long Island and read me what he had written over the phone, I knew he had come up with the best lyrics he or anybody else had ever written. It's a great, great lyric. Because I already had the words, the music took a form I might not have gone to otherwise. I don't know how many bars are in each section of the song, because I never counted, but it was not a normal eight-bar structure. Instead of eight-bar phrases with an eight-bar bridge, there are ten bar phrases in "Alfie," and I only got there because of Hal.

It was still a very difficult song for me to write and I had a deadline, so I was under a lot of pressure. I remember going to a theater in New York to see a play while I was writing "Alfie." My mind was on the song and I was watching the play but I couldn't let go of what was in my head. The result was that I walked out of the theater three hours later without having paid any attention to the play, and I had also not made any progress on the song because my mind had been so split that I couldn't fully concentrate on it. I did have one revelation that night, which was that something in the turn of the melody was not working. I would never have realized this while sitting at the keyboard because I can never tell when I go bar by bar. The only way I can do it is by visualizing the scope of the entire song in my head.

After I finished "Alfie," I made a demo of it in New York with Kenny Karen singing as I played piano. Since Famous Music paid for the session, I was also able to overdub a couple of violins. When the word came down that Lewis Gilbert, who had produced and directed the movie, wanted Cilla Black to record the song, I sent her the demo in London.

Cilla Black: Brian Epstein was my manager and he had me listen to this song and it was some fella singing "Alfie." I actually said to

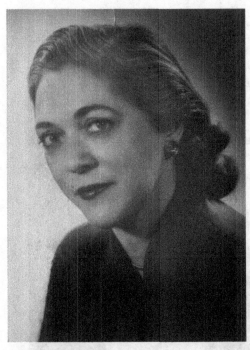

Burt's mother,
Irma Freeman Bacharach

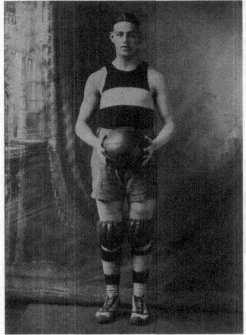

Burt's father, Bert Bacharach,
Virginia Military Institute, 1919

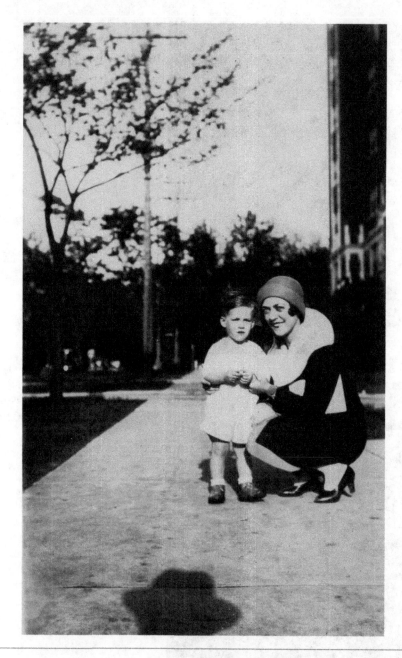

Burt and his mother, Irma, in Kansas City, 1929

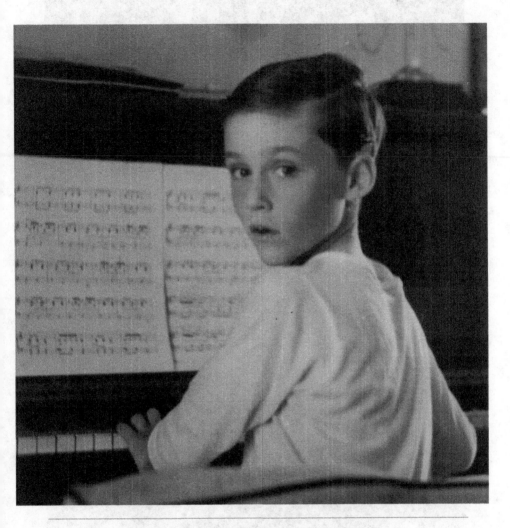

At the piano, eight years old, Forest Hills, New York

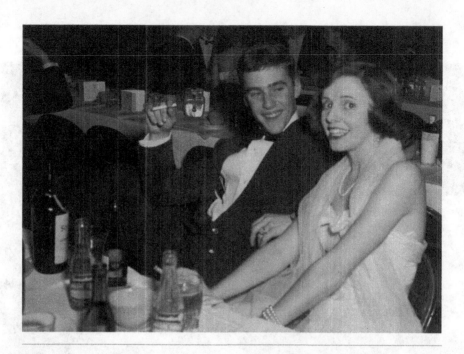

With a date at the winter dance at McGill University

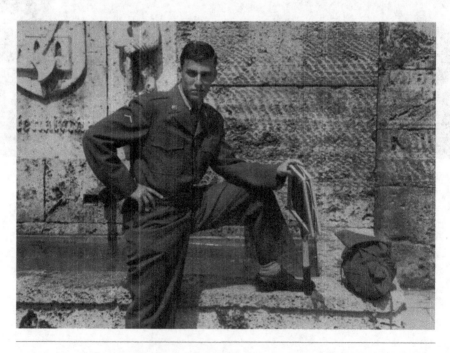

Serving in the Army with tennis racquet in hand

At dinner with his father and mother

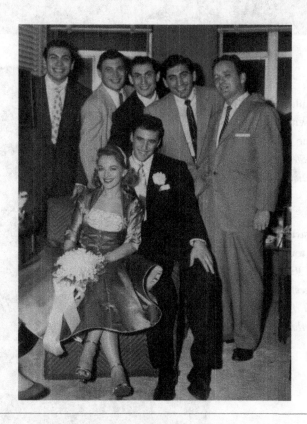

Burt and Paula Stewart on their wedding day, surrounded
by the Ames Brothers (*From Paula Stewart's personal collection*)

ABOVE:
Burt and Paula at Beverly
Hills Hotel with Slim
Brandy in the foreground
*(From Paula Stewart's
personal collection)*

RIGHT:
Burt and Marlene
Dietrich on tour,
circa early 1960s
*(Deutsche Kinemathek/
Marlene Dietrich
Collection, Berlin)*

In the studio with Hal David and Dionne Warwick
(From Hal David's personal collection)

Burt and Hal David
(From Hal David's personal collection)

Brian, "I can't do this. For a start, Al-fie? I mean, you call your dog Alfie. I'm sorry. I can't sing a song, 'What's it all about, Al-fie?' Can't it be Tarquin, or something like that?"

Because I really didn't want to record the song, but didn't want to say an outright "no," I thought I'd be really difficult for a change and start putting up barriers. So first of all I said I'd only do it if Burt Bacharach himself did the arrangement, never thinking for one moment that he would. Unfortunately, the reply came back from America that he'd be happy to. So then I said I would only do it if Burt came over to London for the recording sessions. "Yes," came the reply. Next I said that in addition to doing the arrangement and coming over, he had to play on the session. To my astonishment it was agreed that Burt would do all three! So by this time, coward that I was, I really couldn't back out.

Cilla was a big star and I had a lot of respect for both her and George Martin, who was going to produce the session, so I flew to London and rehearsed Cilla in George Martin's flat. Then I went in to record "Alfie" at Abbey Road Studios with a forty-eight-piece orchestra and the Breakaways singing backup at a session Brian Epstein brought someone in to film.

When I walked into the studio where the Beatles had recorded all their greatest songs, I knew where I was but my focus was such that I didn't think about the history of the place or pay it any respect at all. I didn't say, "Hello, George Martin, it's a pleasure to have you in the booth at the producer's chair." It was more like, "George Martin, yeah, great," because I only had one purpose in mind. All I cared about was that I had to do "Alfie" with Cilla Black and I didn't know what to expect from her and I was going to do it all live and conduct and play piano at the same time while trying to get a great vocal from her.

Cilla Black: There was so much range and it was unbelievably hard, so when I started the song in that soft voice, it was awfully difficult to get all that energy up, literally from my boots, to go for that high note. I was hurting.

I really don't think anyone had ever put Cilla through something like this before. She had a really strong pop voice but what I wanted her to do on "Alfie" was go for the jugular. We did twenty-eight or twenty-nine takes and after each one, I kept saying, "Can we do better than that? Can I get one more?" The way Cilla remembers it, George Martin finally asked me, "Burt, what are you looking for here?" I said, "That little bit of magic," and he said, "I think we got that on take four."

I don't remember him saying this but it wouldn't have mattered to me in any event, because I hadn't come all the way over to London to have someone else tell me that. When I walked into that studio that night, all I wanted was to get 100 percent from the drummer, the bass player, and everybody else. It was a long night and Cilla got exasperated with me but in a good way and she sang her ass off.

Mike Myers: If you've seen the video of that session on YouTube, Burt breaks Cilla in the studio. He was going to do it until it was right and I love the quote from her. "I wanted to foo-kin' kill him but he was so foo-kin' gorgeous."

Of all the songs I've written, I would have to put "Alfie" at or near the top of my list of favorites. One of the reasons I feel that way was something Miles Davis told me one night many years later when I was having dinner with him and Cicely Tyson in Los Angeles. I had always idolized Miles as a musician but as a dinner partner, I found him difficult, to say the least, because he only ever

talked about himself. I really liked Cicely but in terms of the conversation, she didn't get much to say. At one point, Miles said he thought "Alfie" was a really good song.

Despite all the hits I had already written, I still always had the feeling that maybe I was putting the world on and I wasn't really all that good or original. But when Miles Davis said "Alfie" was a good song, he dispelled a lot of that doubt for me and gave me the kind of credibility I had never been able to give myself.

Although Lewis Gilbert decided to use Sonny Rollins doing his own composition called "Alfie's Theme" as an instrumental in the film, Cilla's version was released in England in January 1966 and went to number nine in the charts. "Alfie" was nominated for an Academy Award for Best Original Song in 1967. By then, Dionne had also recorded the song and she performed it at the Academy Awards show.

When I had attended the Academy Awards for the first time in 1965, I was just so happy that "What's New Pussycat?" had been nominated that it didn't matter much to me when I lost, because I never thought I was going to win. With "Alfie," I walked in feeling very hopeful.

I was sitting with Angie when they announced that "Born Free" had won the Oscar. Dusty Springfield's brother, who was watching the show on television and could see me on camera, claimed that when they made the announcement I said, "Shit!" I don't remember saying that but it's entirely possible, because when I heard the announcement, I couldn't believe I hadn't won and I was really pissed off.

Slim Brandy: Burt was married to Angie and he called me. By now, I had been going with somebody else. Burt's a man of few words, and he said, "Hey. It's me. Hi, baby, what are you doing?" I said, "What do you mean, 'What am I doing?'" He said, "Can I see

you?" And I said, "You know, Burt, this is pretty weird. First of all, I'm annoyed with you. It would have been nice if you'd called me to say you were getting married so I didn't have to hear it the way I did. Because we've always been close." He said, "I know, baby. I didn't know how to really say it to you, but I want to see you."

This was in New York City. We went out to a few bars and had a few little dinners and then he told me he was leaving Angie. This was before he knew she was pregnant. I loved Burt. There wasn't one moment, and I'm never shy about saying this, that I would not have gone back to him. I don't know why he was leaving Angie at that point and I didn't want to know. He was telling me he loved me and that was all I wanted to hear.

Then I got a phone call from Burt saying, "I can't leave her. She's pregnant." We sat, we cried, we kissed, we talked, and that was the end of that. Then there was an article about the two of us in one of those gossip columns: "Why is Burt Bacharach seeing his ex-girlfriend?" They called me a model and I had never been a model. We weren't having an affair. It happened so fast, it was like two, three days in New York, and I wasn't ready to hop into bed with him. We were just looking at each other, reconsidering the whole thing. Obviously, we weren't finished with each other. That's the whole point of my relationship with Burt. The truth is, I don't think we ever left each other. We never really finished. Later on, he used to say, "Same time next year." Because we would see each other every year, if not more.

With Slim, I just kept bouncing back and forth. The two of us would connect and reconnect and then connect again. Slim was a tough one to leave because we had so much history together and she had been so young when we had first gotten together in Vegas. In a lot of ways she was still the same woman who had gone to bed with me wearing a bathing suit. The other thing about her was that

she certainly wasn't waiting for me, but then once Nikki was born, everything changed for me.

Angie Dickinson: Although I didn't see Nikki until the fifth day, I thought she was gorgeous and incredible, but she looked like a tiny sculpture of a prisoner of war because her legs were about as thin as a finger and she had fairly big feet. They kept her in an incubator for three months and Burt and I went to see her every single day, but we couldn't touch or hold or cuddle or soothe her because they wanted to protect her from disease. When Nikki was finally released, she weighed almost five pounds but seemed contented and normal, and in my opinion, she was doing wonderfully.

Chapter
12

The Look of Love

Charlie Feldman owned the movie rights to the first James Bond novel but couldn't come to terms with the producers who were making all the other Bond movies, so he decided to do *Casino Royale* as a satire. He asked me to do the score and write some new songs for it with Hal. It was only the second movie I had ever done, and because there were nine screenwriters, five directors, and seven different actors, including David Niven, Peter Sellers, and Ursula Andress playing various versions of Bond, I had no guidance at all.

Before I went to London I had started watching the movie in the house where Angie and I were living, off Coldwater Canyon in Los Angeles. Just like she had done for me on *What's New Pussycat?*, Angie would change the reels for me on the Moviola and then go to bed while I worked in the next room. While she was sleeping, I watched this one scene over and over again because Ursula Andress looked so drop-dead gorgeous in it. And that was how I came up with the theme for her that became "The Look of Love."

I flew to London on Super Bowl Sunday. Angie stayed in Los Angeles to take care of Nikki, so I was living by myself in a rented apartment about a block from the Dorchester Hotel. They had leased some space in the basement for the music editor who would

thread all the reels of the rough cut into the Moviola for me, because I still didn't know how to work it.

By the time I started working on the picture, all the directors had already left so there was no one to tell me where the music should start and where it should stop. I was having trouble writing the score because no matter how hard I tried, I just couldn't seem to get a handle on what the movie was about. My hours were screwed up and the music wouldn't stop playing in my head so I started taking too many sleeping pills, Seconal as well as some other stuff a friend in London had given me.

I would go out to dinner by myself at nine-thirty at night, have a couple of Jack Daniel's, come back to the flat, watch the film, and write for a couple of hours. Then I would take a couple of pills and sleep for maybe three hours. As soon as I woke up, I would make some coffee and go to the keyboard. At about eleven in the morning, I would take a nap and as soon as I woke up I would start all over again. Everything was out of synch and I was bouncing off the walls. I also had to record the entire score in London and by the time I was finished doing that, I was totally blown out and exhausted. Looking back on all this now, I feel like I'm lucky to have lived through it.

There was no pressure on me when I got back to Los Angeles, so I started feeling better. But so long as there was still music running through my head at night when I was trying to sleep, I still had a problem, and it would be a long time before I finally managed to get that resolved.

Hal and I wanted Johnny Rivers to record the theme song for *Casino Royale*, so they brought him over to London but he didn't like the song. He wasn't very nice about it and left abruptly. Herb Alpert then saved my ass by offering to record it as an instrumental with the Tijuana Brass. Herb took the track I had made for Johnny Rivers and inserted his trumpet and the Tijuana Brass. Herb and Jerry Moss released it on A&M Records and the song became a hit.

I had originally scored "The Look of Love" in the film as a very sexual instrumental theme. Then Hal came up with lyrics for it and we took Dusty Springfield into the studio to record the song. I had first met Dusty when she came to New York in February 1964. By then, she had already cut her own version of "Wishin' and Hopin'," a song Hal and I had written that Dionne had recorded a year before as a B-side. I did my best to talk Dusty into releasing "Wishin' and Hopin'" as a single in the States. She was ambivalent about it but let it come out. A disc jockey in New York started playing the song and the record went to number four in the charts.

Dusty was a great girl with a really soulful voice, but she was very hard to record. We were both perfectionists but Dusty was much harder on herself than she needed to be and I think that if we had ever tried to do an album together, we would have destroyed one another. Dusty was so insecure that when we cut "The Look of Love" together in London she would go into a separate control room so she could listen to the playback by herself. I told her that what she had done was great and that it was exactly what we wanted for the picture. I had scored it to begin with a gourd, which is a Brazilian percussion instrument, followed by a very sexy saxophone.

The song was a hit and then became an even bigger one when Sergio Mendes and Brasil '66 cut it a year later. "The Look of Love" was nominated for an Academy Award for Best Song in 1968 but the Oscar went to "Talk to the Animals," from *Doctor Dolittle.* So when it came to winning this award, Hal and I were now three-time losers.

Hal was still a lot more political than me and the fact that one of his sons was now old enough to be drafted inspired him to write the lyrics for "The Windows of the World." Dionne recorded it as a single and I really blew it. I wrote a bad arrangement and the tempo was too fast, and I really regret making it the way I did because it's a good song. "The Windows of the World" was also on an

album of the same name, which had a track on it called "I Say a Little Prayer."

When I cut the song with Dionne, we had a great trumpet player named Ernie Royal in the studio. Although I had never worked with him before, Ernie had played with Dizzy Gillespie and was one of the best, but he had an attitude at times. Back then I would write dummy lyrics that had no meaning and then have the copyist put them on the horn parts after I had done the score. I would write out all the notes for the trumpet line and the score. Although the notation was right, putting words to it, like, for instance, "Just holding on," made the song more lucid for me than just having the notes on paper.

All the musicians I usually worked with got used to this because what I was doing was asking them to think lyrically as they played the notes. I would sing the words I had written to the horn players and then tell them to play those lyrics on their instruments.

After I did this in the studio that night, I said, "Although these words make no fucking sense, do you hear what they are saying?" Ernie said, "I don't get it, man. You want it staccato or not?" I said, "I want it the way I wrote it and just sang it," and he said, "I don't know what the fuck you're talking about." I said, "Let's take a break." Then I talked to the music contractor and said I didn't want to use Ernie for the rest of the date, because I didn't want that kind of attitude in the studio. It didn't take away from Ernie Royal being a great trumpet player, but he could have made things impossible.

Even after we had cut "I Say a Little Prayer," I still thought I had blown it because the tempo was too fast, so I fought to keep it from coming out as a single. One thing I love about the record business is how wrong I was. Disc jockeys all across the country started playing the track, and the song went to number four on the charts and then became the biggest hit Hal and I had ever written for Dionne.

The flip side of the record was the theme song from the movie *Valley of the Dolls*. Since Hal and I had not written it and we were still under contract to Scepter, we cut the song with Phil Ramone at A&R Studios in New York, where we were now starting to make one big hit after another for Dionne.

Phil Ramone: The first thing Burt and Hal cut with us was Dionne's version of "Alfie." My mother, Minnie, came to the date to meet Burt and the record did very well and then she came to another Bacharach date and she was always knitting in the corner and her gift to you would be a sweater or a scarf. Which is what she gave Burt, because he would always complain about the air-conditioning in the studio and tell me, "Turn it down!"

It got so bad I finally had a knob installed right on the console for him to turn the air-conditioning down because otherwise he would keep fucking with it. I would say, "Don't go more than a degree because if you do, the whole system is going to reheat and send up cold air." Burt was also germophobic and would wash his hands before he washed his hands and you simply could not argue with him about it. What Burt never found out until later was that the knob didn't really work. It was just my way of pacifying him during sessions so he could concentrate on the music.

The next session we did together was "I Say a Little Prayer." My mother gave Burt the scarf she had knitted for him and they chatted up a storm. When he and Dionne came in to do a another record, Burt said, "Where's your mom? How come she's not here?" I said, "Well, I didn't think she had to be here. We've had like three hit records in a row. Are you crazy?" But Burt had got it in his head that my mother being there had helped both songs become hits and he would not start the session without her.

So I called my mother and said, "Burt would really love to see you. He's got it in his head that you're his good-luck charm. Can

you grab a cab and come right to the studio?" She lived in Manhattan so she came to the studio, and that was the night we cut "Do You Know the Way to San Jose." The song went into the top ten and Dionne won the Grammy for Best Contemporary Pop Vocal Performance of 1968.

What I would sometimes do back then was write against the mood of Hal's lyrics. The melody I came up with for "Do You Know the Way to San Jose" is bright and rhythmic, so you might think the song is happy, but it's about someone going back to San Jose after having blown a chance at becoming a star, and is not a happy song by any means. When I played it for Dionne for the first time, she couldn't believe Hal had written lyrics with the phrase "whoa, whoa, whoa" for her to sing, and she didn't want to cut it.

Hal had been stationed in San Jose during World War II, and although Dionne says she only recorded the song because it meant so much to him, I had to really push her to do it. After the song became a top-ten hit, Dionne got to love it and I think she also visited San Jose and became an honorary citizen of the city.

"Do You Know the Way to San Jose" opens with bass and a bass drum. I doubled the keyboards, and the strings come in on the second eight and the brass section plays on the instrumental passage. It was a lot for anyone to control, so Phil Ramone would come out into the studio to hear how the music sounded. Then he would know how much of it he could get on tape when we cut it live.

Before he ever started producing, Phil was already one of the greatest engineers. Because he had been a child prodigy on the violin, he could read music and really knew how to keep a string section under control. In the studio, Phil could always tell which violin in the section was cheating by not giving as much as we needed to make a song really work.

Right around this time, Herb Alpert and the Tijuana Brass

were scheduled to do a television special on CBS. Herb was looking for a song he could sing to his wife, Sharon, on the show so he gave me a call.

Herb Alpert: There's a question I always ask great writers that I asked Burt that day over the phone. "Is there a song you have tucked away in your drawer or someplace or a song that didn't get the right recording that you find yourself whistling in the shower?" And he sent me "This Girl's in Love with You." I called Hal David in New York and asked him if he wouldn't mind changing the gender. I flew to New York and waited while he worked on it, and as I was leaving his place, I asked Hal the same question I had asked Burt and Hal sent me "Close to You," a song I had also never heard before.

Burt wrote the arrangement for "This Guy's in Love with You" and he was in the studio when we cut it at Gold Star Recording. In the studio, I'm the opposite of Burt. He is a perfectionist who likes everything to sound exactly the way he hears it in his head. I close my eyes and I'm from the feel-it school. Obviously, Burt feels it as well but I take a different approach. If it feels right, I stop.

So we had the track and I wanted to see whether my voice would sound good on it. A bunch of the singers and Burt and a couple of musicians were in the control room while I was doing a demo of the vocal. I did one take and went back into the control room and they all looked at me and said, "Don't touch it." I said, "What do you mean, don't touch it? That's just the demo." Burt said, "Don't touch it, man. It sounds great." I touched up a couple of things here and there but that was the take.

If it feels good, I stop. In tune, out of tune, it doesn't matter. Burt was conducting and Pete Jolly played piano and Burt may have played the other piano. As far as I remember, it was Burt and Hal's first number-one hit.

"This Guy's in Love with You" starts with a keyboard. The rhythm section comes in after four bars and Herbie starts to sing and then he plays trumpet. He wasn't a great singer but there was a certain charm in his voice because he sang the song like a trumpet player and then emulated what he had just sung when he played trumpet. "This Guy's in Love with You" was never meant to be a single, but the reaction after Herb sang it on the television special was so strong that he and Jerry Moss decided to rush-release it on A&M. It became the first number-one song Hal and I had ever written.

Since then, "This Guy's in Love with You" has been covered by about 130 different artists, including Chet Atkins, James Brown, Booker T. & the M.G.s, Ella Fitzgerald, Arthur Fiedler, and Smokey Robinson and the Miracles. In 1996 I played it live onstage at Royal Festival Hall in London with Noel Gallagher, the lead singer of Oasis.

Noel Gallagher: A lot of people like Burt Bacharach because they think he's kitsch. And then there's a generation of songwriters who respect him immensely for what he's done, and for the songs that he's written. He's a big hero of mine. A big songwriting hero.

We were on the road and I was writing this song and I must say it took me nearly two and a half years to work out the chords to "This Guy's in Love with You." I moved it up two keys, swapped all the chords around, put it backwards, and then put the words to it, and it's called "Half the World Away." I would say "This Guy's in Love with You" is the best love song ever. If I could write a song half as good as "This Guy's in Love with You" or "Anyone Who Had a Heart," I'd die a happy man.

I walked out onstage that night at Royal Festival Hall and got a standing ovation and part of me was thinking, "You're not dead.

You don't have some incurable disease—or do you? Does the audience know something about me that I don't know?"

Noel Gallagher had gone on record saying "This Guy's in Love with You" was one of the best songs ever. We got together before the show in my hotel suite to rehearse it so he could perform it onstage with me and the BBC Concert Orchestra. He was really nervous but I said, "Don't worry. It's going to be great." His appearance was supposed to be a big secret but word got out somehow and there were all these photographers down front who were definitely not there to see me.

When Noel walked onstage, he saw a sixty-four-piece orchestra with a complete string section and it must have scared the shit out of him. But he did well and was very happy about his performance. After the show, Noel got really smashed with his whole entourage. We had another show to do the next night so after Noel left, I asked my band, "What do you think? Will he make it, or not?" Noel never showed up, so I had John Pagano, one of my background singers, perform it the next night.

Chapter
13

I'll Never Fall in Love Again

I was scoring *Casino Royale* in London when David Merrick came up and introduced himself to me at a party. By then he had already won a slew of Tony Awards and was generally recognized as the most successful producer on Broadway. We talked for a little while, but I didn't think much more about it at the time. Two years later, he got in touch to ask if Hal and I would be interested in doing the score for a musical Neil Simon was going to write.

The way I heard the story from Neil, Merrick had taken him to lunch that day to ask if he had any ideas for a musical. When Neil told him he only had ideas for plays, Merrick said, "If you *did* have any ideas, are there any composers you would like to work with?" Neil said the music Hal and I were writing would be a breath of fresh air on Broadway. Then Merrick asked Neil if there was a book or a film he wanted to adapt and Neil started talking about *The Apartment*, the Billy Wilder film starring Jack Lemmon and Shirley MacLaine that had won the Academy Award for Best Picture in 1960.

Writing for the Broadway stage had never been a particular dream of mine and if I had known what I was getting into, I might never have done it. But Merrick was very astute and he sold me on

the idea by saying it was time for theater to change by opening itself up to people so they could do their own thing. I decided to say yes because Neil Simon was doing the book and the property itself was so great.

Some musicals are absurd, but when I read what Neil had written, I knew the show was funny and had a lot of heart. Aside from the fact that the lead character talks directly to the audience throughout the play, Neil's book was pretty faithful to the movie. Chuck Baxter, a young guy who works at a big insurance company—and also just happens to have the same last name I used when I formed my first band at Forest Hills High School—tries to make his way up the corporate ladder by letting his bosses use his apartment for their extramarital affairs. Then Chuck falls in love with one of those girls.

Promises, Promises, the title Neil came up with, refers to all the promises Chuck's bosses make to give him a better job in return for this favor, which they never keep. The movie had been set in 1959. By the time we got around to doing the play, sexual attitudes had changed so much that the show already seemed out of date to a lot of people. My concern was the music, and so I thought Neil would fix any of the problems with the story before we opened in New York.

I knew all the songs had to come from what Neil had written and serve the characters he had created. For me this was a good thing because it was restrictive. Hal wrote all the lyrics first and I spent the summer working on the music. By the time I flew to New York in September, I had sixteen songs to play for the cast on the first day of rehearsal.

I wish I could say I was happy to be there, but I wasn't, because I was going to have to spend the next three months rehearsing in New York and then go on the road to Boston and Washington for previews. Nikki was just two years old and so Angie and I decided it would be better for them both to stay in Los Angeles while I was

working on the play. Angie did agree to fly in a couple of times so we could all be together.

We rehearsed for the first time on Labor Day on the sixth floor of the Riverside Plaza Hotel on West Seventy-Third Street. Hal was there along with Merrick, Neil Simon, choreographer Michael Bennett, and Robert Moore, who was going to direct the show. All the actors were there as well, including Jerry Orbach, who had been cast to play Chuck. After we rehearsed the show for about two weeks, Neil Simon went to Merrick and said, "I hate Jerry Orbach. I can't stand him. Let's get Tony Roberts to do the part instead."

Since it was Neil's play, Merrick called Tony Roberts in Hong Kong and had him fly to New York. By the time Tony landed at the airport, Neil had suddenly fallen in love with Jerry Orbach's performance and told Merrick he couldn't imagine anyone else ever playing the part. Tony Roberts eventually wound up playing Chuck in London and he was very good.

We spent six weeks rehearsing in New York. Right from the start I was obsessed with getting the rhythm section in the orchestra to play what I had written the way I wanted to hear it. Even though no one in theater would have ever considered doing something like this, I was such a complete novice that I even offered to pay for extra rehearsals so the rhythm section would be steaming by the time we got to Boston.

To get as close to the kind of sound I was used to hearing in the recording studio, I brought Phil Ramone in to mix the sound, and the two of us came up with the idea of creating a different kind of orchestra pit for the show. Our initial idea was to have the pit partially enclosed with the background singers down there to reinforce the voices onstage. By the time we finally got to New York, the concept got even more complicated than that.

In those days, producers always took a show out of town before it opened on Broadway, so we went to Boston, where the open-

ing night reviews were pretty good. Eliot Norton, the theater critic for the *Boston Globe*, said the songs Hal and I had written were "as freshly different from those of their contemporaries as were those of Rodgers and Hart in their first shows. . . . It is sophisticated music with its own quick pulse, a nervous beat that catches and reflects something of the tension of the times and suits perfectly the people and the plot of the show, which is sophisticated."

Despite that, we all knew we still had work to do and Neil Simon had to revise certain scenes. It was something he was very good at doing, which was why they called him "Doc." The weekend after we opened, I had the worst sore throat of my life. I thought it was just a cold but by the third or fourth day, it just kept getting worse. What I should have done was call my physician in L.A., but instead I called the hotel doctor and he put me into Massachusetts General Hospital, where they told me I had pneumonia.

I hadn't been in a hospital since I'd had my tonsils out when I was four years old, but at least I was lucky enough to be in a great one. I also knew that as soon as I got out again, I had to write four new songs for the show. David Merrick may have been a great producer but he was not a very pleasant guy. I never knew if he really liked anything, because I never saw him smile.

While I was in the hospital, he started calling me to ask, "How long do you think you're going to be in there? Because we have new music to write." When I told him I didn't know, Merrick said, "Can we get a piano in the hospital room? Because if you don't get better soon, I'm going to have to bring in some other writers." At that point I said to myself, "Screw this! This is my life and it's more important than this show."

The day I got out of the hospital, I still felt like shit. The last thing I wanted to do was sit in a hotel room with Hal and try to write a new song for the show. Hal had already come up with the lyrics to "I'll Never Fall in Love Again," and my hospital stay had

inspired him to write, "What do you do when you kiss a girl? / You get enough germs to catch pneumonia / And after you do, she'll never phone you."

I sat down at the piano and set Hal's lyric sheet up in front of me. Maybe because I was still not feeling all that well, I wrote the melody for "I'll Never Fall in Love Again" faster than I had ever written any song before in my life.

Phil Ramone: Merrick was famous for being a dick. The show was damn good in Boston, with lots of laughs. Neil, Burt, Hal, myself, and Michael Bennett were all in the men's room after the show when Merrick came in and said, "If you think this fucking show is going to work, you're out of your minds." Then he looked at Burt and Hal and said, "We're missing a song in the middle of the second act and what we need is something the audience can whistle on their way out of the theater." Michael Bennett went into a stall and just started sobbing and Burt and Hal went off to write "I'll Never Fall in Love Again."

We came in with the song the next morning and it went into the show a couple of nights later. "I'll Never Fall in Love Again" became the outstanding hit from the score and pretty much stopped the show every night.

When we got to Washington, D.C., I still didn't feel right. I was sure my pneumonia had returned but I had to stand in a cold sweat at the back of the theater every night and listen to Merrick tear into Michael Bennett by saying the dancing was not good enough. It was brutal to watch because I knew how brilliant Michael really was.

I was still coughing and the only person I knew well enough in Washington to call and ask about a doctor I could go see was Ethel Kennedy, who had come to a couple of my recording sessions in New York and was a fan of my music. Ethel sent me to a doctor who

took some X-rays and told me my pneumonia had not returned. That made me feel better but I still had to stand at the back of the house every night and watch what was going on between Merrick and Bennett. Angie had come to see me in Boston, but by now she had gone back to Los Angeles, so I was alone in a not-so-great hotel and none of this seemed like fun to me.

It was also torture to be in the theater and listen to someone else conducting my music. And I just didn't think the guy we had was right for the job. Merrick felt the same way and he kept nudging me and saying, "Why don't we fire the bastard?"

One night I went backstage and said to the conductor, "What were you doing with the tempo of the second song in the second act?" When he said, "Was it too fast or too slow?" I knew we were fucked. If he had said, "Yeah, it was a little fast," I could have dealt with it. But this was like my coming out of the control room in a recording studio to tell a trumpet player he was out of tune only to have him ask, "Am I sharp or am I flat?" Which was also something I'd gone through before.

I went to Merrick and said, "This guy isn't making it. We have to get rid of him." We decided to have Harold Wheeler, the dance music director who was playing piano in the pit and now does *Dancing with the Stars* on television, take over. Harold had never conducted a show before but I said, "It doesn't make a difference. Get him. He understands my music." Merrick liked the idea of having a black conductor so he hired him and Harold proved he could do it.

When we finally came into New York after seven weeks on the road, I walked into the Shubert Theatre only to discover that the place was acoustically dead. Phil Ramone came up with the idea of not only partitioning the pit but also putting four girl singers alongside the orchestra so that for the first time in Broadway history, the chorus would be in the pit rather than onstage.

Phil covered the walls and floors and ceiling of the pit with acous-

tic insulation and put in seventeen microphones and processed what the girls were singing through an echo chamber. He installed an eleven-channel mixing board at the back of the house so the sound could be mixed live during the show. Everything we did at the Shubert has since become standard practice for Broadway musicals.

Phil Ramone: I wasn't union, so I couldn't run the board, but I would be standing over the sound guy at the back of the theater during the show so I could tell him what to do. Burt was so sensitive that he would say, "No, no, no. We lost that word." He didn't like the sound at the Shubert and although what we did there had never been done before on Broadway, it wasn't like we invented it.

Merrick said to me, "You can't do this show without wireless microphones. It's impossible." And I said, "Put your money where your mouth is." Wireless microphones were still in their infancy back then, and during a show you were as likely to hear the taxicabs outside as the vocalist, so the set designer and I worked really hard to hide microphones all over the stage.

I put surround sound in the theater for the background effects and the girls and the strings. The girls were singing around two mikes and the pit was like a studio. It had some separation and was lined with acoustical material and we had speakers around the theater mainly for the special effects, but the music was still coming from the pit. In the Rodgers and Hammerstein era they had hardly ever miked the orchestra but we had more input so it became a well thought out process.

Even at the end, when things started to work really well, Merrick said to me, "You've got to cut back some of that pit. People think it's a recording. They think you're just playing a fucking tape." That pit was horrible, very deep, so we could actually bury the band in it, but that wasn't the idea. So we cut the pit back and at the end of the show, people used to come down the aisles to watch the band

play the walk-out music. They could see and hear them and there would be two or three rows of people just looking into the pit while listening to Burt's songs. At that point, I think we could have even sold records from the pit.

There were some challenging songs to sing in that show, and the toughest one had to be "Promises, Promises," which had successive bars of five/four, three/four, four/four, six/four, three/four, four/four, six/four, three/eight, four/eight, and four/four. When I first wrote it out, I knew I was changing time signatures nearly every bar but the reason I did it that way was the urgency of what was happening onstage and it felt really natural to me. God bless him, Hal also wrote some really brilliant lyrics for that song.

If I had been an actor who had to sing that song every night, I would have been pretty angry at the composer, and that was exactly how Jerry Orbach felt about it. He once told me, "You're breaking my back every night with that song. Why did you have to make it so difficult?" I said, "That's because the song has to be faithful to the story line and I'm governed by what the character has to say onstage. Chuck is pissed off because he's been lied to and betrayed by his bosses and he's all through with promises, promises. So when he sings that song, he has to show his anger." As it turned out, Jerry wound up winning a Tony Award for his performance in the show.

By the time we got to New York, Neil had made the show half an hour shorter than it had been in Boston, and Hal and I had replaced five of the original songs in the score. The show opened on Broadway on December 1, 1968, and by then we had already racked up a million and a half dollars in advance ticket sales. Angie had flown in from Los Angeles and my parents were there and the theater was filled with people like Merle Oberon, Sidney Lumet, Ethel Merman, Tammy Grimes, Carol Channing, Milton Berle, Cab Calloway, Herb Alpert, Ben Gazzara, and George Segal. Just

as I had done on the road, I watched the show from the back of the house with Neil, Hal, Merrick, and Robert Moore.

Neil, who had been through far more opening nights than me, was nervous because he thought the audience was not responding as it should. When the curtain came down at around nine-thirty, all the critics rushed out of the theater to write their reviews. I went with Angie and my parents to El Morocco, the nightclub on East Fifty-Fourth Street where Merrick was throwing a party for about 250 invited guests.

Angie and I got there at around eleven and went to a little office upstairs so we could watch the first reviews on television. The reviews were good but not raves. At about two in the morning, someone walked into the party with a copy of the *New York Times*. Clive Barnes had given us a great review, so everyone knew the show was going to be a hit.

Freddy Robbins was at El Morocco that night interviewing people for a promotional record that was then sent out to radio stations to help plug the show. Although Freddy spoke to every celebrity he could find there that night, Hal was not one of them. While Freddy was talking to my mother, Merrick walked by and said, "Thank you for giving me Burt." Merrick also told Freddy he thought I would be writing many other shows because I was stagestruck and that I was the first new original American composer since George Gershwin.

After the show opened, I actually got to spend time with Ira Gershwin in L.A., because Angie was friendly with him and his wife, Lee. On Saturday nights, Angie would often go to their house to play poker. I didn't play but I would turn up about a half hour before the game broke up because they always had great corn rye bread. I got to know Ira a little and he was kind enough to give me a copy of the sheet music for "Strike Up the Band." On it he wrote, "For Burt—The Fifth B—(in no particular order)—Beethoven,

Brahms, Berlin, Bach & Bacharach—with admiration, Ira Gersh-win."

It was a gift I treasured but I never liked hearing anyone say I was the new George Gershwin, because I knew I could have never even carried that man's music case. If George Gershwin hadn't died when he was thirty-nine years old, there is no knowing how much more great music he would have written.

Even though I knew *Promises, Promises* was a hit and I should have been really happy about it, all I could say to Freddy Robbins when he interviewed me that night was how much I was looking forward to getting away to Palm Springs for a couple of weeks with Angie and Nikki. More than anything, I was worn out. *Promises, Promises* was the hardest thing I had ever done. I had seen Angie six times in four months, taken too many sleeping pills, and still hadn't gotten enough sleep because music kept running through my head like a jukebox playing all night long.

None of it had been really joyful or exciting for me and I al-ready knew I would never write another Broadway musical. In the theater, with a live orchestra in the pit, the tempos change nightly, and all that was out of my hands. In a recording studio, I could get it right on tape and it would be there forever.

I spent another couple of days in New York and went into the studio to record the cast album. Then I got on a plane and flew to California, where Angie had rented a house in the desert. All I wanted to do was get away from music, hang out in the sun, play tennis, and start feeling better. About a week and half later, I got a call from Merrick, who said, "I just wanted you to know that Rich-ard Rodgers was in to see the Sunday matinee." I thought that was great but then Merrick told me there had been a substitute drum-mer and five other key subs in the orchestra for the performance. I said, "That's just terrible! That's the way Richard Rodgers got to hear my show?" It just killed me to know that, but the only way I

could have controlled that was to be in the pit myself every night conducting the orchestra, which was something I was not willing to do.

Promises, Promises ran on Broadway for four years. The show opened at the Prince of Wales Theatre in London a year later and ran there for 560 performances. The cast album wound up winning a Grammy Award and Dionne had hits with both "I'll Never Fall in Love Again" and "Promises, Promises."

Shortly after the show opened I got a call from the American Symphony Orchestra saying Leopold Stokowski wanted me to write a serious work for them to perform. When I told my mother about it she broke down and started crying. After I learned that it would be at least two years before the orchestra could perform whatever I had written, because of the way symphony orchestras scheduled their programs, I turned the offer down. My mother was really disappointed but I was used to the immediacy of the record business, where you write a song, play it for the artist, go into the studio, make the record, and then track it on the radio for the next six weeks.

While I was in Palm Springs I didn't touch a piano and I stopped writing. Instead I played tennis every day. I called my agent, Freddy Fields, and told him to get me out of scoring a new motion picture comedy called *The April Fools*, starring Jack Lemmon and Catherine Deneuve. I told Freddy I was too burned out to do the job but I agreed to write the title song and they brought in Marvin Hamlisch to come up with the score.

Two weeks in Palm Springs became four weeks, and then six, and I still didn't miss having to sit down at the piano every day and write. After two months, I was tan, my backhand had improved, and for the first time in a very long while I wasn't even thinking about music. Larry Gelbart, who created *M*A*S*H* for television and wrote *A Funny Thing Happened on the Way to the Forum*, had a great

line: "If Hitler is alive, I hope he's out of town with a musical." At the time, that was exactly how I felt as well.

The pneumonia had really taken a lot out of me and it was hard to recover. What I learned was that the longer you stay away from your craft, the harder it is to reenter. What I would say to people who write music is that if you stop for a while and think you can pick it up again anytime you like, it's really not that easy. There is something to be said for going to your piano or guitar every day, even if you don't write anything, just so you can keep in touch with your music. If you do that, there will be days when something magical happens, but you have to do it on a daily basis.

Chapter 14

Raindrops Keep Fallin' on My Head

At a time when no one under the age of twenty-five wanted to listen to the music their parents liked, the songs Hal and I were writing seemed to appeal to both generations. I guess the best way to explain what started to happen for me during the next two years is that *The Hitmaker,* the first album I had done on my own, sold a grand total of 3,500 copies in America. My second album, *Reach Out,* which Herb Alpert and Jerry Moss put out on A&M in 1967, sold 135,000 copies in nine months.

Herb and Jerry were great guys and I loved them both. While I was making *Reach Out,* I saw Herb on the A&M lot one day and he asked me, "How did it go in the studio last night?" I said, "You know, it was good but on 'What the World Needs Now Is Love,' I didn't get what I was looking for." These were the days when I would try to cut three songs in a three-hour call. Certainly two, but since I was working with a huge orchestra, I never wanted to run over because that would cost the record company money. So I was stunned when Herb said, "You didn't get it? Go back in and do it again." I said, "Just that one song?" And he said, "Yeah." I had never heard that from a record company before but that was just how good A&M Records was.

A few months later I got a call from the brilliant film director George Roy Hill at Twentieth Century Fox, who said he wanted to meet with me. Since I had still done only two films at that time, it was really more like an audition. When I walked into George Roy Hill's office, he was sitting at the piano playing Bach, and doing it really well, too, and I thought, "This is just amazing. A good director who also knows music." In terms of my working on the score, that could have been both a plus and a minus. After I got to know George a little better, I learned he had studied music at Yale with Paul Hindemith, who had also taught Helmut Blume, my piano teacher at McGill.

George knew exactly where he wanted music in this picture he had just shot and where he didn't want it. When the music was there, he wanted it to be important. After he showed me a rough cut of *Butch Cassidy and the Sundance Kid,* I agreed to score the picture for him.

There were certain scenes in the film that had been shot as musical interludes. During one of them Paul Newman is riding around on a bicycle with Katharine Ross sitting on the handlebars. George had cut the sequence to "The Fifty-Ninth Street Bridge Song (Feelin' Groovy)" by Simon and Garfunkel. Even after I started working on the movie, I had no idea if George wanted to hear someone sing during that sequence.

After running the scene over and over on a Moviola, I heard this melody I thought could be a song. When I hear a melody, the orchestration comes out of the same cloth. I knew this song was going to start with a ukulele, and that there would be a tack piano on it to get a honky-tonk kind of feeling. What I would do back then was come up with words that had no meaning but just sounded good to me on the notes I was writing. I think Paul Simon also does this to help guide him to where he is going on a song. I wrote the entire melody, and the only words that kept run-

ning through my mind from top to bottom were "Raindrops keep fallin' on my head."

I got together with Hal and gave him the melody. He tried very hard to come up with another title, because if you watch the scene in the movie, the sun is shining pretty brightly as Newman and Ross ride around on that bicycle. My title might not have made any literal sense but those were the words that sounded good to me on the notes I had written and they did contour the melody.

Hal came up with lyrics in a couple of days. Then he wrote another set of lyrics and took what he liked best from each and glued them together. George Roy Hill had to sign off on the song, so he came to my house. Hal was there and when I played George our song, he liked it right away.

After I had finished scoring the movie, I ran into Dick Zanuck, the president of Twentieth Century Fox, in a restaurant. He told me he had to fight the board at the studio to keep the song in the picture because they thought it was too risky and unconventional. All I knew was that the song seemed right to me for the time period of the picture. Although it wasn't particularly pop and not a western song by any means, it did fit what the actors were doing in the scene. If I had known that Dick Zanuck was fighting the people at the studio to keep the song in the picture, I'm sure I would have freaked out.

Ray Stevens was a very hot singer at the time, so the studio brought him out to watch the movie and hear the song to see if he wanted to record it. Ray Stevens hated the movie and he hated the song. Time was running out so we took it to B. J. Thomas, who was on Scepter Records, which made things comfortable for us. He had sort of a country pop voice and even though B. J. had laryngitis when we cut the song in the studio together, he knew exactly how I wanted him to phrase it. We did five takes and I thought it was great.

On the day after Sharon Tate was murdered in Los Angeles, I flew up to San Francisco to watch a preview of the movie. Paul Newman was there but he was drinking beer in his trailer and so we never talked to one another. Because the composer always comes in last on a picture, the only person who worked on *Butch Cassidy and the Sundance Kid* that I ever met was George Roy Hill. I had a lot of respect for him, and since he was on my side, I thought, "Well, if he's not worried about this song being in the picture, it must be all right." When the bicycle scene was over, the audience erupted and I thought, "This is great."

Two weeks later I cut the version of the song that was released as a single with B. J. Thomas at A&R Studios in New York. I was torn between two takes, one that sounded comfortable and one that had a lot more energy. I wound up making a splice right in the middle of the song so that it moved from the slower version to the faster one and that was the single they released.

George Roy Hill also had me write a piece of music called "South American Getaway" to accompany the sequence when Paul Newman, Robert Redford, and Katharine Ross go to Bolivia. That's the piece I'm most proud of in the picture. George always liked the Swingle Singers and what we did on it was use vocalists like instruments. The love theme I wrote for the picture didn't have any lyrics, but after the movie came out and we were making the soundtrack album, Hal offered to write words for it.

He came up with a lyric I hated for "Come Touch the Sun"— "Where there is a heartache, there must be a heart"—but when you're writing with somebody and rolling along together very successfully, you have to pick your battles carefully. It wasn't like I could go to Hal and say, "Could I take my melody back and have somebody else write the words?" I just had to let it go, and what I did from then on was to call the song an instrumental.

"Raindrops Keep Fallin' on My Head" was released in October

1969 to coincide with the opening of the movie. The song went to number one on the charts in January 1970 and stayed there for a month. On March 11, I won a Grammy for the cast album from *Promises, Promises* and another Grammy for Best Motion Picture Score for *Butch Cassidy and the Sundance Kid*. Three days later, Dwight Hemion, who had directed a Kraft Music Hall special I had done on NBC, and Peter Matz, who had conducted the orchestra, were given Emmy Awards for the show.

"Raindrops Keep Fallin' on My Head" was nominated for an Academy Award for Best Original Song and I was also nominated for Best Score. I had already been through all this three times before and then gone home depressed when someone else won the Oscar, but when I walked in there with Angie for the ceremony that night, I was very excited. I was also scared because I thought we had such a great chance to win.

After I won the Oscar for Best Score, I thought, "Hey, it's looking really good like we're also going to win for Best Song." Hearing them call my name when they announced that Hal and I had won the Academy Award for Best Song was an unbelievable, spine-tingling feeling, an incredible rush. The only problem was that once you get that feeling, you want it again. Right away, I started thinking, "Now that I've won this, what can I look forward to? Do I have a horse running in the fourth at Santa Anita in a few days? Maybe I can win that, too."

Angie Dickinson: Winning the Academy Award puts you in the driver's seat and Burt won two that night. When his name was announced, Burt slapped my knee as he jumped out of his seat to accept the awards but he didn't reference or even acknowledge me in his speech, which was fine because I don't think you should thank spouses unless they were so instrumental that "I could not have done it without you feeding me at three in the morning."

When you're in that state you don't know what hit you but Burt did say, "Nikki, this will be on your breakfast table in the morning." After Burt won those awards, he started performing, and all this adulation came like a wave that started slowly and built and rolled over on him.

The way I started performing was accidental because at that point, I could hardly even speak to an audience. It wasn't stage fright. It was just something I had never learned to do. What happened was that the *Reach Out* album was making some noise and a woman in Los Angeles asked me if I would perform at a charity event. She said she would pay for all the expenses and get the band, so I agreed to do the show.

At that point, I didn't even have endings for my songs so we did fade-out endings onstage like we were in a studio. That was how I started, and it felt okay. Then my agent came up with a date in San Diego. I didn't think I could get enough people in the audience so I had the Carpenters open for me. In May their version of "(They Long to Be) Close to You," a song Hal and I had written in 1964, went to number one on the charts and stayed there for a month.

I had originally cut the song with Richard Chamberlain, the actor who was playing Dr. Kildare on television and had also come up with a couple of songs that were hits. Nobody ever heard the record and nobody should have, because it was terrible. It was a terrible arrangement, which I wrote, and terribly produced, and I was the producer, and Chamberlain wasn't a great singer. It was probably the worst record I ever did in my entire life, and had it not been for Herb Alpert and Jerry Moss, no one would have ever heard "Close to You" again.

Herb Alpert: I was thinking of doing "Close to You" as a follow-up to "This Guy's in Love with You." I recorded it, and as I was lis-

tening to a playback in the studio, my engineer friend Larry Levine looked at me and said, "Man, you sound terrible singing this song." I lost confidence in it and put the song away in my drawer. Then, in 1970, I gave it to Richard Carpenter.

The Carpenters recorded the song, and the first time I heard it, I wasn't crazy about it, because Karen was playing drums and it was very light. I think they recorded it three times and the third time was the charm because they brought in the Wrecking Crew, with Hal Blaine on drums. Prior to that, the Carpenters had an album out that didn't sell for a year. It was just kind of lying there but that song was the door opener for them.

Richard Carpenter: "Close to You" is one of the few exceptions where I believe Burt wasn't exactly on his game as far as the arrangement being up to the potential of the song. Burt said, "I want you to do your own arrangement of this with the exception of one thing. At the end of the first bridge, there are two five-note groupings." He thought that had a particular hook to it and he said, "If you just keep that in mind, you can do whatever else you want with it." Which I did. I took it into the sound stage and came up with a slow shuffle and then we added the vibraphone and then Karen by herself. It was classic Bacharach.

Richard Carpenter didn't change any of the notes but he got a completely different feeling out of the band and rhythm section with the shuffle. When Jerry Moss first played me the record over the phone, I thought, "Man, this is just great! I completely blew it with Richard Chamberlain but now someone else has come along and made a record so much better than mine."

I still really wasn't thinking seriously about going out on the road as a performer, but I did some shows at the Westbury Music Fair in New York that sold out. At one of them, I got to introduce

my mother from the stage. Then I played Las Vegas for the first time.

Angie was pretty friendly with Sidney Korshak and his wife, Bea, and every once in a while, they would come over to have dinner with us. Sidney was a powerful guy who knew everybody in Hollywood and was also connected in Vegas. One night while the four of us were eating Kentucky Fried Chicken, Sidney said to me, "Listen, I want you to go in and play a week at the Versailles Room at the Riviera Hotel. I'll give you thirty-five thousand dollars for the week." I thought that was a lot of money, so I said yes, but when I told my agent about it, he said, "Oh, why didn't you tell me? I could have gotten you a lot more."

I flew to Vegas and got into a limo, and as I was coming up the Strip, I saw the marquee outside the Riviera. In huge letters, it said, "Burt Bacharach in Concert." At the very bottom in really small letters, it said, "In the Casbah Lounge Nightly, Vic Damone." Every night while he was onstage, Vic would mention my name and say, "I discovered this kid. I know talent when I see it." After I went in and did the week, I started working pretty regularly at the Riviera and also doing shows with Dionne at Caesar's Palace.

It wasn't really in my genes to drink but I always liked drinking Jack Daniel's when I worked in Vegas, maybe because it gave me a little self-confidence before I went onstage. Those were the days when you did two shows a night, so I would have two Jack Daniel's before I went onstage at eight-fifteen and then two more before I went on at midnight. I couldn't ever go to bed right after the second show, so I would go hang out somewhere. It got to the point where I began playing games with myself that I had to be in bed twice a week before 5 a.m. Most nights, I broke that rule.

In those days, I thought I could do it all, and I had a regular routine. I would do two shows a night and drink and then get up and play tennis every day. I really loved the game and was pretty good

at it. I would play doubles with Pancho Segura and Bobby Riggs, who would never play unless there was money down. To balance out the match, Bobby would come up with crazy stuff like him not being able to use the left alley on our side of the court. We would be playing really intense tennis in the blazing hot sun and people would come out to watch us.

In Vegas, I would always work with the house band, but some of those guys were really tough and would eat you alive if you let them. About the third or fourth time I played the MGM Grand, I gathered the horn section around my piano during rehearsal so I could show the lead trumpeter how I wanted the phrasing to sound on a certain passage. First trumpet players in house bands are notorious because they rule all the other musicians. When the passage still didn't sound right, I made them go over it again and again. Eventually, the lead trumpet player got really pissed off at me because he thought I was doing this just to embarrass him and the horns.

When we played the show that night, he paid me back by playing all the notes marked soft very loudly, and vice versa. He also proceeded to blow the ending of every song by playing an extra note after we had hit the final chord. I got really livid at his total lack of respect. I wanted to take him in front of the union and get his ass fired but then I decided against it.

I also met Frank Sinatra for the first time in Vegas. Angie and I went to his show one night and Frank introduced me from the stage by saying, "There's a man in the audience who's a good composer. He writes in hat sizes. Seven and three-fourths." It was a very hip line and I don't know how many other people got the joke, but I thought it was funny.

While I was in rehearsals for *Promises, Promises* in New York, I had gotten a call from one of Frank's underlings. It was kind of like dealing with the Mafia because this guy said to me, "Are you going to be at this number tomorrow? I can't tell you what time. It could

be late afternoon or early evening." I said I would and the next day I got a call from Frank's pal Jilly Rizzo, who said, "Where are you going to be tonight at eight or eight-fifteen?" I told him where he could reach me and then at six-thirty I got a follow-up call that Frank was going to call me.

The call came in and Sinatra said, "This is Frank. I'd like to make an album with you. You write all the songs and all the arrangements, pick the studio, tell me where and when, and I'll be there." I said, "Gee, this is great, I'd love to." Frank said, "Okay, when can we do it?" I said, "Right now I'm in rehearsal with *Promises, Promises* and then we're going on the road with the show—" I didn't even get to finish the sentence before Frank said, "Forget it, man. Just forget it."

It would have been difficult for us to work together, because sometimes I write complicated songs and Frank would have had to know them and be willing to do more than one or two takes. Still, I was very flattered he wanted to do it because I would have really loved to record Sinatra.

What with all the awards and hit songs and sold-out shows, I had been having a terrific year. The icing on the cake came when *Newsweek* magazine put my picture on the cover and ran a long profile about me called "The Music Man 1970." The guy who wrote the piece basically lived with me for almost three weeks, first in New York, where I was playing the Westbury Music Fair, then in California, and then back in New York again. It was a lot like going through analysis because he asked me question after question. I thought we were done but then the guy said he still needed to talk to me for three or four more days, and he would come to see me in my apartment in New York at five o'clock every afternoon.

I was in the elevator one day with an actress who lived down the hall. She asked me what I was doing so I told her about the guy from *Newsweek* and what a drag it was to have to talk to him for two

hours every day. I said good-bye to her and the guy arrived and we were talking and he had his tape machine on. After about forty-five minutes, the doorbell rang and the actress from down the hall was standing there totally naked, holding an empty coffee cup. She walked in and said, "I've come to get some sugar." Then she put her lower body right up against the guy, went into the kitchen, got the sugar, and left.

I was married to Angie at the time and I knew I was screwed. What he had just seen was going to make his story a lot more interesting to read. I told him, "You have to believe me. Nothing ever went on between us," and he kept saying, "Yeah, yeah, yeah." After a couple of days of me pleading my case to him, the guy finally said, "I'll tell you what. Just give me her number and I'll let it go." So I did and the story never appeared in print.

The piece itself covered my entire career and went into great detail about how I was now making so much money that I'd had to hire a business manager to look after it all for me. I already owned some racehorses but the business manager bought me two restaurants on Long Island, a car-washing service in New Jersey, five hundred head of cattle, and a lot of real estate in Georgia.

From the outside, it must have looked as though everything I touched turned to gold. I had a beautiful, famous wife, I loved my daughter, I had a lot of money, and my career was going great guns. The truth turned out to be a lot closer to something I said right near the end of the *Newsweek* article. "Happiness is a question of percentages. You're lucky to get a 50–50 split."

Chapter
15

Lost Horizon

Angie and I had bought a beach house down in Del Mar, not far from San Diego, so I could be near the racetrack there during the racing season. That was where I was spending most of my time when the producer Ross Hunter told me he was going to remake *Lost Horizon*, a film Frank Capra had done in 1937. Hunter had a script by Larry Kramer, who had been nominated for an Academy Award for writing *Women in Love*, and a $12 million budget. Because Hunter was going to remake *Lost Horizon* as a musical, he asked Hal and me if we would come up with the songs for it and we said yes.

Just like the original, the remake was the story of a group of travelers whose plane crash-lands in a paradise known as Shangri-La, where no one ever gets old. It took Hal and me a long time to write the songs and then Ross Hunter decided to invite the press to a sound stage at Columbia Pictures so I could present the songs to them. He asked me to sit at the piano and sing. It was ludicrous because my voice is quite limited and I should have known I couldn't sing all those songs, but somehow I managed to get through it.

I had to answer questions from the press, and when I was asked about the movie by a reporter from the *New York Times*, I said, "The idea of the picture is very close to me. Imagine. Somewhere in Tibet

in the middle of those mountains is a place called Shangri-La. Where you can live forever—almost. And you can stay healthy! And there is love! And peace! It's exactly what everybody wants today."

As it turned out, *Lost Horizon* was a movie nobody wanted. Nobody wanted to see it or listen to the songs Hal and I had written for it, and the experience of working on that picture was so bad that it nearly ended my career. To begin with, the movie should never have been remade as a musical. The idea was absurd. Unlike what we had done with *Promises, Promises*, Hal and I couldn't take what we had written to Boston or Washington to find out which songs worked and which didn't. If a song didn't work in a film, it would cost millions of dollars to rewrite and reshoot the scene.

I saw some of the rushes, and even though they were shooting the picture on the back lot at Warner Bros., some of it looked really beautiful. They used dummy singers while they were filming so I had to coach the actors when it came time for them to do their vocals. Sally Kellerman, Bobby Van, and George Kennedy could sing but we had to use other people's voices for Peter Finch, Liv Ullmann, and Olivia Hussey.

Not only was I writing the songs for *Lost Horizon*, I was also doing the background score, which was nonstop music. I just couldn't write it all and I was hating the work so I farmed some of it out. I had two top orchestrators come in and they also did some composing. It was the only time in my life I ever farmed out my music.

Although I still think a lot of the music I did for *Lost Horizon* was good, there was one scene in the picture where Peter Finch, who played the leader of the travelers, has to make a big decision. He misses his life in London but if he stays in Shangri-La, he can be with the woman he loves forever, so he sings "If I Could Go Back." The song had a lot of heart and I thought it was very powerful.

When I saw the song in the rushes, I thought it was good. But after I watched a rough cut of the entire film for the first time, I

knew it was a disaster. It didn't matter that Peter Finch was singing, "How do I know this is part of my real life? / If there's no pain can I be sure I feel life? / And would I go back if I knew how to go back?" Because when you saw it in the movie, you didn't give a fuck if he went back or not. What came before and after the song was so bad that you just didn't care.

I knew *Lost Horizon* was a dog and that the songs in it were not going to fly, but I had signed a contract, so I had to keep working on it. But I started getting into jams. I was in the dubbing room trying to give credibility to this music but it wasn't sounding the way we had recorded it and I would be bitching while they were dubbing.

When we were in postproduction I went to Peter Guber, who had taken over as the head of Columbia Pictures, and I said, "Listen, I hate the way the music is sounding. It really sounded so much better when we recorded it." I enlisted his help because we were sort of friendly and he said, "Okay, listen, go back in the dubbing room."

He got me back in the dubbing room, and I don't know how long that lasted because I was really focused and going for what I wanted 100 percent. I must have been a real pain in the ass because during the last week of postproduction, the head of mixing at Todd-AO had me banned from the dubbing room because I kept saying, "This sounds like shit," and fighting for what I wanted to hear. It was a lot like when I wasn't allowed into the studio while Brook Benton was cutting "A House Is Not a Home." But all I was trying to do was protect the integrity of the music.

I spent nearly two years working on *Lost Horizon*, killing myself coaching George Kennedy and Sally Kellerman on how to sing, and working with the kids who were in the picture. The best thing that happened to me in the entire process was when I got to drive Liv Ullmann back to the Beverly Hills Hotel from the set one day.

While I was doing all this, Hal was in Mexico playing tennis

because his work was done. My work was far from done and our deal was that Hal and I would split five points on the movie for our songs. So I called him up in Mexico and said, "Hal, listen, I know we're getting five points but we're never going to see anything from this picture. From what I hear, it may even bankrupt Columbia. Still, it would really make me feel better if instead of splitting the five points, I had three and you had two." Hal said, "I can't do that." And I said, "Fuck you and fuck the picture."

Gary Smith: We decided to do a television special with Burt in conjunction with the opening of *Lost Horizon* and I convinced Ross Hunter to let us shoot on the set. Chris Evert had just turned eighteen and Burt was a big tennis player so I booked her and built a big tennis court on the back lot at Warner Bros., where we did this wonderful spot with the two of them. Chrissie was adorable and they played tennis with one another for about three or four minutes.

I had been doing television specials with Dwight Hemion and Gary Smith in England, but now they wanted us to do one that would be a tie-in to *Lost Horizon*. In one segment I was going to play tennis with Chrissie Evert. I thought it would be a good idea to get to know her so I went over to the Beverly Hills Hotel to meet her. She said, "You want to play a set or two?" We got on the court and I thought I was a pretty good tennis player but I never got a single point off her. You would have thought maybe she'd miss a shot and give me a point but it was six–love, six–love.

When we were shooting the scene, we were supposed to play this match in what was sort of like a dream sequence. The idea was she would hit the ball into the net and say, "That's it. You win, Burt!" and I would jump over the net. The next day they would have another set built with a tennis net and I would jump over it into a pond and then they would cut the two bits of film together for the show.

We were out there and they were having a little technical difficulty. Dwight Hemion was saying, "Come on, Burtie, we gotta get this in—we're running out of daylight." Chrissie said to me, "Get them to lower the net, Burt. It's too high for you to jump over it." I told them this and Dwight said, "Burt, don't be a pain in the ass. Come on, we're running out of light. Just hit the ball to her, she'll hit the ball into the net, and then you jump over it." I jumped and caught my foot in the net, and came down on my side and broke two ribs. That night I had to prerecord the music for the next scene so I went in the studio with a bottle of Jack Daniel's and two broken ribs. It was agony to cough or laugh or sneeze and I just hated every fucking human being in the world.

Gary Smith: Ross Hunter found out what we had done and decided we had ruined his set by putting a tennis court on it and he went to court to get an injunction to keep our show off the air while we were editing it. We actually had to reshoot the concert segment in a jungle somewhere. When we finally did go to court, the judge threw out the injunction so the show aired on ABC the way we had shot it. It was called *Burt Bacharach in Shangri-La*. The movie itself was terrible.

Two months later, I went to the premiere of *Lost Horizon* in Westwood with Angie. I had already seen the review in the *Los Angeles Times* and the movie had gotten killed. After that, it seemed like every critic in America just started piling on. Roger Ebert wrote, "I don't know how much Ross Hunter paid Burt Bacharach and Hal David to write the music for *Lost Horizon*, but whatever it was, it was too much." *Newsweek* said, "The songs are so pitifully pedestrian it's doubtful that they'd sound good even if the actors could sing, which they can't."

Columbia had made *Lost Horizon* their number-one release for

1973 and the studio had put so much money into promoting it that people in Hollywood started calling the picture *Lost Investment*. The day after it opened, I got in the car and drove down to Del Mar to escape because I thought nobody down there would know me. The movie was so personally embarrassing that it almost destroyed me. Once I got to Del Mar, I didn't want to do anything. I didn't want to play piano, and even though Hal and I had signed a contract to write and produce an album for Dionne at Warner Bros. Records, her new label, I didn't want to write with Hal anymore or even be around him.

My attorney in New York kept telling me I was going to be in major trouble because I had a commitment to Warner Bros. Records but I said, "I don't give a shit." When Dionne flew up to Lake Tahoe, where I was doing a show at Harrah's, to tell me the record company was going to sue us if Hal and I did not honor our commitment, I told her there was no way Hal and I would be getting together to do anything anymore.

What happened next was that Dionne sued me and Hal, and then I sued Hal, and I didn't talk to either of them for the next ten years. It was really stupid, foolish behavior on my part and I take all the blame for it. If it happened now I would cop to it and say, "Hey, it was all my fault." But that wasn't the way I saw it then.

Angie Dickinson: Burt started working on *Lost Horizon* in 1971 or 1972 and it became the greatest failure in his career. The fact that not all of the songs he had written with Hal had become hits came with the territory, so you can't call them failures. All songwriters go through that. This was a monumental failure. It was a public humiliation and Burt retreated to Del Mar and Palm Springs. He was not impossible to deal with. He was just depressed and that affected everything in his life, including our marriage.

During all the time Burt and Hal had been working together,

Burt had been getting almost all the accolades. Hal chose not to give Burt the half point because of his ego, but since Hal had been ignored for years, that was understandable. When they had only been known as songwriters, Hal got almost equal credit. But now it had gone past that.

As we get older we're supposed to learn and grow, but that only happens if you do some work on yourself. Otherwise, the flaws just get worse. Not long ago, a very wise man I know asked me about the split with Hal and what had caused it. I said, "It would have made me feel better to get the extra half point because I had to be working with George Kennedy and Sally Kellerman and all these kid singers and that was what split us up."

He said, "You know, it's about your ego." I said, "Yeah, maybe. I know I was wrong and I should have never done it because I was told I was going to get my ass sued but I did it anyway." I've owned it since then because it was all my fault, and I can't imagine how many great songs I could have written with Hal in the years we were apart. So I now know that on every level, it was a very bad mistake.

This guy looked at me and said, "You should have called Hal up in Mexico and said, 'I'm giving you five points. You can have them all.'" Instead, I broke up a partnership that had lasted for seventeen years and tried to forget about everything by playing tennis every day with Pancho Segura and hanging out on the beach in Del Mar.

At the time, Angie was still a much more public figure than I was. She was out there and I was hiding behind a sand dune. After *Lost Horizon* opened, I got into my car and went down to Del Mar and disappeared. I disappeared from Hal, I disappeared from Dionne, and I disappeared from my marriage.

Chapter
16

Only Love Can Break a Heart

The first time I realized something was wrong with Nikki was when Angie got up to speak at a big charity event where my dad and I were being honored by the March of Dimes as "Men of the Year." It took place at the New York Hilton in November 1969. The guest list read like a Who's Who of celebrities and the program was filled with congratulatory messages from people like Frank Sinatra and Richard Rodgers. That night, Angie was wearing this incredible white dress that left her stomach bare and she looked terrific.

I don't know what set her off, but as Angie started talking about children, she suddenly lost it and began to cry. I thought, "Maybe there's something going on with Nikki I don't know about." Nikki was three years old at the time, and until then, I thought my beautiful little blond daughter was doing fine.

Angie Dickinson: I was speaking about my daughter and I broke down because I had been concerned from the moment Nikki was born that she had some really heavy problems. I had also seen this movie on the plane coming into New York and it had just absolutely wiped me out so when I got up to speak and mentioned my daughter, it all just overtook me. I'm sure I'd had a few vodkas, which

didn't help, but the sadness and injustice of it all just hit me like a ton of bricks.

Before she was a year old, Nikki started having difficulties with her eyes. She had strabismus, where the eye turns inward, and for the rest of her life she could only use one eye at a time. Nikki didn't start speaking until she was three years old, but then Einstein didn't, either, and the doctor used to say, "If she wants the ball, the reason she's not talking is because you're giving her the ball before she asks for it." I think that was half true but she was obviously storing a lot of information, because one of her first words was "meditate." That was the word I would use whenever I'd see her sitting in her infant seat on the bench looking out at the trees and the sky, so she probably got it from me.

That night at the March of Dimes charity event, I felt my child was in jeopardy and I might lose her. I'm amazed I could even talk at all. Someone else might have acknowledged the emotional burden I had to bear and asked everyone to give me a hand for all the love and devotion I had given our cherished baby, but I think Burt and his father were simply embarrassed by my breakdown.

When Nikki was a young child, I couldn't really tell if there was something wrong with her even though I definitely felt something about her was off. She had to wear a patch over one eye and then switch it to strengthen the other one, and then she had surgery at UCLA to help correct the problem. By the time Nikki was four years old, her behavior was so strange at times that neither Angie or I could really understand it.

Angie Dickinson: When Nikki was four years old, she could play the piano like a prodigy and made up songs with fast rhythms and notes that went together. Burt's father heard her play once and said, "I know this sounds silly but I haven't heard any wrong notes." She

was that amazing. One of her songs was "I Can't Cope with My Purple." As a child, Nikki excelled at gymnastics, horseback, ballet, scuba diving, and swimming.

We had this little gym at our house, and the few friends Nikki had would be invited over to watch her do gymnastics. She would take forever to do it, and you couldn't leave or go pee because you had been captured. I was playing a lot of concerts, so I would go out on the road, and when I'd come back, Nikki didn't want me sleeping with Angie because that was what she had been doing. She didn't really want me around the house because it took away from her time with her mother. Angie made herself very available to Nikki but she didn't know what was wrong with her. Neither of us did.

Angie Dickinson: Early on, Nikki started cutting the hair off her dolls and the manes of her toy horses. When she was around four years old, Nikki began saving everything—broken toys, pieces of glass, old batteries, and dog poo—in a mound about a foot and a half high on top of a dresser in her closet. She also started coming up with names for herself like "Yellow Collar" or "Instead Blender," and you had to call her by those names.

When Nikki was five, she decided she was Lorne Greene. Nikki never watched *Bonanza* that I knew of but she was Lorne Greene for months. When she had exploratory surgery on her eyes, she wouldn't let them put on the wristband unless it said "Lorne Greene." So they made two bands for her. One day we went to the doctor's office, and who should be at the end of the hall but Lorne Greene, and so I introduced him to Nikki. I don't know what I said Nikki's name was, but after that, Lorne Greene was over for her.

By the time Nikki was eight years old, her relationship with Angie was so symbiotic that it was driving me crazy. Nikki would sit at

the dinner table and Angie would feed her. Nikki should have been feeding herself and I knew all this aiding and abetting was no good for either of them, so I said, "Just let it go, Angie. Don't feed her. When she's hungry, she'll eat." But that didn't work.

At this point, Nikki was really out of control. She would take the pet mice Angie would buy her, throw them against the wall, and kill them. Then Angie would go out and buy her some more.

Angie Dickinson: The Catholic Church says you reach the age of reason at seven, so I decided not to work too much until Nikki was that old. I took the lead in *Police Woman* in 1974 because it was a television series that would keep me at home so I could be a mother and act and not have to leave L.A.

We enrolled Nikki in an experimental elementary school at UCLA for kids of all races and backgrounds, some of whom were disabled. Nikki didn't consider herself an oddball but she knew people stared at her because of the way her eyes looked. She still managed to make friends with the kids who were more understanding and nicer to be with. She would sometimes talk obsessively and tear pages out of books or kick a wall in sheer frustration. I didn't understand why she couldn't deal with certain things, so I couldn't help her tolerate them or change them. I just found her excessive.

Burt was much more into pushing Nikki to be on her own than I was. He'd tell me, "Let somebody else do that for her." I remember him coming back from Barbra Streisand's house one night and he said, "Oh, she's so great. She drives her child to school every day." And I said, "I drive my daughter to school and you criticize me and you come home and praise Barbra Streisand because she drives her kid to school?" I really laughed at that one.

For Burt and me, dinners had always been about candlelight and conversation. For Nikki, dinner was a time to talk endlessly

about horses and gymnastics and imaginary friends. She had needs that had to be met constantly and in these kinds of situations the father usually can't understand why the mother just can't make everything right. Most fathers blame the mother. They lose the love and the interest and then they're gone.

I don't think we were very happy by the time we were living in Del Mar. It didn't last very long, to tell you the truth. The marriage was already in trouble before Nikki was born. Very much so. I didn't feel Burt really wanted to be there. I was working on a TV movie while I was pregnant but I was fine. Since she weighed less than two pounds, I barely showed but I was working late hours. Something unimportant happened and I said, "Well, you don't love me anymore," or some stupid thing like that and Burt said, "You have to understand. It'll never be like it used to be."

For me, that said it all. In my stupid young ingénue mind, that was the most crushing blow and I fell apart for a little while. That's how I know it wasn't the birth of Nikki that made it all more difficult.

It's hard even now for me to explain how stifling it was to live like that, because at this point, Nikki was really quite nuts. As she got older, there was definitely a kind of deterioration, because if a child was born as prematurely as she was back then, there was no way she was going to come out with a full deck.

Angie was a smart woman, but when it came to Nikki, she was lost. One night when we were in Del Mar, I took Angie out onto the beach and told her I had a list of about twenty-six things that would have to change because I couldn't live like this anymore. Angie just listened. It was almost like she knew I was right. She was so tied to Nikki and Nikki was so tied to her that I wound up leaving. I moved down to Del Mar and Angie stayed with Nikki in the big house off Coldwater Canyon Drive.

Angie Dickinson: I don't remember Burt giving me an actual written list of things that had to change in the marriage. If he had, you'd think I would have saved it. I would have stuck pins in it and held it up to say, "See what a prick I married?" The definition of a narcissist isn't that you look in the mirror and think you're great-looking. It's someone who thinks they always have to do the right thing, and cannot be held responsible for anything that did not go the way they hoped or planned or thought it should. And that is who Burt is.

Even after we were separated, Angie and Nikki would come down to Del Mar so we could spend Christmas and New Year's together. I would always think, "This time will be different," but it never was. On Christmas morning there would be forty gifts for Nikki, and because she didn't want to tear the wrapping paper—she wanted to save it all for the next year—it would take her hours to open all her presents. It was sheer torture to sit there and watch her do it.

When Angie got the *Police Woman* television show she became a much bigger star than she had ever been before. Whenever we would go to the racetrack together, no one would ask for my autograph anymore. Instead, they would ask Angie for hers. That made me smile because Angie was a great lady and a terrific actress, and I knew she deserved that kind of attention and fame and success.

Right around this time, the two of us were asked to do a television commercial for Martini & Rossi vermouth. In it, Angie walks through this living room in Malibu to where I'm sitting at the piano. Looking great, she leans over and asks me what I say to the glass of Martini & Rossi on the rocks she's holding in her hand. Then I start singing and playing the advertising slogan, which was "Say yes to Martini & Rossi."

The commercial turned out to be such a hit that the company

decided to renew it. But they wanted an assurance that Angie and I would still be together for another year, so I said we would. Angie and I were not yet separated but we were having trouble. I didn't stay with Angie just to keep the commercial on the air, but by then, I'd already had a couple of affairs.

My relationship with Slim Brandy had begun before I ever knew Angie, but there were also a few others. For a while, I was pretty crazy about a stunning violinist who was on the road with me but she was the only one who had an impact. There was another woman in New York, too, but that happened after Nikki was born, when I was having problems with the way Angie was raising her.

Would our marriage have lasted if not for Nikki? I doubt it. There should be a rule that no one is allowed to get married until they are thirty years old and maybe not even then, because what marriage is really all about is communication. And by that I don't mean surface bullshit communication about the kids or the dog. Angie and I had great times together, but after Nikki was born, everything changed because the focus was always on her.

Chapter
17

Best That You Can Do

I was playing tennis every day and taking the game quite seriously. In 1974, Pancho Segura and I were invited to play in the big celebrity tournament that Prince Rainier of Monaco held every year in June on the clay courts at the Sporting Club in Monte Carlo. Bill Cosby and Fred Stolle were the team to beat because no matter where Cosby was working he would always have a pro with him so he could hit every day. The tournament always coincided with the big yearly Red Cross benefit on Saturday night, with guests like the Aga Khan and princes, princesses, barons, and counts from all over Europe.

The star of the show that year was Sammy Davis Jr. Sammy flew into Nice but he got pissed off because nobody from the palace was there to meet him at the airport. He had a whole entourage with him and all these perks, including the use of the royal yacht. Because his feelings were hurt, Sammy said, "Fuck this." Then he got on the yacht with his entire entourage and just sailed away.

I had played tennis that afternoon with Segura. As I came back into the hotel I heard a voice in the lobby. It was Sam Spiegel, the legendary producer who had made *Lawrence of Arabia*. Sam was standing there saying, "Vee got a problem." He told me what Sammy had done and how all these important people were here but

we had no show. He said, "So, go up to your room and just get the operator and ask her to put you through to the princess."

I went up to my room and said, "Can I speak to the princess, please?" Princess Grace came on the phone and said, "We have this problem. Can you help us out? We have no show for tonight, so can you organize one?" I couldn't say no to her so I said, "Well, I can play a little piano and do a couple of songs." Desi Arnaz Jr. was there and I knew he could play the drums. Merv Griffin was there, too, and I figured he could also do something. I said, "We'll get it together, sure. And we've got Bill Cosby, who's brilliant. He'll do his act." She was very grateful.

I played the piano but there were a lot of Germans in the audience and the atmosphere was very stiff. Desi Arnaz Jr. played his drum solo, but nothing was happening. Then Cosby came on. He was our star. The guy who was really going to do it for us. I was falling off my chair, but nobody else was laughing because they couldn't understand him. Even when the Germans did understand what Cosby was saying, they didn't get it. Cosby was hysterical but he bombed, too. When it came time for them to serve us all dinner, I sat with Prince Rainier, Princess Grace, Prince Michael of Greece, Princess Helen of France, Maria Callas, and David Niven and his wife.

My tennis career peaked a couple of years later when I played in the Robert F. Kennedy Pro-Celebrity Tournament at Forest Hills. This was back when they still had the Nationals there. As a kid I would go to that stadium for all the early rounds of the tournament, and I got to see great players like Pancho Segura, Vic Seixas, Pancho Gonzales, Lew Hoad, and Ken Emerson. For this tournament, I was paired with Arthur Ashe, and we made it to the semifinals, where we played against Oleg Cassini and Jaime Fillol, a Chilean pro.

There were thousands of people in the stands watching us and the pressure was horrible. Before the match began I said to Arthur,

"I'll take the backhand side." In doubles, the backhand side is the most vulnerable and important side. His backhand was a lot better than mine but my backhand was better than my forehand so it was the right thing to do. But we still got beat. In a situation like that, you forget who you are. Being a composer was what had gotten me invited there in the first place.

All throughout this period, I wrote songs with different people without having a hit. Then my agent came up with the idea of going out on tour with Anthony Newley. I had first met him back in 1966 when he was in the first flush of his success with *Stop the World—I Want to Get Off*. I had gone to a recording session at Bell Sound, where Jerry Leiber and Mike Stoller were cutting Tony doing "My Clair de Lune" with English lyrics.

Tony Newley was a great guy with a great sense of humor who could be so funny onstage that I'd put him right up against Don Rickles any day of the week. Tony and Leslie Bricusse had written a lot of great musicals together but neither of them played an instrument. What they would do is sing a melody and then Ian Frasier, who was a brilliant conductor and their go-to music guy, would say, "You like this chord better here, or that one?" I don't think Tony could even read music. He was just a self-taught genius who had a very different kind of voice and when you heard it, you knew immediately, "It's Tony Newley."

The two of us started working together. Tony would come out and do about forty minutes with an orchestra and then I would come out and do forty. Tony would come back and sing "Make It Easy on Yourself" and then I would conduct "Who Can I Turn To?" for him. We would end the show with "What the World Needs Now Is Love."

During the summer, we played places like the Westbury Music Fair and Valley Forge in Devon, Pennsylvania. Right before we did "Who Can I Turn To?" near the end of the show, I would give Tony

some straight lines or ask him a question. He would then go off and just be hysterically funny, sometimes for a good twenty minutes.

The third year we were working together, the two of us played the Diplomat Hotel in Hollywood, Florida. It was a Saturday night and the place was packed with about two thousand Jews. Irv and Marge Cowan, who owned the Diplomat and were friends of mine, had off-duty policemen wearing tuxedos lined up on both sides of the stage to do security. Tony came out at the end of the show to sing "Who Can I Turn To?"—or, as he sometimes called it, "Who Can I Turn On?"

Before he started I said, "How's your mother, Grace?" And Tony said, "She's fine. Thanks, Burt." She was living in Florida at the time. Then I said, "Does she still roll those really great joints?" With that, some guy in the audience threw a joint onto the stage.

Tony and I looked at the joint. Then we broke it in half and lit it up onstage. Tony took a couple of hits and I took a couple of hits and then we passed it to the orchestra. I passed my half to the string section and Tony passed his to the saxes and the brass. We were both getting absolutely stoned, not because we had smoked that much, but because we knew we were doing something very crazy.

Then Tony said, "Whoever you are, thank you very much. What else have you got?" And the guy threw some coke up on the stage in a Baggie. Now Tony had himself a dealer. He picked up the coke, set it on the piano, and said, "Hey, you have any Quaaludes?" The audience didn't know what to make of it and all these cops in tuxedos were watching us and it was wild. Then Tony said, "Hey, our next date is at Westbury. Can we count on you to show up?" People started screaming with laughter and Tony and I were falling apart onstage.

After our shows were over, Tony and I would always hang out together. I really enjoyed the guy. I was separated at the time and the only trouble I ever had with him was that when I was with a

woman I really liked, Tony would always want her, too. He would never get her but there was always this game going on between us and we had fun. The two of us were going to do a musical about Charlie Chaplin but we barely got started before Tony got sick. He died of renal cancer in 1999 at the age of sixty-seven. It was a big, big loss.

Tony and I did write a piece together called "The Dancing Fool," which I recorded live with the Houston Symphony Orchestra as part of an album called *Woman*, released on A&M in 1979. I cowrote a couple of the other tracks with Libby Titus and Carly Simon, who both sang on the album. We recorded it live onstage at Jones Hall in Houston during a single four-hour session. For two months after I cut that record, I had the same dream every night that I wasn't going to get the music done and time was running out. I would wake up in a state of utter panic. The album itself turned out to be a very expensive failure.

Paul Anka and I then did the soundtrack for a movie called *Together Again*, starring Jacqueline Bisset, which no one ever saw. I was going through a very cold period in my career and it had been so long since I'd had a hit that radio stations pigeonholed me as part of the easy-listening school of music. Since nothing I was writing was getting any airplay, I decided to spend most of my time performing.

Angie and I were still married but I was living by myself in an apartment in the Comstock on Wilshire Boulevard when Mike Douglas asked me to cohost his show for a week in Los Angeles. One of the guests was Carole Bayer Sager. She looked great and sang great and after the show was over, I asked her out for dinner.

Angie Dickinson: I was on *The Mike Douglas Show* when Carole performed. I came on toward the end as a surprise guest. Someone was talking about divorce, and Burt looked at me and said, "Maybe

I should ask you for a divorce now." On the air. It wasn't so much that he mentioned divorce because by now our marriage was long over, but I was so humiliated that I just laughed and said, "See what I mean? What a sense of humor!"

Carole Bayer Sager: I had actually met Burt some months before, at a party in honor of his new album. At the time Burt's writing career was cold and he was trying to make a comeback. I went to the party with Marvin Hamlisch and Burt was kind of holding court in the back of the room with a glass of wine. A lot of stories about, "Oh, when Dionne sang this," or "When I used to . . ."

We said hello, and then he called me afterward and said, "I have a couple of songs and I need a really good lyricist. Will you listen to them and possibly put lyrics to them?" Then I got this tape from him. To be very honest, I listened to the tape once and I thought it was not in the world of what I was writing, so I didn't do anything with it and I never thought about it again.

The next time I saw Burt he was cohosting *The Mike Douglas Show* and I was a guest. I sang a song and Burt told me he thought I was very talented. He asked me out to dinner and suggested we should sit down and write a song together. Years later I'd tell people, "If I could ever remember which question he asked me first, I think I could figure out the nature of our relationship."

Carole was very sharp. I thought she was really cute and brilliant and gifted and I was really taken with her. I knew she had been with Marvin Hamlisch because the two of them had just done the score for *They're Playing Our Song*, a hit show on Broadway that Neil Simon had written. At the time, I was still half keeping up the pretense that I was married to Angie. I didn't want to embarrass Angie by being seen in public with Carole, so I took her to a restaurant where no one would know us.

Carole Bayer Sager: He took me to a Chinese restaurant on Rodeo Drive up one flight of stairs. I had never been there, and I had never heard of it. When I got into his car I noticed he was driving this big green Lincoln that was not at all in style, so I immediately assumed, "Oh, his car must be in the shop and this must be a loaner." I found out later it was a car that had actually been given to him and Angie after they had done a commercial together. So this was the beginning of my inventing who I thought Burt Bacharach really was.

I remember the first time I ever saw where he was living. We stopped at his apartment so he could pick up some sheet music. It was a one-bedroom apartment in the Comstock on Wilshire that was practically empty, except for a bed, a chair, one little sofa in the living room area, a television, a piano, and sheet music thrown all around. I thought, "Oh, I guess because he's getting divorced his new house isn't ready yet."

From the first time we ever discussed it, I thought Burt was separated and getting a divorce or had just gotten a divorce. I was very surprised to find out well into our spending time together that he would sometimes go back and sleep at his old house off Coldwater Canyon because he wanted to be with Nikki. He was no longer with Angie, but it takes Burt a very long time from when he decides something to when he acts on it, because he processes things very slowly. Just like he writes a song. Very slowly.

I had never really thought about me and Burt romantically. At least not at that point. I just thought he was a great writer who was kind of old and past it and probably wasn't going to have any more hits. Before I dated Burt, I had been with Michael McDonald, riding around on his motorcycle, and then Burt came into my life. Once he did, I started to find him more and more attractive. Suddenly I saw him in a different way. But I had a girlfriend who said to me, "Are you out of your mind? You're going to go out with Burt

Bacharach instead of Michael McDonald? He's the hottest thing going." But what happened, happened.

Carole and I became a couple kind of quickly but I wasn't ready to move in with her. She was so different from Angie, very intense and funny but also serious. She didn't miss a beat and she could talk to anybody. Carole had been in the music business ever since she had graduated from the High School of Music and Art in Manhattan, and she had written songs with people like Neil Sedaka, Peter Allen, and Melissa Manchester. When we first got together, I said to her, "You know, I had a great run as a songwriter but now I think it's gone." And she said, "Where did it go?"

Carole Bayer Sager: Burt and I would go somewhere together and people would say, "Hey, Burt, don't you write anymore?" Or, "What are you writing?" Or, "How come we don't hear any songs of yours anymore?" To me, the absurdity of it was that here was this man whose contribution to music was phenomenal. Who if he never wrote another song after "Alfie" and "Do You Know the Way to San Jose" and "What the World Needs Now Is Love" and "A House Is Not a Home" and "Message to Michael" had already done it.

When we started writing together, Carole said she wanted to get me to simplify my music a little bit so it would find its way back on to the radio. Carole had a very alert nose for the business and she knew all kinds of people I had never met. She was very helpful in turning me around, because at the time I was really out in left field and writing music that wasn't accessible anymore.

The first song we wrote together that was recorded was "Where Did the Time Go." The Pointer Sisters cut it with Richard Perry producing. I played piano and conducted the string section. Although the song wasn't a hit, I felt like Carole and I were headed in

the right direction. About a year later we did a concept album about a relationship, called *Sometimes Late at Night*, for Boardwalk Records, a label owned by Carole's good friends Neil and Joyce Bogart.

Carole and I wrote most of the songs together. I produced the album with Brooks Arthur and we had great musicians like Jeff Porcaro, Jim Keltner, Leland Sklar, Lee Ritenour, and David Foster in the studio. The single "Stronger Than Before" went to number thirty on the charts.

There was a duet on the album called "Just Friends," and Michael Jackson came in to sing it with Carole. I had written the arrangement and we had the strings and the rhythm section there when Michael said, "Can you just give me a few minutes so I can try something?" He took Paul Jackson Jr., who played guitar on the date, into the bathroom and came back out with a totally different flow and concept for the song that was five times better than what I had done. When you listen to Carole and Michael singing together on that cut, you wonder, "Which one's Michael and which one is Carole?" Their voices went together that well.

After we made *Sometimes Late at Night* Carole and I went out on the road together. Although the album wasn't really selling all that well, people thought it was because the single from it, "Stronger Than Before," was making some noise on the charts. So when Carole and I played the Roxy on the Sunset Strip in L.A. for five nights, we sold out every show. What with the orchestra and all the background singers, we lost money on the gig but at least we sold out, right? During the show Carole would sing some of her songs and I would do some of mine, and then we would perform the songs from the album together.

While Carole was doing her set during one of the shows at the Roxy, I looked into the house and saw Dionne and some of her friends sitting at a table right down in front. Dionne was just glaring at Carole. I mean, if looks could kill, this was it. Dionne and I still

weren't talking to one another because of the lawsuit but there she was, giving Carole this totally wicked look.

Carole Bayer Sager: *Sometimes Late at Night* seems like it was about our relationship but I didn't know that at the time. It was a concept album about love where every song moved into the next with a sense of continuity. Looking back, I think it foretold certain things I didn't even know I was feeling.

Mike Medavoy was running Orion, the movie studio he had co-founded a couple of years before, and he asked me to do the music for a romantic comedy called *Arthur*, starring Dudley Moore, Liza Minnelli, and John Gielgud that Steve Gordon had written and directed. When I saw the rough cut, I wasn't sure it was going to be a great movie but the picture just kept on getting better as Steve edited it, so I decided to take the job.

There were going to be a couple of songs in the movie and we needed to get the main title written quickly, so we were in a rush. By now Carole and I were living together, so Christopher Cross came over to the house one night to work with us. He'd had a number-one hit with "Sailing" and won four Grammys that year, and he had been very hot for a while but had done nothing since.

I had maybe a fraction of where I thought the song should be going but once we started working together, it all evolved very quickly. Having three people in the room was a great way to write, and by the end of the night, we had basically finished "Arthur's Theme (Best That You Can Do)." I taped what we had done and listened to it the next morning and nudged it a little here and there to make sure it was right and complete.

A couple of days later, I said something to Carole about what a great line "When you get caught between the moon and New York City" was, and she told me it came from a song she had written

with Peter Allen that had never gone anywhere. Because they had written the lyrics together, she didn't know whose line it was. It fit so well in the song that Carole said she would talk to Peter about it. When she called him, Carole said, "Listen, Peter, I used this one line. Are you okay with it?" He said, "No. I want to be a writer on the song." And that's why all four of us are credited on it.

Christopher Cross recorded the song and it sounded like a hit to everybody at Warner Bros., so the label decided to release it as a single to coincide with the opening of the movie. The only problem was that Christopher Cross had a clause in his contract that allowed him to hold up the release of the single for radio play until he saw how much money the film had grossed on the opening weekend. Once he knew the film was going to be a hit, he let the record come out, and "Arthur's Theme" went to number one on the charts. Then it was nominated for an Academy Award for Best Original Song. I thought we had a great shot at winning the award because the movie was so huge.

Carole Bayer Sager: Burt and I had been living together for a while and I certainly would have liked to have gotten married. We were nominated for an Academy Award and I don't know how it came to be but Burt said, "I tell you what. If we win the Oscar, we'll definitely get married right away." And I thought, "Fine. Okay. Even more reason to want to win the Oscar." We won the Oscar, and got married very shortly after.

Carole and I won the Oscar on a Monday night. We were both really riding high so we decided that if we were ever going to get married, this was the time to do it. Neil Bogart, who died of lymphoma a few months later, offered to let us have the ceremony at his house the following weekend. Carole's mother, Anita Bayer, had come out for the Academy Awards and was staying at the Beverly

Hills Hotel. She was a great character, a Jewish Auntie Mame who could be so outrageous and difficult that I sometimes thought it was a miracle Carole could even function in this world.

Even though she approved of me, Anita could also be like a truck or a steamroller running right over you. She was like nobody I had ever known, a really exasperating woman who kept right on smoking cigarettes like crazy even after she learned she had lung cancer. She also had a very caring side, but I decided I did not want her at our wedding, which was not very cool of me. Instead, I told Carole that after the ceremony was over we would go see Anita at the Beverly Hills, have a drink with her in the Polo Lounge, and tell her we had gotten married. It was not a nice thing to do for someone who is basically a nice guy. But it was like, "If I'm marrying you, I don't have to have your mother there, do I?"

Carole Bayer Sager: I had mixed feelings when Burt said my mother couldn't come to the wedding, because I had mixed feelings about my mom at that point, but it was really a horrible thing to do and I didn't even really realize how inappropriate it was at the time.

I don't think Burt had ever dealt with his own feelings about his own mother, because he was very obedient with her to the point of being dutiful. When Burt told his mother for the first time that he loved me and we were thinking about getting married, she said, "But she's Jewish." Which I think says everything.

There were only six people at the wedding—me and Carole; Neil Diamond and his wife, Marcia; and Neil and Joyce Bogart. We all had an ample amount to drink and I smoked some dope. Then this guy who I guess was a judge in Santa Monica said, "Do you, Burt Bacharach, take this woman to be your lawful wedded wife, in sickness and in health, till death do you part?" I said, "I'll try," and Neil Diamond said, "Holy shit!"

Carole Bayer Sager: Burt loves to tell that story. Neil Diamond actually said Burt became his hero when he said that because Neil had never quite heard anything like it in his life.

After the ceremony, we got in the car and went to the Beverly Hills Hotel, where we brought Anita down to the Polo Lounge and told her. From then on, whenever Carole's mother would get on an airplane to come out to Los Angeles, she would say, "Can you move me up to first class? Burt Bacharach is my son-in-law. Here are a couple of his records." And the funny thing was, they would do it for her.

Bert, Angie Dickinson, Burt, and Irma out for a night on the town

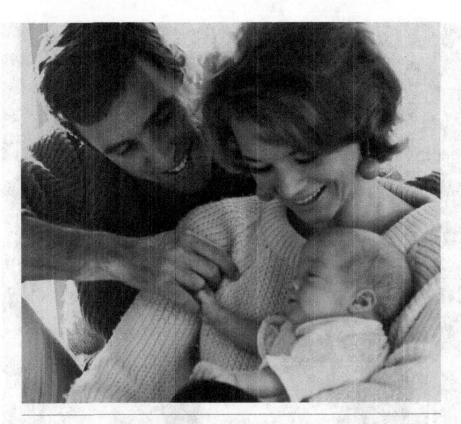

With Angie and Baby Nikki

Burt, Jerry Orbach, Jill O'Hara, Robert Moore, Neil Simon, and David Merrick at rehearsal for *Promises, Promises.*

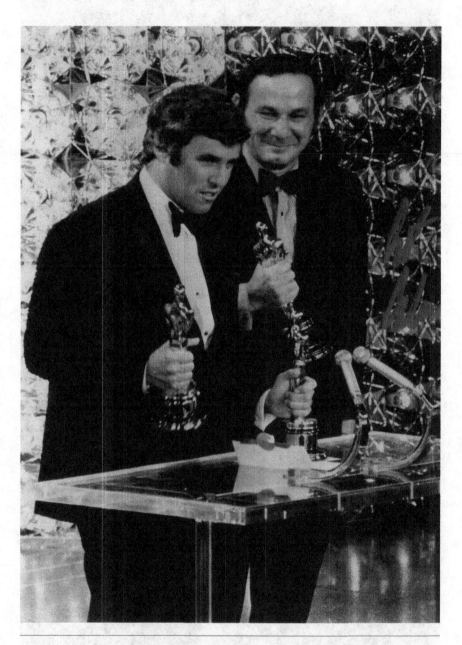

Hal David and Burt, Oscar winners at last, April 7, 1970

(Ron Galella, Getty Images)

With Nikki

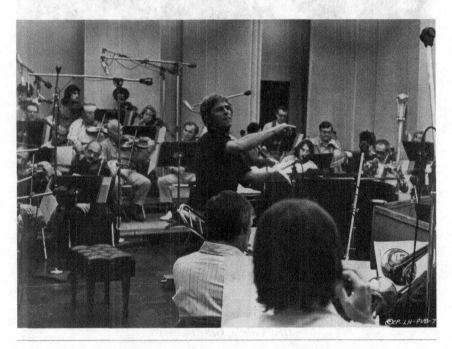

Burt conducting the orchestra during the recording
of the score of *Lost Horizon*, 1973

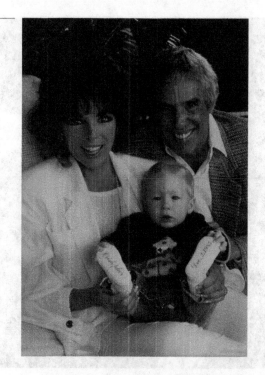

Elton John, Gladys Knight, Carole Bayer Sager,
Burt, Stevie Wonder, and Dionne Warwick at the recording of "That's
What Friends Are For," 1985

Burt and his family at the Library of Congress for presentation of the
Gershwin Music Prize, May 7, 2012

With Mike Myers, Elvis Costello, and Jay Roach
on the set of *Austin Powers: International Man of Mystery*, 1997
(From Mike Myers's personal collection)

Burt receiving the Gershwin Prize from
President Barack Obama
at the White House, May 8, 2012
(Getty Images)

Chapter
18
That's What Friends Are For

Carole and I had been living together in her house on Donhill Drive, off Laurel Way in Beverly Hills, but after we got married, I told her I wanted my own bathroom and a gym, so we moved into the Beverly Hills Hotel while they were adding on to her house. Then we bought a house on Nimes Road in Bel Air. One of our neighbors was Elizabeth Taylor, and that was how Carole's friendship with her began.

Carole Bayer Sager: What I now realize is that nothing changes with Burt when he changes wives. The only thing that changes is the wife, but his routine remains the same. I had no idea how important his routine and working out was for him. It didn't matter when dinner was. What mattered was that he had to work out. There was this very large hill that led up to our house and Burt would run up and down it with a jump rope and jump up the hill and down the hill and then all through the street. After dinner, he would say, "Hey, you want to take a little walk?" I thought, "What a nice idea," and then I realized that walking after dinner every night was part of his routine. I was invited to come along but no matter what I said, he was going anyway.

The first big song Carole and I came up with after we were married was "Heartlight." We wrote it with Neil Diamond, and then we cut it with him and the song went to number five on the charts. After we were quoted as saying the song had been inspired by the movie *E.T.*, Universal Studios came after us and said they wanted part of the publishing for infringing on their copyright. We wound up paying them twenty-five thousand dollars but I didn't think they were right at all.

Carole Bayer Sager: I had gone to an advance screening of *E.T.* and fallen in love with it, and I just couldn't stop thinking about this magical film. I told Burt, "You know, I'd really like to write a song about it," because there was no song in the movie. I kept thinking about "Turn on your heart light." I don't know how I got Neil Diamond involved, but I did it because I still didn't feel secure enough writing alone.

I think Burt wrote the music for the verses and Neil wrote the music for the chorus. It was easy, which was why I loved bringing another person in to write with us, because then we were going on the combined energy and it wouldn't take as long. It was also a way to keep Burt on track with the hit melody. We finished most of it in Burt's apartment in New York on the Fourth of July, and then Neil Diamond chartered a boat to take us around to see the fireworks.

As the song was climbing up the charts and definitely looking like a top-five record, the pressure was on for Neil to record a new album, so Carole and I started writing with him every day out in Los Angeles. Neil and I are both pretty intense guys and very serious about our work. Carole, on the other hand, was very quick when it came to writing lyrics. Most of the time, she was way ahead of us, and would get quite bored watching the two of us ponder over

notes and chords. I got to be as friendly as you could be with Neil but he was a very private person.

After we finished working with Neil on the album, Carole and I went to see him in concert in Hartford, Connecticut. When this guy who was always very serious and didn't smile much walked out on-stage that night and said, "Hello, Hartford!" he suddenly became a completely different person. In the middle of the concert Carol said, "Who *is* this guy?"

When we came back to L.A., Carole and I had dinner with Neil Simon and we told him about having seen Neil Diamond in Hartford and how totally different he was onstage. Neil Simon said, "You should have a party in your house and invite two hundred people. Then ask Neil to come and you'll see that guy again."

Although Carole and I were really doing well at the time and pretty much having one hit after another, I can't say I was ever comfortable writing with her. It's tough enough to be married to somebody without the added strain of having to work with them. The two of you are in a recording studio all day and then you come home. Instead of talking about something personal, you're saying, "No, the drums should be playing the backbeat with a snare and not the cross stick." If two people are making love, you should not have to get out of bed to write down what you're hearing and say, "The G will go to the A-flat, not the A-minor. Be right back, baby."

Carole played a little piano but she wanted to compose. She wanted to have input into my music, and sometimes Carole would be right when she said, "The bridge isn't good enough." But Hal had never done that when we were working together and I didn't like her interfering with where the melody was going. That was my private property. I wasn't giving her words because that was her property. But she wanted to have something to say about the words and the music, and her musical instincts were quite different from mine. Maybe I would never have written a song like "Alfie" with

Carole, because she had a real pop sensibility and always thought a lot more commercially than I did.

Carole Bayer Sager: If we didn't have something, I would always say let's do it next week because I'm bored. Burt can spend and thinks he has to spend hours finding the right chord, trying it this way and that way. Out of sheer self-defense, I would say, "I like it that way." But it didn't matter, because he never really cared what my opinion was. He just needed me in the room as kind of a muse. Eventually I wrote the words to whatever melody he came up with, but then we would fight about that as well.

This was radically different from the way Marvin Hamlisch wrote. He was so quick that he made me seem like Burt. "Boom! That's it. If you think it needs something else, I'm back in town next week." Burt and Marvin were extreme opposites. Nobody I know writes at a pace like Burt, but that's why when you hear his melodies, it's hard to be dismissive because you know how hard he has labored over each one. So we had some stuff we had to work through about that.

In 1984, Aaron Spelling asked Carole and me to write the title song for a television show called *Finder of Lost Loves*. When I played it for him, he loved it and said, "How do you feel about getting Dionne to record it?" I said, "Aaron, I haven't spoken to her for ten years." Actually, I had taken her out to dinner once to try to reason with her and had said, "Listen, Dionne, I want to record you," but Dionne didn't want to hear about that because she still wanted to win the legal battle with Hal and me.

By the time I met with Aaron Spelling, Hal and I had already gotten our masters back from Scepter in return for all the royalties the label had never paid us. To settle the lawsuit with Dionne, we had given her back the songs she had done with us for Scepter and

they had generated a lot of money for her. I still wasn't excited about working with Dionne again but Carole urged me to do it. So I called Dionne up and said, "Hey, it's Burt," and she said, "Burt who?"

Dionne was living in Beverly Hills, so I went over to her house and said, "I've got this song. Are we talking?" She said, "Yeah." So I went to the piano and played it for her and she loved it. We recorded it with Dionne and Glenn Jones. The song wasn't a hit but it got Dionne and me back together.

About a year later, Carole and I were invited by President Ronald Reagan to play at a state dinner at the White House for the Prince of Liechtenstein. When we got there, they asked us how long the show was going to run, because everything had to be rigidly timed. Then we moved into a drawing room that had about forty people in it to do our twenty-nine-minute set.

Everyone had finished dinner and taken their seats when President Reagan introduced us by saying I had won two Academy Awards, and I said, "Three." When I sat down at the piano, I was looking at the Jefferson Memorial and my back was to the audience. I said, "I can't play like this." So they had a couple of guys come in to move the piano, which took some more time and was like a major thing.

Now we were finally ready to start and I played the first chord—but nothing happened. I said, "The piano doesn't work." That caused a stir, of course. Carole knew the inner workings of the piano so she found this piece of wood that had slipped during the move and was locking the keys in place. Carole pulled it out and everything was fine. When we were done playing our set, the fashion designer Bill Blass came up to us and said, "That was very entertaining. Was the piano not working part of the act?" And he was serious.

Carole Bayer Sager: Neither one of us were Reagan fans but the idea of being asked to perform at the White House was very flat-

tering. Liechtenstein was one of the smallest municipalities in the world, so I said, "Well, they're starting us small and they're going to see how we do." We sat next to Henry Kissinger at dinner and while we were performing, Reagan fell asleep.

Carole was intensely social. Early on in our relationship, Elizabeth Taylor and Richard Burton were appearing together in a play in Los Angeles and I knew Elizabeth, though not all that well. Carole asked me if she could meet her and I introduced them to one another at the theater. After we found out Elizabeth was living down the street from us on Nimes Road, she and Carole became really close friends and Carole started wearing her hair like her.

Carole Bayer Sager: I started talking to Elizabeth one day while Burt and I were at the Breeder's Cup at Hollywood Park and I realized we were moving into the street she lived on. Our house was just a couple of doors away and she actually sent us sugar when we moved in. We became kind of friendly, and on my birthday this big gift-wrapped box was delivered to our house. It was a birthday present from Elizabeth, a white mink jacket she had brought back from Christian Dior, Paris. I remember Burt saying, "I don't understand. What am *I* supposed to get you? What does this mean you get her?"

Carole and I went out to dinner one night with Elizabeth and Neil Simon. At one point, Elizabeth got up to go to the bathroom. While she was gone, Carole said to Neil, "What do you think? Do you like her?" Elizabeth had been sitting there wearing these big diamond rings and Neil said, "She's got too many fingers."

Carole Bayer Sager: Elizabeth was looking great that night. She was a little overweight, not at her heaviest, but loving food and not

denying herself much. She was looking at this menu and couldn't decide what to eat. When the waiter came over, Neil said, "Miss Taylor will have the entire left side of the menu."

Carole and I had written "That's What Friends Are For" in 1982 for a movie I was also scoring called *Night Shift*, starring Henry Winkler, Michael Keaton, and Shelley Long, which was directed by Ron Howard. We'd had a really tough time writing the song because Carole didn't like the original bridge, and she was right, so I'd replaced it. Rod Stewart cut the song and it was sort of a hit, but neither Carole nor I really liked the record.

Carole Bayer Sager: Burt and I had a big thing about "That's What Friends Are For," because I started the song with the word "I" and he said, "That's not what I played. I played da-dom." I said, "What's the difference?" And he said, "There is a difference. There is a difference." So what was the difference? It was a little eighth or sixteenth note. I got annoyed but I think that's part of Burt's brilliance. Those sixteenth notes. Most of the people I've written with would have said "Fine," but he was so precise and it was so important to him that he would sit in the music room and spend an hour figuring out whether he did or didn't like the sixteenth note.

Which, I might add, could be rather maddening if you were the lyricist, because by now you were drawing many pictures and writing your name in different forms and colors, but he was right so I finally said, "Fine. Just add 'And.'" And that's why the song starts with "And I thought . . ." I've told him many times since then that whenever I hear the record on the radio, I think, "Not only was he right musically, but just by throwing that word in, he made it a better lyric, because you're beginning in the middle of a conversation rather than starting with a statement."

In 1985, Carole and I played Dionne "That's What Friends Are For" for a new album she was about to record and she liked it. I thought we needed another female voice on the track so we brought in Gladys Knight, and then Dionne got Stevie Wonder to accompany her on chromatic harmonica and sing with her. The way that song was built, we still needed one more voice on it and I wanted a cleanup hitter who could hit a home run. That was Luther Vandross, who I always thought was an unbelievably great singer and very cool.

The day after we put Luther on the record, I called Clive Davis and said, "Clive, I'll send you the record, but it doesn't work with Luther on it and I really feel terrible about this." Clive said, "I'll talk to Luther and tell him." We brought in Elton John to do it and about a month later I called Luther to tell him how sorry I was that it didn't work out. He said, "What didn't work out?" Clive had never told him what we had done. I felt awful about that, because I could tell Luther was really hurt.

Carole Bayer Sager: Elizabeth Taylor loved Stevie Wonder and we were recording him for "That's What Friends Are For," so I asked her if she wanted to come in to the session. While she was in the studio and we were listening to the playback, the idea came to me that because Elizabeth was so committed to the American Foundation for AIDS Research, we should donate the proceeds of this record to them. Although Dionne Warwick has taken credit for it in every interview I've read, the idea came from me. What Dionne actually said was "Do I have to? I just gave for 'We Are the World.'"

"That's What Friends Are For" went to number one on the charts and stayed there for a month, and we raised $3 million for the American Foundation for AIDS Research. It was *Billboard's*

number-one single for 1986 and won a Grammy for Best Pop Performance by a Duo or Group with Vocal. Carole and I also won a Grammy for Song of the Year. After the song took off, Dionne and I went back out on tour together and played all over the world.

One of the strangest experiences I ever had playing overseas happened a couple of years earlier, when I went to the Philippines to do some solo concerts with a pickup orchestra and a couple of key musicians I had brought with me. Imelda Marcos, the wife of the Philippine president, came to one of the shows and sat right down in front. The next night I got a message asking me if I could come to the presidential palace to join her and Ferdinand Marcos. It wasn't like I could turn the invitation down, so I went. It was kind of risky because the regime looked like it was going to explode at any moment and there were tanks with mounted machine guns outside the palace.

Ferdinand and Imelda Marcos were sitting at a table in this disco room they had built downstairs and they asked me if I would play. I couldn't refuse so they moved the piano and I was right in the middle of a group of about thirty people. During one of my songs, the president got up and went to bed. I'd had some wine and somebody had given me a joint to help me get through it, so I was just taking everything in, but it was still really bizarre.

At about four in the morning, Imelda came up to me and started making a speech. "Burt Bacharach, I want to you to know what your music has meant to my country and all my citizens and how much respect we all have for you. . . ." Meanwhile, I could hear the house piano player in the background going from one key to another. When he got down to a G-seventh chord, she leaned right into my face, just inches away, and started singing, "I'll be seeing you / In all the old familiar places," a standard that Sammy Fain and Irving Kahal had written before World War II, and she did the whole fucking song.

She couldn't sing well enough to pull it off and I was breaking up, and I had to keep looking down at my shoes so she wouldn't see me laughing. It was surreal. Then she sang Noël Coward's "I'll See You Again." Not long afterward, the regime was deposed and both Ferdinand and Imelda Marcos had to flee for their lives.

A couple of months after "That's What Friends Are For" went to the top of the charts, Carole and I wrote and produced "On My Own," a number-one hit for Patti LaBelle and Michael McDonald. Michael has one of the great white soul voices of all time and he can also really play great piano. The mix was very hard to get because we were trying to balance the vocal between Patti and Michael and we weren't getting it right. Then Carole rode the faders on the mixing board, and it was perfect.

Professionally, Carole and I were really doing well together but life with her was a little too social for me. When Carole threw Elizabeth Taylor a birthday party, we had 160 people at our house. I said to Carole afterward, "I want to be remembered for the music I wrote, not the parties I gave."

Carole Bayer Sager: We gave Elizabeth her fifty-fifth birthday party and it was her guest list and ours so it was pretty awesome. Burt did say he wanted to be known for the music he wrote and not the parties he gave, but I don't know if he said it at the end of that party because he had the most spectacular time. At the end of the night, he was jamming with Stevie Nicks, Stevie Wonder, and Bob Dylan and he was in heaven.

On August 17, 1987, Carole and I were under extreme pressure to finish a song called "Ever Changing Times" for the movie *Baby Boom*, starring Diane Keaton. I got a phone call from the hospital in New York that my mother had died. It was not unexpected, since

she was eighty-five years old and had been in and out of hospitals for a while and just gradually breaking down.

I was very undecided about what to do. Should I get on a plane to New York right away or should I finish the song with Carole? I had no family in New York other than my aunt. I told myself that if I stopped working to fly back east, all I could really do was talk to some doctor, but I could do that on the phone. So I stayed and finished the song and flew in a few days later. Did I feel good about it? No. Do I feel all right about it now? No.

I didn't have to face this kind of decision when my dad died on September 15, 1983, after suffering from a long illness related to a heart ailment. Carole and I had been in New York and we had gone to see him in the hospital every day. My dad was kind of out of it at the end but I think he was very much at peace with himself because he'd had such a great life. Carole and I were actually making a phone call down at the end of the hall in the hospital when they told us he was gone. As soon as we got the news I called my mother, who had also been expecting this to happen at any time. Then we all took his ashes out on a boat and scattered them in the East River.

The bottom line was that both my father and mother got to witness what I was doing with my life. They came to see me perform at my concerts and they saw me win Academy Awards and they were there on the night *Promises, Promises* opened on Broadway, so I knew they were both really proud of what I had accomplished.

Before she died, my mother had told me she wanted her ashes buried on the grounds of the house on Nimes Road where Carole and I were living. Because things between the two of us weren't going so great at the time, I had to explain to my mother that I didn't know if I would be living there that long. Two days after my mother passed away, I flew back to New York and had my mother's remains sent to Los Angeles, where I put them in a cemetery.

The last time I ever spoke to my mother, I knew she wasn't well, but I didn't want to deal with that. Instead, I thought that if I just kept on going, then she wouldn't die. Someone who knows me very well once said I don't like funerals or weddings. Although I do feel guilty about being this way, I think it's true.

Chapter

19

Anyone Who Had a Heart

I had never been in therapy but Carole had and she understood psychiatry a lot better than me. The two of us had a silent agreement that we would work together to get Nikki the help she needed. When Nikki was fourteen she decided to become a Sikh. Angie would get up with her at four in the morning so Nikki could go to the ashram. My daughter was getting weirder and weirder but I didn't know what to do about it.

While Nikki was in her Sikh period, which lasted for two or three years, I thought maybe she was thinking, "My dad's good-looking and my mother's a beautiful movie star and I can't compete with that so I'll cut off all my hair and I won't bathe or shower and I'll let the hair grow under my arms."

Angie Dickinson: The Sikhs were loving and gentle—which Nikki had to have. Perhaps the uniformity of the dress and the rituals made her feel like one of them, as opposed to an outsider who was always being looked at and stared at. I never asked why. She loved it, and that was all I needed. They gave her the name Sat Kartar, which I later found out means something like "Walker of Truth."

We would get up at 3:30 a.m. and I would drive her down there for *sadhana*, the devotionals before sunrise. I've got one picture of Nikki in her white turban with a rat sitting on it while she's holding another rat. Nikki loved rats. We had thirteen at one time. That's a lot of rat shit.

When I was playing Vegas in the middle of the summer, it would be 110 degrees. We would be by the pool and Nikki would be jumping off the high diving board in a full wet suit. Somebody would say, "Oh, that's your daughter?" and I would feel a little embarrassed. That was tough to deal with, but when I found out Nikki had been smoking dope with one of the workmen who was doing repairs on Angie's house, I finally said, "I've got to get her into a treatment program."

Angie Dickinson: There were a lot of workmen in the house and one of them took a liking to Nikki. Although I was not aware of it, I believe she must have begun smoking marijuana with him. It was 1982 and she was sixteen. Later on I realized that this gave her peace.

The fact that Burt thought I would permit this was a problem. The workman was forty-two or something, but I don't think there was anything sexual going on between them because Nikki didn't care about that. She just wanted to be loved and to have someone put their arm around her. But Burt was not wrong to lay down some laws.

Being a New Yorker, Burt was very pro-psychiatry. In his world, you did that sort of thing—go to psychiatrists. I'm from North Dakota, and there we didn't. We went barefoot. Nikki began getting psychiatric treatment when she was about eight, but the psychiatrists had no answers. There was one I would kill if I could get away with it. He'd tell me that when she'd act out or keep talking or repeating herself, I should just say something like "doorknobs"

or "spaghetti." Something to make her go "Hmmm?" That hardly explained why she could not cope. He didn't get to the heart of what she needed at all.

Carole found out about this place in Brea where they didn't keep kids for long but they did put them in deep therapy. Carole had never had any children, but she was a very bright woman and now her mission was to help Nikki. Together we were going to get Nikki better.

Carole Bayer Sager: Burt looked to me to help him with Nikki. Late at night when he'd had some wine, Burt would say, "What should I do? How can I help Nikki?" Burt would get very sad when he talked about Nikki and he cared very much about her, but he felt he was just hitting a wall because nothing ever got better. I think it was the most heartbreaking part of his life and I also think he was misunderstood by Angie, who felt Burt didn't give Nikki enough time and support and love because she didn't turn out perfectly.

I thought I only had Nikki's best interests at heart, but after it was all said and done I had to question that because I really wasn't helpful to her. What Nikki really needed was as much connection as she could get with people who cared about her. And the acceptance that she was not capable of being anything but who she was.

Some of the things I was angry and sad and frustrated with Angie about, I now realize were just a mother's gut feeling. Burt always felt Angie always knew something about Nikki that he didn't. That maybe she had kept something a doctor had told her from him. But as a mother, she was just totally intuitive with her child and so attached to her.

The point is that Nikki wasn't doing well at all here in L.A. Some people are likable in their neuroses and other people push you away. Nikki pushed people away because she would become so entirely absorbed by one thing. And whatever that thing was,

she would hold you hostage with it. She would go on and on and on for so long after any human being could have any interest in the subject, whether it was Steve Perry's voice or Christopher Cross's version of "Sailing." And worst of all was her obsession with having missed an earthquake that had killed people in Los Angeles.

Angie was against Nikki going into the treatment center at Brea, so I talked to my lawyer and we decided to take out a court order that would allow me to put her there. I was fighting for my daughter's life and I thought, "I have got to get Nikki help, because this is spiraling totally out of control." We were on our way downtown to file the order when I withdrew it.

Angie Dickinson: Burt threatened to take out a court order if I didn't help him put Nikki in the Brea clinic. I knew I couldn't compete with his hatred or his money so I said, "Okay," and I'll never forget it. It was the worst day of my life because I never thought any of this would help her. Brea was Gestapo in the night. A pound on the door and you're going in and they shoved her into a new world.

After Nikki went into the clinic in Brea I'd drive down to see her. She hated the place because she felt like she was in prison. I was expecting a very uptight therapist, but the man who ran the program was like a street guy who worked with kids all the time. Nikki stayed there for about five or six weeks and then she was released. In the meantime I'd been looking for a place outside of L.A. where she could get treatment. I went to see a therapist in Westwood with Nikki, and while I was sitting in the waiting room, I heard the doctor talking on the phone. He was saying, "Yeah, I'm with Burt Bacharach and he's here with his daughter." I thought, "This guy's a real dick."

I talked to some other people and Carole and I did some research

to find the best place for Nikki. Then we met with some people from the Constance Bultman Wilson Center in Faribault, Minnesota. It was a beautiful campus with no gates, and a mansion that looked like it could have been in Brentwood for the adolescent residents.

Angie Dickinson: Burt still thought Nikki was not doing well enough and that it would be good for her to get some distance from me because I was too permissive. And I thought, "Maybe he's right. Perhaps I am too close." And that was the reason I gave in. I kept telling Nikki that all kids go away to school to learn and grow on their own. I guess I convinced her and we flew to the Wilson Center in August 1983. Weeks after she arrived, Nikki called me and said, "It's not a school, Angie. It's a hospital."

Nikki was really unhappy there but Carole and I would go see her twice a year. We would take her out to dinner and talk to the people at the center about how she was doing. After Nikki had been there for several months, her therapist said, "We're having some difficulty treating her. Would it be possible for you and Carole to stop communicating with her for a while?" No calls, nothing. We all agreed to this, and then twenty minutes later Nikki was on the phone with Angie.

Angie Dickinson: The bottom line was that Burt did it to get her away from me. He thought this would help Nikki but it destroyed her. She was there for ten years. I mean, Jesus Christ! Ten years. Ten years! Think about it. With no change because she didn't have the mechanism. Poor soul. That poor darling. She was so heroic and still loved the sonofabitch because Burt can charm everybody.

There was no progress but I kept thinking that maybe there was. When my medical insurance ran out, you would think somebody

there might have told me that Nikki could have been in therapy every day and it still wouldn't have helped her but no one ever did. If somebody had just leveled with me and said, "Hey, we can't do anything about this," I would have taken her out of there in a heartbeat. But they never did. Instead, they just kept right on taking the money.

Carole Bayer Sager: There was something deeply wrong with Nikki, but they would send us these reports and I kept saying to Burt, "I don't see a diagnosis. What is the problem? Any doctor should be able to articulate what is wrong with her. Why are they keeping her there?" And he kept saying he didn't know.

When Nikki was about to turn eighteen, she wrote Carole and me a really loving letter. But then her negative feelings about me began to build and I became her enemy, as did Carole. Nikki thought I had locked her up and imprisoned her and she hated me for having done that to her.

Angie Dickinson: I talked to Nikki on the phone a lot and I would go see her at least four or five times a year. They gave me permission to take her out on trips to places like the Canadian Rockies and the Tetons and the Yucatan. She made some friends at the Wilson Center and had a couple of jobs. When she could no longer see well enough to make out the notes, Nikki gave up the piano and began taking drumming lessons. She was a natural drummer and when Burt played a charity concert in Minneapolis, he let her sit in with the band on "Heartlight."

When Nikki entered the Wilson Center, she had beautiful thick hair that ran down past her shoulders. At home, she had been used to taking showers for as long as twenty-five minutes, obsessively scrubbing and rescrubbing her arms and legs. At the center they

wouldn't let her stay in anywhere near that long, so she ended up not washing her hair much. After a few years of their bitching at her to get it clean, she said, "I'll fix it for you," and she buzzed it off and kept it that way. I'm pretty sure she did that out of spite, but when anyone asked her why, she said, "For convenience."

They were trying to make her into somebody who could hold a job so they forced her to drive, which was insane. She totaled one car and wrecked another one pretty good. By some miracle, she wasn't hurt in either instance. As I later learned, she just couldn't see cars coming from that far away. The psychiatrist there told her, "Nikki, someday your mother is going to die and then you're going to have to be responsible for yourself," and that put her into a spiral she never got out of.

Nikki was sixteen years old in the winter of 1982, when she was released from the Wilson Center. Angie threw a freedom party for her at the house in Trousdale Estates, where she was living. I went and it was very weird, and then Nikki decided she wanted to become a geologist. Angie enrolled her in California Lutheran University in Thousand Oaks and found Nikki an apartment near campus. Her eyesight was so bad she could only take one class a semester, but Nikki also started studying karate and got a green belt.

I'd go up to where Angie lived about every other month and bring her and Nikki lunch and stay a couple of hours because that was about all I could take. As Nikki got older, all of her problems became bigger and more impossible to deal with. Whenever I visited, I could feel the venom she had toward me for imprisoning her. After leaving the house, I would have to pull my car over to the side of the road and just sit there and meditate for about twenty minutes so I could get myself together enough to drive back down the hill.

The way it was with Nikki was that she would bounce from one obsession to the other. For a while it would be "The loud noise. I

can't stand the loud noise. It's driving me crazy. I'm going to kill myself." She would get that one going and then she would start talking about earthquakes and how she wanted to be in L.A. for an earthquake so she could feel the shaking.

Angie Dickinson: Earthquakes were what made Nikki want to study geology in the first place. She loved feeling the power of earthquakes and always wished they would happen more often but without all the devastation. Most people feel they're leaving the ground during an earthquake but for Nikki it was one of the few times she felt grounded.

Nikki loved going to Hawaii and she was there when the big Northridge earthquake hit Southern California in 1994. I called Angie four or five days later and said, "How's Nikki doing?" Angie said, "She's grieving." I said, "Really? Who died?" Angie said, "Nikki's grieving because she missed the earthquake." I thought they were both crazy and I just couldn't deal with it anymore because nothing I had ever tried to do for Nikki had helped her. As far as I could tell, she just kept getting worse.

This Guy's in Love with You

Carole and I wanted to have a child together but we were having difficulties so we decided to adopt a baby. I was little reluctant to do this at first because I wasn't sure how Nikki would react to it, but I also felt it was unfair for Carole and me not to be able to have a child together.

Our son was four days old when we got him, and although the birth mother was not supposed to name the child, she had decided to call him Nicky. Carole and I renamed him Cristopher Elton Bacharach. Elizabeth Taylor was his godmother, and his godfather was Elton John. I wasn't sure I could handle having a child but when Carole brought him into the house, he was just so perfect and seemed to have so much potential that I broke down and started crying.

Carole Bayer Sager: I was just so glad that it was a boy. Because Burt wasn't certain how this was going to work and was doing it more for me, I really wanted him to develop a relationship with Cristopher. I would move out of the way so that every day Burt would take him for a walk through the streets of Bel Air in that baby holder you can wear around your shoulders. They had a wonderful relationship, which was what I had prayed for because I

wanted us to be a family. It was joyous for Burt. All I can say is that Burt wasn't the greatest husband in the world but he was a great father. Until Cristopher was eighteen, there wasn't a single night when, wherever Burt was, he didn't call him to say good night.

I was always astonished by couples like Alan and Marilyn Bergman, who wrote "The Windmills of Your Mind" and "The Way We Were," because they would work together all week in L.A. and then go up to their place in Santa Barbara on the weekend and work there as well and somehow still stay married.

The way it worked with Carole and me was that we would get up in the morning and have breakfast together and sit by the pool and then go to the music room or the studio and work all day long. Then we would have dinner and go to bed. We'd get up the next day and do the same thing all over again. It was not as though we were arguing with one another, but I liked a little more distance in a relationship. I wanted to be not too close with someone but also not too far away, and Carole and I were very close.

We were literally together all the time and I'd always had trouble being with someone who was needy. It was in my DNA that this wouldn't work. Carole was very sensitive and I couldn't be with a woman who was that touchy-feely. Here I was on my third marriage and I was starting to think, "I'm still not ready to be married. I haven't earned it and I don't get it and I don't even know what it is." More than anything else I just wanted to be by myself and have more space.

Carole Bayer Sager: Burt once said to me, "What do you want from me? I'm a selfish guy." I was so enamored of him and I so bought into the look of him and me together. Superficially, it was just perfect. She's pretty, he's great-looking. She writes the words, he writes the music. They write the love songs and look at them.

It was very hard to feel a hundred percent confident with Burt, because he enjoyed adulation. He enjoyed women liking him and he had this reputation of being a sexy, handsome, talented man who could pretty much have an active and interesting sex life at any given time.

When you're with a man who enjoys all that, even though he is committed to you, there is always that feeling, "Is he looking at her like he would like to go out with her? Nah. That couldn't be. Maybe she's flirting with him." It was exhausting. He should have been worried about me but he wasn't like that. I used to feel like this was my *The Way We Were*. He was Robert Redford and I was Barbra Streisand. He was Hubbell.

I used to take photographs of him. I had my camera and he was like fifty-three years old and I said to him, "You are so handsome." He said, "Hey, baby, you should have seen me ten years ago." I thought, "Whoa." But it didn't matter. I just kept taking pictures of him. Even while he was eating breakfast.

All those pictures I took were going into frames and I was deluding myself that this was our life. I was making up my own story. I'd done this with Burt right from the very beginning, when I thought his car was in the shop and he was living in that apartment until he could move into his new house.

When Cristopher was three years old, Carole and I went to spend Christmas with him at the Little Nell Hotel in Aspen, Colorado. They were both sick one day so I went up on the lift by myself. The woman who had been my instructor wasn't there, so they paired me up with someone else. The name on her ski instructor tag was Janie Hanson.

Jane Hanson Bacharach: I met Burt on December 29, 1989. I was an instructor for the Aspen Ski Company and it was my rookie

year. The woman Burt had previously been skiing with was pregnant and couldn't come to work that day because she was suffering from morning sickness. So by default I got plugged into the role of Burt's instructor. I knew who he was but he kept talking about Carole and I didn't know who she was. At the time I thought he was still with Angie Dickinson.

I had already instructed Iman, the Hilton girls when they were little, and the Trump kids, so I'd had a little exposure to celebrities. We were going up on the ski lift for the first time and Burt was telling me to put on sunscreen and to meditate. I thought, "What the fuck?" I understood the sunscreen, but meditate?

I think I got hooked on to Jane really quickly because she wasn't in the business. She didn't sing, she didn't want to write songs, and she didn't want to be an actress. She was a civilian and an athlete and she had this great vitality. She was also really bright and grounded and very sensible. She knew who I was because she had taken piano lessons when she was fourteen years old and played from my songbook, and her mother had seen the original production of *Promises, Promises* on Broadway. So it was a funny kind of circular thing.

Jane Hanson Bacharach: I thought Burt was coming on to me but he was so different from the bartenders I normally hung out with that I wasn't really sure if this was just Hollywood schmooze or if he was really interested. I never did see Carole because Burt was always alone on the slope. When Burt left, he told me he was going to come back to Aspen to ski again, and he did within two or three weeks.

Burt says he got on the ski lift and fell in love with me. I also think at that point in his life he was looking for simplicity. And I was as simple as it got. I was just a hardworking girl trying to pay

a mortgage and the money I owed my ex-husband. I was working my ass off, going from one job to the next. So it took me a while to realize that Burt was indeed married, but to Carole, not Angie.

Initially, I was definitely more into Jane than she was into me. I think she thought I was a little bit weird because I was trying to teach her how to meditate on the chairlift and telling her to use a higher sunscreen because she was fair and had blue eyes. The fact that I was sixty-one at the time and Jane was twenty-nine also caused some problems. Because I thought Rachmaninoff's third and fourth piano concertos were so romantic, I sent them to Jane when I got back to L.A. I thought she would love them, but she didn't. Instead, she asked me if I had any Jimmy Buffett albums.

Carole Bayer Sager: I used to get what I called weather reports from Burt. "Today I feel like I'm fifty-five percent into the marriage and if I could go away for a few weeks . . ." I didn't get it. I thought he was having a late midlife crisis. I never dreamed there was another person. And when he finally told me about Jane, because he had to, he said, "You know, she's very young." I always thought I was very young compared to Burt.

For Burt, our life together was too social. Of course, he never even once said to me that he would rather not go out or that he'd rather not do this or that. So it came as a total surprise to me when he finally blurted out how much he hated these parties we had been attending.

One night we were at a party at Wendy and Leonard Goldberg's house and Burt went to the bathroom and stayed there for over twenty minutes. I didn't know if he had gone home or if he had drowned. When he finally emerged, Burt said, "I thought I was going to go crazy if I had to sit at that table for one more minute." This was before I knew about Jane. I only knew that he was in this

weird mode of behavior where all he wanted to do was go skiing and talk about skiing. "I love skiing." "That's so wonderful, Burt."

When it looked like our marriage wasn't going to make it, we went to couples therapy and the therapist said to us right at the beginning, "The only chance this has of working is if the two of you make a commitment that neither one of you is going to see anyone outside of the marriage while we're working in therapy." Burt had already met Jane so the whole thing was useless. We were also supposed to listen to these tapes. I listened. Burt threw his in the back of the car.

I was writing songs with him that were cries for help but he never really listened to them or ever once said to me, "Gee, is that how you feel?" There is a verse in "Someone Else's Eyes" that goes, "This is my song / And for too long I sang to someone else's melody / It wasn't really me / In someone else's eyes / I saw reflections of the girl I was / It caught me by surprise / Being a woman who's defined by you / I can't love you / I can't love me / Through someone else's eyes." When Aretha Franklin recorded the song, we must have listened to it a million times while we were checking the mix. I thought it was so poignant. Burt would say, "Do you think the bass is high enough?" I don't think he ever really heard the lyrics. All Burt cared about was whether the right-sounding syllables were on his notes.

One of Carole's close friends was Marvin Davis, who owned Twentieth Century Fox, the Pebble Beach Corporation, the Beverly Hills Hotel, and the Aspen Skiing Company. When Carole and I were talking about splitting up, Marvin said to me, "Are you going to stay with her or not?" And I said, "Well, what if I don't, Marvin? Are you going to break my legs?"

What I wound up doing was making a decision to not make a decision. I moved out of the house on Nimes Road and moved into

a house Carole and I had bought on Zumirez Drive in Malibu. I lived there by myself for most of the winter. It was lonely but there was something very gratifying about my being able to say, "I'm just staying put. I'm by myself. I'm not with Carole. And I'm not with Jane." Every day, whether or not I had business in town, I would get in my car and drive in to see Cristopher, who was then five years old.

I tried to write some songs with Paul Williams but that didn't work because he was still coming out of a period of being totally off the ground and wasn't yet sober enough for us to work together. Then Bobby Russell, a Nashville songwriter who'd had big hits with "The Night the Lights Went Out in Georgia," "Little Green Apples," and "Honey," gave me some lyrics that I set to music and we went in and recorded them with Glen Campbell.

Jimmy Bowen was the A&R guy and he and Glen liked one another because they were both country boys. We were running into overtime with a big orchestra so Jimmy got up on a chair and turned the clock in the control room back half an hour so we could get thirty minutes more from the musicians without being charged for it. When he got busted for doing that by the music contractor, it became a big hassle. The songs themselves were okay but none of them ever became hits.

Even though I was in love with Jane, I knew that if we got together I was going to have to move to Aspen or spend a lot more time there. And there was always Cristopher and my wanting to be there for him. This beautiful child who had come into my life after all the years of pain and difficulty trying to help Nikki.

Carole Bayer Sager: When we were splitting up, Marvin Davis went up to Burt and said, "Are you out of your mind? You're crazy if you do this." And Burt said, "Marvin, I'm just a piano player. That's what nobody understands. I'm just a piano player." But I

understood what he was saying. "I'm not this person Carole would like me to be or that you might think I am."

What Marvin didn't get and I tried to forget was that Burt was the person happily living in one little room with a piano in the Wilshire Comstock and driving a green Lincoln. That's who Burt is. Burt's a pretty simple guy. He wants to be at a piano, he wants to write his songs, he wants to perform, he likes going on the road and being in front of an audience, and being the star. He loves that life, just like he loves the racetrack.

And that is why I really think we were not very well suited for each other. We were both artists. We both craved an adult. Someone who would take care of us in ways we wouldn't have to do as artists and I think once that was clear, our relationship was doomed.

I met Jane's mother for the first time when I was playing with Dionne in Atlantic City. Jane introduced me to her mother by saying, "This is Burt. We just had a miscarriage," and I said, "Nice to meet you." Her mother was very sweet and nice, and I remember telling her I had never loved anybody as much as I loved Jane.

At the time, I was still married to Carole. Unlike my divorce from Angie, which had been very simple, this one was tough because Carole was very angry at me. Even though we had signed a prenuptial agreement, it still took us a long time to work out the terms of our divorce and it became a long, drawn-out process that wasn't pleasant.

I wound up losing our house in Bel Air as well as the one in Malibu but I was okay with that. They were just houses. I also lost a substantial amount of money. I took a hit but fine, it was just money. But I was in a cold period in my career at the time so this didn't help.

Jane Hanson Bacharach: We became a couple late in 1990 and started living together at the Westwood Marquis. After five or

six months, we moved down to the Sea Colony, a condominium complex on the beach in Santa Monica. In the summer of 1992, I got pregnant again. That summer, five months pregnant, I returned home to see my parents on our farm in Smithfield, Ohio. We lived right next door to the cemetery.

It was late spring and Jane was five months pregnant. She had gone home to visit her parents so I flew into Pittsburgh and had a white stretch limo drive me to Smithfield. We pulled up to the farm and her father was sitting in a rocking chair on the porch looking quite unhappy.

Jane Hanson Bacharach: It was over a hundred degrees and my father had been up and working since five-thirty in the morning. His day had started off when he found his favorite cow dead down by the spring. As a farmer, you're always worried that whatever that cow had died from might infect the entire herd. So my father had spent the bulk of his morning on his backhoe digging a deep hole where he then buried his favorite cow.

Exhausted, my father was sitting on our back porch. He had just loosened his work boots and opened a cold Budweiser when Burt, who was twice my age, pulled up in a white stretch limo. Burt hadn't had breakfast yet and here was my dad with a Bud. The difference in their lifestyles was apparent to all of us.

His favorite cow had died and he saw this white stretch limo pull up. Then a chauffeur in a cap got out to open the door for me. Jane's father didn't say anything, which is sort of the way things are in Ohio. Let's shove it all under the rug. Let's not talk about it so we can pretend it never really happened.

I did have a couple of things going for me. Jane's mother had seen *Promises, Promises* on Broadway, and as a girl Jane had played

my songs on piano. Besides, I wasn't just some bartender who had knocked up their daughter but a bit of a celebrity. But I *was* old enough to be Jane's father and I was Jewish and I was still married.

Jane Hanson Bacharach: My mother was a little worried that I was in over my head. My dad was simply not speaking and it was like a scene from a movie. Burt stayed for lunch and then for dinner but things didn't really get better.

Did it go well? Tolerable. It was Ohio. Nobody was saying, "When do you think you're going to get a divorce?" or anything like that. The question in my mind was "Are they thinking that? Or are they just pretending?" After dinner, I went back and stayed in a hotel at the airport, and left the next day.

Jane Hanson Bacharach: Burt left in the limo, and I stayed with my parents for a short while before returning to our home in Santa Monica. Our son, Oliver, was born that December at Cedars-Sinai Hospital, and my mother came out to help me look after him. That was when she kind of got her head around the situation. It was not exactly what she had wanted for me but she quickly realized Burt was a pretty decent guy and she eventually came to terms with it.

Burt and I got married in October 1993. We stayed at the Auberge du Soleil, up in Napa, and the ceremony took place on a Tuesday and was performed by somebody I found in the Yellow Pages. My friend Kristin and Burt's former road manager, Charlie Herman, were our only guests. Getting married never really seemed all that important to Burt and me because I didn't necessarily want to be wife number four and he had already been through it three times. So I think that's why there were just four of us there on a Tuesday.

We had planned to get married a couple of other times and I don't know, maybe I was getting my nails done, so we put it off. We got married mainly because we were thinking about another child, and three years later I gave birth to our daughter, Raleigh.

A lot of what has been imparted to our kids comes from Jane. She took some chances in her life and picked up and got out of a small town in Ohio and went to teach skiing in Switzerland, hitch-hiked through Europe by herself, and crewed on sailing ships in the Caribbean. Jane has great common sense. If you ask her a question, the answer may not be what you want to hear but it will be honest. She is a very independent person and we give each other space. We can be together and also live parallel lives. This marriage is different because my relationship with Jane is just right. Not too close and not too far.

Battle Royal

I had spent a long time writing with Hal and then a long time writing with Carole, and in a way I had been married to each of them. After Carole and I split up, I began writing with other people and it felt like I was dating a lot. I was going through another cold period and didn't come up with another hit for a couple of years, but I did manage to get back together with Hal. Our public reconciliation came when we were both honored with ASCAP's Founders Award in May 1993. By then we had both also buried the hatchet with Dionne, so the three of us were talking again.

Even when everything else in my career hasn't been going well, I've always had my horses and it was during this period that two of them ran in the Kentucky Derby. My interest in horse racing started when I was fourteen or fifteen and one of my mother's friends, Edith Friedman, took me to Jamaica Race Track in Queens. After that I started reading Ken Kling's race selections in the *Daily Mirror*. I would always look at the paper the next day to see how right he had been, and who the hot jockeys were. So I started to know guys like Eddie Arcaro by name and I thought, "If I ever can afford it I'll own a racehorse."

Eventually I met up with Charlie Whittingham, one of the all-

time great trainers. I don't think he would have paid that much attention to me but he liked Angie, so for fifteen thousand dollars, which would be about forty-five thousand dollars now, Charlie bought me a horse named Battle Royal.

On the day before I had to fly to New York to start rehearsals for *Promises, Promises,* Angie and I went to Hollywood Park to watch Battle Royal run his first race under my colors, blue silks with two music notes on the back. It was a very close finish and they didn't show replays like they do now so we had to wait for the stewards to look at the photo and then Battle Royal was posted as the winner. I went down to the winner's circle with Angie and the feeling was incredible.

I fell in love with Battle Royal and the horse became the family pet. Nikki would go out and pat him and Angie always made a big fuss over him. We ran Battle Royal in Del Mar on the grass in a $15,000 claiming race, which meant that anyone could buy any of the horses who were running in that race for that much. Battle Royal finished a close second and someone claimed him. I didn't really understand how all this worked back then, so I was really shocked to learn that I no longer owned this horse. He now had to go to another barn with another groom and another trainer. I felt really bad because Battle Royal was like a pet and he couldn't even bring his own toothbrush with him, if horses had toothbrushes.

Six months later, when someone told me Battle Royal was running at Santa Anita in an $8,000 claiming race, I got in touch with Charlie Whittingham and said, "Charlie, I want to get the horse back." He said, "Can you get the fuck off the phone and leave me alone? I have to get up at four a.m. tomorrow."

By now Charlie had become a great friend. We had houses next to each other on the beach at Del Mar and we had gotten drunk and gone swimming together in the ocean at night and lived to tell the tale. If it had been anyone else but me, Charlie would have said, "Please just get out of my life. Fire me." Instead, I got him to cave

in and he said, "Bring your check for $8,000 and be here before the first race tomorrow."

We got Battle Royal back and wound up running him down in Del Mar in a couple of races. He wasn't doing well so we dropped him down into a $5,000 claiming race that he won. Angie and Nikki and I went down to the winner's circle and sure enough, Battle Royal got claimed and Angie said, "I swear I saw a tear in Charlie's eye." I said, "If you did it was a tear of happiness, because he's so glad to finally be rid of this horse!"

What I like about people in horse racing is that they tend to be understated. A jockey doesn't get off a horse and say it's the best horse he ever rode. Bill Shoemaker, who was a good friend of mine, rode a number of horses for me. He won a couple of stakes races with a horse I thought was pretty good and said, "Burt, he's a nice horse. Just a nice horse. But don't get your hopes up."

After having been such a control freak in the studio for years, and trying to get a certain performance out of a singer, or a drummer to play differently, I would have a horse that was not very talented and ran slowly and there was nothing I could do about it. In the music business, it was always "The record's a smash! It's top five in Detroit! It's got a bullet." People in the racing business have been dealing with disappointment their entire careers. They spend years trying to get a horse to the Kentucky Derby, only to have the horse break down and never run again, so they really understand losing. Charlie Whittingham and I won our first race with Battle Royal. Then I bought some more horses and we ran forty-three times in a row without ever winning a race.

Being in racing has taught me to try to stay in the moment. When you're getting your picture taken in the winner's circle, enjoy it. Don't be looking ahead to the next race, because you just don't know what tomorrow will bring. Stay in the moment. I've tried to bring that attitude to my life as well. That's the great lesson racing

has taught me. I've also learned that racing is a very expensive business and that slow horses eat just as much as fast ones.

By the time I met Jane, I had no idea how many horses I had or how much money I was spending on them. Knowing how practical and sensible she is, I decided to bring her into it as well.

Jane Hanson Bacharach: Early in our relationship, before we even had any children, we were staying down at La Costa and Burt had to go on the road. He left me there for a few days on my own, which was fine. I was at the pool, I was in the gym, I was completely happy. Burt had a racing form delivered to the room every day and he told me, "Read that form and figure out how it works and then we'll talk about it when I get back." He taught me a whole lot early on and I'm still learning.

The first really great horse I had was Heartlight No. 1, who won the Eclipse Award for three-year-old filly of the year. To get the Eclipse Award, we had to beat the top horses on the east coast so I took Heartlight No. 1 to Belmont to run in the Ruffian Handicap in August 1983. Dinny Phipps was the head of the Jockey Club and a really powerful figure in horse racing in New York. I knew him a little from the club scene in the city. He said, "You can't run with those colors here because you're advertising yourself with the two music notes on the back of your silks." I said, "Cut the shit, Dinny. Come on." So he waived the rule for me and said, "After the Ruffian, you're going to run in the Beldame Stakes in October."

What he was saying was, "This one time, I'll make an exception. But if you run again, you're going to have to change the colors." I fought with him about that as well so he let it go and we went out with Laffit Pincay Jr. as our jockey and two eighth notes on the back of the silks. We got beat right at the wire by Dinny's horse but it was still a great experience.

For the six months that Heartlight No. 1 ran, it was like I was managing a rock star and I dropped my music career so I could be totally into this horse. I would call the trainer every morning to see if she had a good bowel movement and then I came up with the brilliant idea to play Neil Diamond's "Turn On Your Heartlight" on a boom box right outside her stall all day long because I thought it would inspire the grooms, the trainer, and the horse. That idea lasted about half a day because someone stole the boom box.

By 1994, Dick Mandella was my trainer and we had a really good horse named Soul of the Matter, who almost beat Cigar in the first Word Cup in Dubai on March 27, 1996, a $4 million race. Soul of the Matter had run in the Kentucky Derby and finished fifth. Jane and I were in the paddock right before the race when we found out Dick had not been paid in months because my business office had dropped the ball. After that, I made sure that the bills came directly to Jane, who I knew would take care of them properly.

A year later, we had a horse named Afternoon Deelites, who also made it to the Kentucky Derby, and that was when I did "the walk." Before the race begins at Churchill Downs, they bring out the horses from the stable area in the middle of the backstretch and walk them toward the stands. It's about a half mile.

I was wearing a suit and tie and dress shoes and walking in the dirt on the track and loving it because there were more than 100,000 people watching. As I came around the turn with Dick Mandella, the groom, and Afternoon Deelites in front of me, the crowd started yelling out my name and singing "Raindrops Keep Fallin' on My Head."

Because of all the noise, Afternoon Deelites started getting a little fractious. Dick said, "Burt, could you walk about ten feet behind us?" I said, "Absolutely." I didn't want to do anything to make the horse a nervous wreck and jeopardize his chances. Afternoon Deelites finished eighth but it was another experience I will never forget.

The fact that I had two horses back-to-back in the Derby and that they were both home-bred taught me never to complain that my horses weren't running well, because nobody could be that lucky. A home-bred horse means you own the mare and you breed her to a stallion. Most people buy their horses at a sale where they can cost as much as three or four hundred thousand dollars. The cost to have both Soul of the Matter and Afternoon Deelites bred back then was fifteen thousand dollars each and we were running against really well-bred horses who could have cost twenty times that much.

Jane Hanson Bacharach: Burt doesn't ride because he's afraid of horses. He will occasionally place a bet but gambling isn't why he's so into racing. What he really loves are the characters at the track and the sport itself.

I've been in racing a long time, and from Battle Royal on, there have been good times, better times, and bad times but I have a kind of mantra that I always go back to. Which is that I have no right to complain about the way my horses are running now, which is not very well, and hasn't been for a while. Instead I just say, "Remember that you had three really terrific horses that were home-bred."

I had a champion filly that won the Eclipse Award and two horses that ran in the Kentucky Derby in consecutive years and that was just amazing luck. Afternoon Deelites and Soul of the Matter both made more than a million dollars each and were sold as stallions to Brereton Jones in Kentucky for $4 million.

Although the horses I have now are running very poorly, that comes with the territory and is out of my control, because I can't make them run faster. I now own thirty-two horses but the ones that race are outnumbered by Jane and Raleigh's show jumpers. The season in Del Mar starts on the third Wednesday in July and goes

for seven weeks. I'm always at that meeting and then our horses do the full Southern California circuit at the Pomona Fairgrounds, Hollywood Park, and Santa Anita.

If you look at the photographs on the walls of my house, I'm always smiling in the pictures taken after one of my horses has won a race. For me, this is still one of the greatest thrills in life.

Chapter
22

God Give Me Strength

I got a call from the music supervisor on a picture called *Grace of My Heart*, who said they needed a song and asked if I would consider getting together with Elvis Costello to write it. I said yes. I had met Elvis once at Ocean Way studios in Los Angeles, but until we started writing together, I didn't really know him at all.

Elvis Costello: By sheer chance in 1988 or 1989, I was working at Ocean Way with T-Bone Burnett on the record *Spike*. We were doing this song that in my mind was kind of a Burt-influenced piece. I'd already written a few songs that were me trying to write a Burt Bacharach song. One was called "Accidents Will Happen" and another much less well known one was called "Just a Memory," which Dusty Springfield recorded. That song was very much influenced by Burt, although when I actually sat with him and saw what he was doing, I realized I was miles off the model.

"Satellite," the song I was doing on *Spike*, was not at all like Burt melodically but I was using marimbas and these little suspensions that reminded me of him. I don't know what record Burt was working on but suddenly someone said, "Burt Bacharach's down

the hallway!" I went and introduced myself and asked him if he would come listen to the track.

Because I was deep within the recording, I imagined Burt would instantly hear the homage and the instrumentation. He listened as he listened to everything and said, "That's interesting, thank you," and then he left! He was complimentary but it wasn't like, "A-ha! I get it now!" But he was great and it was really thrilling to meet him.

Elvis was in London and I was in Los Angeles, but they needed the song quickly so we started working together by phone and fax and pretty much put it all together in less than a week. The lead character in *Grace of My Heart* was loosely based on Carole King and a lot of the movie took place in the Brill Building, so I started writing in the six/eight, twelve/eight thing, which I hadn't done in years.

I couldn't go back and write something like "Don't Make Me Over" again because I just don't think that way anymore, but since this was for a movie about the Brill Building, I thought, "Okay. Great. I can do it." Elvis wrote the lyrics and the music for the verse and I suggested a couple of new chords and changes, wrote the bridge, and did the orchestration.

Elvis Costello: When the music supervisor said, "Would you write with Burt?" I went "What?" It took me all of ten seconds to answer because I couldn't even believe it. In our first conversation over the phone, I asked Burt if we could work together on the music and he agreed to that. I don't know what possessed me to say that but I'm sort of glad I did, because I actually got out of the gate first and wrote everything from the opening line of the vocal to the hook line and sent it to him.

Burt responded immediately and stretched a couple of the lines and revoiced some of the changes, but it was essentially the same

melody. Then he added the intro figure. The fantastic thing was where he went on the choice of the bass note by saying, "Let's make that a minor sixth," or something. There were no uneven bars in the first body part of the song but I was rushing some of the phrasing on the back end. He stretched the melody in some sections over twice as much music so it sort of went half time in just one phrase.

And then I told him, "Oh, by the way, I've written a bridge." There was no e-mail back then so we were doing all this by fax and these faxes were going back and forth with sheet music on them. I wrote a top line and then I recorded the song and played it into his answering machine. He transcribed it and a fax came back with the question, "Is this it?"

Then Burt sent me his bridge and this kind of huge symphonic thing happened in the middle of the song. I had to write lyrics to it and that gave me the way to write a third verse, and then we had the reprise and the tag and suddenly we had this epic song. That was the composition of that one. If I had said, "Okay, I'll be the lyricist," and waited until he had sent me something, it might have been totally different. I don't really recall where the title "God Give Me Strength" came from. Out of thin air, I think.

I was down in Palm Beach, Florida, and I wrote the arrangement there for the strings. Then I went to New York and met Elvis so I could explain what I had written on the intro and the ending. The next day we went into the studio with a rhythm section and it wasn't happening, so Elvis said, "Maybe you should move the synth player and you play piano." I didn't know this band and I didn't want to hurt anyone's feelings but I said, "Okay," and I wound up playing piano like I always used to do in the old days.

We did it that way and it came out good, and the next day we put the strings and the horns on it. Allison Anders, who directed *Grace of My Heart*, was there when we did it, and she was ecstatic.

Elvis and I were saying, "This is good. Maybe we should do an album together sometime."

Elvis Costello: We sent off what we had written and they asked us if we would voice it for the end titles. We were at the Power Station in New York and this was the first time Burt and I had been in the same room together. We had just borrowed the studio to rehearse, so Burt and I were in there learning the song as we performed it and he was telling me how he was going to orchestrate it.

Then we went in and cut it with Allison Anders and Illeana Douglas, who played the lead role in the movie, in the studio. It was a great band, with Will Lee on bass and David Spinoza on guitar, and at the end of it, we were filmed fake-performing it with a cross fade and they made a little video. And it was like "Hold on. This is sort of a partnership here." We had barely met and now we were doing publicity photographs together and suddenly we had gone from a standing start to making the record.

To me, "God Give Me Strength" has a certain timelessness. It worked as a period piece, but it also worked for the time when the movie was released and I was really happy with what we had done. I like to think that if the movie had been a little bit better, the song might have been nominated for an Academy Award, but that didn't happen.

Elvis Costello: The film came out and it didn't really go anywhere. I knew we were technically eligible for an Oscar nomination but there was no way the film was visible enough for the song to have any kind of audience. Had it been any kind of high-profile film, I think the song would have been a serious contender. Just the scale of it. But you don't write songs with the idea of what kind of awards you might win.

The song was nominated for a Grammy and I'd never been to the Grammy Awards, because it never seemed like anything I would ever be involved in. But Burt and I had gotten friendly by then so I said, "I'll only do this for you, Burt."

Burt and I were asked to present together. We went through a curtain and there was this like nine-foot spokesmodel person who was guiding us through and I noticed, not for the first time, that if I stood next to Burt Bacharach in the company of a woman, I would suddenly become invisible. Just invisible. She was a young woman but she looked at him and went, "Oh my goodness!" And I was just some bloke who was standing there.

Some years later, I got to read the citation when Burt was given the Polar Music Prize. I was standing in the lobby of the Royal Concert Hall in Stockholm with Burt and the other two honorees, Karlheinz Stockhausen and Bob Moog. Quite a group. Here comes the queen of Sweden and she sees Burt, and I could see her just go weak at the knees. She looked at Burt and went "Whaaa," and I thought, "Here we go again." Everyone else just becomes invisible.

About a year later, Elvis and I started working on an album together that took us months to do. Except for "God Give Me Strength," nothing was ever fast with Elvis and me. We started in a room in my condo in Santa Monica with me at a keyboard, an acoustic piano, and a synthesizer playing stuff over and over. Then Elvis would go his way and I would go mine but neither of us could ever let it go. I could call Elvis at four in the morning and I knew he would be awake thinking about the same thing as me.

Elvis Costello: So I rang Burt up and said, "What do you think about doing a whole record together?" I went to a writing apartment he had on the edge of Santa Monica and Venice and we worked in

a room and got started. It only occurred to me later that the only other person he had ever written music with was Neil Diamond. We both came up with openings or sections of music and in some cases, we ended up writing the complementary or bridging section. In some cases, the music was complete.

It doesn't make any of us better to know who wrote which portions of what song, but I don't know whether you can tell who wrote what. I think the assumption by most people reading the credits was that Burt wrote all the music. In fact, he wrote all of the music to just three of the songs. One of them was "This House Is Empty Now," which I wrote a bridge for that we didn't use, and the only purpose that served was to prove that the song, despite its length, needed one. He then wrote the one that you hear and replaced mine because the one I wrote wasn't as good. "The Long Division" is entirely his. "Such Unlikely Lovers" is entirely his.

All of the other songs are some kind of collaboration in different proportions. The collaboration also grew and changed with how much comfort we had with one another. Once we started to get into the rhythm of this language, the songs stopped sounding like my idea of what Burt sounded like, with him correcting me like I was doing some kind of crazy, very esoteric exam. It became a dialogue, not because we were so in tune, but because we could literally complete each other's sentences in songs like "I Still Have That Other Girl." And there were sections where we were writing within the phrase together.

Most of the songs were written with us both sitting at a piano or a synth and playing together or me standing and waving my arms around going, "That's it!" If I suggested a musical phrase, he would get inside it and stretch it over a longer framework. It was his idea to take "Painted from Memory" off the piano and put it on the guitar. In "My Thief," we actually wrote the two

sections and then Burt did these incredible things to make it hold together.

From the point of view of being the lyricist throughout, I had to listen to what was being said in the music whether or not I had anything to do with it but particularly when there were these sections where I would go, "Oh my goodness, what is this saying?" I took away some of the pieces in instrumental form and really struggled for a while trying to match the scale of the composition with baroque lyrics.

What I then realized was that I was competing with the music rather than complementing it. What I had to do was to listen to the voice in the song and what it was saying and arrive at the feeling of it. I didn't think for a moment we were writing songs that were in any way comparable to what Burt had written with Hal. I was quite happy just to be where we were but it did give me an appreciation of what an incredible technician Hal was. That he could write songs that opened up in the right places for the melody but beyond that were not merely facile but also stories that moved you and used language that was familiar without being clichéd. It's a very, very difficult balance.

On "This House Is Empty Now," I kept singing the word "remember" over and over while I was playing a passage on the piano, so Elvis used that to shape the lyrics for the song. Elvis later told me he was worried he wouldn't be able to come up with words to match the music we were writing, but once he broke through with the lyrics for that one, it all started to flow for him.

Thematically, *Painted from Memory* was about lost love. Elvis always liked to call it a heartbreak record of sad songs for people who luxuriate in melancholy. Even though we would work together for four or five days at a stretch every couple of months, it still took us two years to finish writing all the songs.

Elvis Costello: Then I came up against the non-negotiable aspect of the shape of the melody. Like what Carole had been through with Burt. "Could it just have a three-syllable word here that makes sense or makes the rhyme?" "No." Of course, Burt didn't know that I didn't know the terminology. "A sixteenth note? What's he talking about? Is that a semiquaver?" I'm thinking in quavers because that's the little bit of learning I have. He'll joke about the fact that we were both up at three o'clock in the morning and he knew I was the other person pacing about that one phrase. He'd call and say, "Elvis. I've got it!" You'd think we were safecrackers or something. It was absolutely fantastic.

Perhaps the most thrilling thing is that when we wrote "I Still Have That Other Girl," we were tinkering with the melody and we came to this part of the song where Burt said, "I think it needs a bridge." And he started sketching there and then in the room. I looked at him and his eyes were back in his head and he was playing and it was so thrilling that I went, "That's it. That's it!" When we stopped the tape, he said, "What did I play?" We just about managed to decipher it with me blurting out over it. But at that moment, Burt had just left the room. He had gone somewhere. It was like, "Oh my God, that's him composing."

I was sitting at the keyboard and we were up to the bridge. I just started to play something that was off a little metrically and changed bars and Elvis said, "What is that?" I said, "It feels pretty good." It seemed to evolve from where Elvis had been with the opening verses and he was very enthusiastic about it. I didn't remember what I had played, which is the reason I always run a tape when I'm at the keyboard and just communing with music.

I don't want to stop to write it down, because by the time I do, I could lose half of what I did. I want to be able to leave the keyboard and hear exactly what it was. I can check it on the tape and then go

away and listen to it in my head and get a picture. I know there are people who go from one bar to the next but I can't. I've got to see the whole perspective of how the song evolves. It really worked on "I Still Have That Other Girl" and made the song more immediate than some of the others we did on the album.

Elvis Costello: Burt wanted Johnny Mandell to write the chart for "Painted from Memory." He talked about David Foster doing some stuff. He talked about Quincy Jones doing some stuff. In the end, I said, "I really think it's you. You've got to do it." And then once we got in the studio, Burt was in the control room with the 58, a Shure vocal mike, plugged into the board because he speaks so quietly. He was waiting in the chair and we've got the flugelhorn players out there and he's going, "No, no." He's written it, mind you, the chart's out there, and he's going, "No," and singing minute phrases that can't be written down. And he sang it back to them exactly as he heard it. He was just as emphatic about that as the way he wanted me to phrase the melody.

When we recorded *Painted from Memory*, I wound up playing piano on practically every track because it was like, "If it doesn't work, I'll take the blame." After we cut the record, Elvis and I went out to perform it live onstage with a twenty-four-piece orchestra.

Elvis Costello: It was fantastic being on the road with Burt. We really didn't make it easy on ourselves, because we opened at Radio City Music Hall in New York. So we weren't kidding around. And we were not going out there to play the Burt Bacharach/Hal David songbook. We were playing new songs, so it was a big thing to ask people to come see the first rendition of this in a live performance. I opened the show with an acoustic version of "Baby, It's You" just to kick it off, and then I introduced Burt, who did "What the World

Needs Now Is Love." There weren't many fast songs on *Painted from Memory* so I did "Alison" as well as "My Little Red Book."

It was a very demanding schedule for Burt because of his perfectionism in terms of the orchestration. He didn't delegate. We went to Chicago to play the Chicago Theatre and ran out of time to rehearse on the stage, so he put the string section in the lobby and rehearsed with them with an electric piano in the lobby. It was incredible. He had string players all the way up the stairs. We also played the Universal Amphitheater in Los Angeles and went to London and did it at the Royal Festival Hall.

When we started doing the interviews for *Painted from Memory*, there were people who didn't understand who Burt was. They'd come in and say, "Of course, you are the King of Easy Listening. You are in the lounge. You are the elevator music." And I would go, "What are you talking about?" I remember this one German journalist who was very belligerent and started to lecture Burt for not ever having gotten on the rock-'n'-roll train because the world had been in social uproar and rock 'n' roll was liberating the kids, man. And Burt very patiently said, "You know, I had just come out of the Army and I had studied with Darius Milhaud and listened to Dizzy Gillespie so Bill Haley and His Comets just didn't make it for me." It was such a killer argument.

I really felt like I was blessed to be able to work with Elvis, because he had such a spectacular way of telling stories and tracking down words that said things so differently from anyone else I had ever written with. Both of us were perfectionists but we still wanted to go for feeling in every song. I think that's what came through on *Painted from Memory* and why people responded to it so positively.

Elvis had never had much use for the Grammy Awards, because when he had been nominated as the Best New Artist in 1979, the award was given to a disco band named A Taste of Honey for a

song called "Boogie Oogie Oogie." I dragged him with me to the ceremony after "God Give Me Strength" was nominated, but we lost to Natalie Cole. A year later, Elvis and I won the Grammy for Best Pop Collaboration with Vocals for "I Still Have That Other Girl."

Chapter
23

Man of Mystery

I knew who Mike Myers was from seeing him on *Saturday Night Live*. He had an idea for a movie he wanted me to be in, so I met with him at his house and he turned out to be a huge fan of my music. I never saw the script and it wasn't a lot of money but I really liked him so I said I would do it, although I don't know if we even talked about what it was going to be.

I was on my way to Chicago to do a concert so I stopped off in Las Vegas, where Mike was filming. I stayed at the Hard Rock Hotel, and when it came time for me to do my scene, I got on top of this open-top bus going down the Strip at two in the morning.

Mike Myers: I was driving home from hockey practice in Los Angeles one day shortly after my father had passed away, and "The Look of Love" came on the radio and I instantly felt the character and the movie of Austin Powers enter my brain. Peter Sellers was my dad's hero and that scene with Peter Sellers and Ursula Andress in *Casino Royale* when "The Look of Love" is playing just delighted my dad because it was a combination of Sellers, James Bond, and Burt Bacharach. For my father, the highest praise he could ever give anybody was "I wish he was English." And my father used to

say of Burt, "He's one of them great Americans, you know, that you just wish were English. And you feel he is somehow."

My dad was from Liverpool, and there is a strange Mersey tunnel between the north of England and Burt Bacharach because he's a sensual guy who writes sensual music and Liverpool is all about being sexy and funny, and having a strong take on the world and being able to sing a song, tell a joke, or tell a story. Oasis are from Liverpool, and they are obsessed with Burt and have his photograph on the cover of their first album. Elvis Costello is from Liverpool and both he and Burt have been in the Austin Powers movies.

The scene with Burt in *Austin Powers: International Man of Mystery* was in the script from the beginning. If you write it, they will come. We shot all night long on the Strip in Las Vegas and there were some considerations like stoplights that weren't straight up and down but sort of bow in the center, almost killing Burt and Elizabeth Hurley as they sped by them while he was singing live on top of the bus.

I was doing "What the World Needs Now Is Love" to a prerecorded piano track but I was singing live. We shot it and then they had to reshoot it, and by the time we were finished, it was four in the morning. Then I got on a plane and went to do a show in Chicago.

Mike Myers: It was all about me being a straight-up fan of Burt, and so for all of us who had the privilege of being there that night, this was one of those can't-believe moments. The scene runs about a minute and a half in the movie and if that was what began the Burt Bacharach resurgence, I would be completely honored. Because truly he's the greatest ever.

Nobody thought the movie was going to do anything, but all of a sudden seven-year-olds all over the country were coming up to me and saying, "I just saw you in *Austin Powers*." About a year after

the movie was released, I was in Los Angeles when I got a call from Lilly Tartikoff, the widow of NBC president Brandon Tartikoff. She was running the Fire and Ice Ball at the Beverly Hilton Hotel. It's a very prestigious benefit for breast and colon cancer research and just about every star in Hollywood was going to be there that night. Lilly said, "Burt, you'll be the only performer and you don't have to do your whole show, just fifteen or twenty minutes."

I said, "Lilly, you know I've been to the Beverly Hilton for a lot of charity events. People can't get out of there quick enough, and most of them like to leave before ten o'clock. They'll all be looking at their watches while I play so I really don't feel all that good about doing this." But she talked me into it.

I was introduced by Antonio Banderas, who did one of the worst introductions ever. I was up there with my band and my singers to make some music and I had picked out a medley of songs I had written for movies because I figured, "Hey, we're in Hollywood, right?" Before we started to play, I explained what we were going to be doing, and it wasn't as though I lost the audience at that point because I'd never had them. I could see a lot of people I knew and they were all up talking and networking with one another. Jane was sitting with Terry Semel, the CEO of Warner Bros., who said to her, "These people are making so much noise that Burt is going to blow up." And about seven minutes into the set, that was exactly what happened.

We were right in the middle of "April Fools" when I cut the band and picked up the microphone and softly said, "Listen, folks. I'm having a really difficult time up here onstage even hearing myself play. The whole band is having a difficult time. I've done concerts all over the world and you are the rudest people I've ever performed before."

Everyone shut up and we all went back in and picked up right where we had left off. I got to the end of the set and when I went into the chorus of "What the World Needs Now Is Love," everyone stood up. I took a bow, quietly said, "Fuck you all," and walked offstage.

What I was feeling was a combination of real anger and frustration but also self-doubt. Like, I must not be very good. And then I said, "Fuck! I'm just as good as any of those people out in the audience." But something like that is a real blow to your self-esteem.

Then Jane and I went to Aspen, where she had asked me to do a benefit for a ski and snowboard company that brings disadvantaged kids out there to learn how to ski and snowboard. It was at the St. Regis Hotel. Just like they had done at the Fire and Ice Ball, people started talking while I was trying to play. So I said, "People, if you want to talk, you can talk. But it's not considerate to me or to other people in the audience who want to hear the music. So if you want to talk, why don't you just go outside?"

What made it even worse for me was that these two shows were back-to-back. The way I reacted at both of them was completely different from what I would have done when people talked in the audience while I was playing Vegas in the early days. I mean, if I had ever said something like this back then to the customers at the Riviera Hotel, one of the guys who ran the place would have had me killed!

I don't think it's ever good to beat up an audience or get angry with them, but when people act this way, they're being disrespectful to the music itself. Although I really haven't had that many bad experiences performing in public, I still remember these two shows a lot more clearly than the good ones. However, thanks to Mike Myers, at least my movie career was going great.

Mike Myers: In terms of putting him in the second Austin Powers movie, it was "More of the same, please. Can I have another helping?"

In the second Austin Powers movie, Elvis Costello and I are doing "I'll Never Fall in Love Again" in an outdoor market that was

supposed to be in London, even though they shot it on a back lot in Los Angeles. Elvis is singing and I'm playing piano and I've got a little band behind me and Austin Powers walks through the shot.

Mike Myers: Burt and Elvis Costello were supposed to be the world's most talented buskers, and it was by design that Elvis looks so funky. Was Burt not in the third one as well? There was an incarnation of it when he was but I watched the movie so many times that I don't remember what I cut because things fly in and out a million times. I do remember we used "What's It All About, Austin" over the end credits and Susanna Hoffs really sang the crap out of it.

How people feel about what I write is not something I can control. Before I met Carole, no one was playing my stuff, and then after we split up, I went through another long cold period where nothing I was doing or had ever done seemed to matter to anyone anymore. It's not like you stop working when that happens, because you don't. You just keep writing and hope things will change. For reasons I still don't understand, things started turning around for me after I did the first Austin Powers movie and began working with Elvis.

All of a sudden. Julia Roberts was telling a reporter how the sing-along version of "I Say a Little Prayer for You" had changed the whole tone of *My Best Friend's Wedding*. The *Atlantic* ran a really serious six-page article about my music and the *New York Times* sent someone to interview me. I hadn't changed but a lot of people who had never heard my music before now thought it was cool.

Chapter

24

Overture 2000

Dick and Lili Zanuck were doing the Academy Awards show and they came to see me perform in Vegas. Then we all went out and had a drink together. They loved the show and asked me how I felt about putting together a medley of Academy Award–winning songs as well as some that had been nominated. They also asked me to serve as the music director for the entire show with Don Was.

For the next three months, all I did was work on a very cohesive fourteen-minute medley of songs with a group of killer singers like Ray Charles, Garth Brooks, Queen Latifah, Isaac Hayes, and Dionne. I wanted the medley to be so seamless that it never felt like we were changing keys at any time. I sketched it out and wrote the arrangement and we were going to have the band onstage to perform it live.

We were looking for a diva and Whitney Houston's name came up. I had known Whitney since she was a little girl and I loved her voice, but Dick and Lili's concern was "How straight is she?" Whitney was going to sing at Clive Davis's Grammy party so I went to see her and she knocked me out. What I didn't know then about an addict was that you can give them the songs they sing year in and year out like their early hits and they will be perfect. But give them a song like "Somewhere Over the Rainbow" and they can't sing it.

I didn't understand this until Whitney came to my house four nights before the Academy Awards show with Bobby Brown in a caravan of cars. She walked in wearing dark glasses and a baseball hat and Bobby scared the shit out of my kids because he was making these weird gestures like coke addicts do. I started working with Whitney at the piano, and although the key I was playing in was right, she thought it was too high for her to sing.

Whitney was supposed to sing "Somewhere Over the Rainbow" and "The Way We Were" and then at the end, she and Dionne were going to do "Alfie" together with a great harmonica player and I was going to sing four bars with her as well. When Whitney said the key was too high for her, I had to lower it, which upset the seamless transitions I had written. I had no choice. I lowered the key.

About three weeks before the show, I got a call from my agent, who said, "Don't quote me on this but there's a rumor Ray Charles has taken a date to play on the Saturday night before the Oscars." I said, "That's our dress rehearsal," and he said, "Maybe you should talk to Ray."

I had shown Ray the layout of what he was going to do a couple of months before and he had been amazing because when I played the song for him, he said, "Man, that chord is not the right one." I said, "I know. I'm just trying a different version to lead into the next song." But he didn't really like it that way so I changed it back for him. Even though Ray wanted more than they were willing to pay and was only doing it for the money, he agreed to do the show.

I called him after my agent had talked to me, and I said, "Ray, I heard this rumor you're taking a date on Saturday night before the show. That's our dress rehearsal. First of all, is that true?" He said, "Yeah, it's true." I said, "Where's the date?" When he said Germany, I said, "Ray, what if you're delayed coming back?" That alone was enough to make me a nervous wreck.

The Academy Awards were on Sunday, and on Friday night

we had a rehearsal in the Shrine Auditorium. There were about three hundred people in the audience. Whitney came in wearing the baseball cap and sang "Somewhere Over the Rainbow" and it was unrecognizable. There were only twelve bars of it before the next song began but I stopped the band and went over to talk to her.

I said, "Whitney, everybody knows and loves this song, so you've got to sing the melody. You've got to sing at least most of the melody." She said, "Okay." Her next song was the title song from *The Way We Were*, and she wrecked that, too. Then we got to "Alfie," which should have been a real moment for Dionne and Whitney. Dionne wanted them to sing it in harmony but Whitney rode right over Dionne. I know Dionne really well and I could see how angry and frustrated she was, but Whitney was her niece, so it wasn't like Dionne could say, "What the fuck do you think you're doing?" So that was also a disaster.

We decided to run the whole medley all over again right from the top, and when it came time for Whitney to sing, she didn't know where she was. She came in on the wrong song and it was obvious to everyone she couldn't do this. Lili Zanuck came up onstage, and I broke the band and went into a trailer with her and Dick. It was their show, so instead of asking me, "What do you think we should do?" they said, "Fire her ass! Get her out of here! Because if we do this with Whitney, nobody will remember who won for Best Picture. They'll just remember the train wreck."

It wasn't a closed rehearsal and there were some news people there, so they could see how bad this really was. Lili got on the phone at about eleven o'clock that night and called Faith Hill, who was a friend of hers, and said, "If I send a plane for you, can you get here tomorrow?" Faith Hill said yes. She got to L.A. on Saturday afternoon and came over to my house. I gave her the demo of the medley I had cut with my band and my singers, and I played the songs for her on the piano.

She took the demo with her, came into rehearsal the next day, and did the songs perfectly. They got her a dress to wear for the show and she looked gorgeous. But now we had a problem with Garth Brooks, who said, "What do you mean Whitney's not going on? I want to talk to her before I'm willing to go on to make sure she's okay and find out why she can't do the show." What was really bothering Garth Brooks was that we had replaced Whitney with Faith Hill. If we were going to bring in a country artist, he wanted it to be Trisha Yearwood, who he was crazy about and later married.

They told him he could talk to Whitney but I'm not sure if he ever did, because Whitney herself wasn't around when she was fired. Instead we told her representative, "You want to do something for Whitney? Get her into a treatment center. You're not helping her by saying, 'She's just marking the song and tomorrow she'll be fine.'"

It was all really harrowing. Ray Charles got back from the date in Germany just in time, so they had to send a police escort for him, but he came through onstage just like he always does. Garth Brooks also sang really great that night, but he only did the show because Dick and Lili had said that if he wanted out, they would replace him with Faith Hill's husband, Tim McGraw.

Even with everything that had gone on, it was a good medley, so I thought, "This will bring the house down and I'll get a standing ovation." When it was over, my son Cristopher stood up with Jane and then some other people also got up because the two of them were standing, but they had already given out so many awards by that point that no one really cared about the music. I had spent three months working on this and it stressed me out so much that I don't think I did a very good job. We had a small band onstage, with Don Was in the pit conducting a nine- or an eleven-piece band when what we really needed was a big string section and a full orchestra.

What happened with Whitney became a big story. Although it wasn't true, Whitney's people told everyone that the reason she

didn't sing that night was that she had a sore throat. I never heard from Whitney again but I found the whole incident really sad. I was also disappointed in myself for not realizing she would have so much difficulty with new material.

Right after the awards show, I went out on the road to tour. I was so stressed out that I was going too fast and doing too much. When I played in Columbus, Ohio, with the Columbus Symphony Orchestra, Jane's family was there. Afterward I got on the tour bus and was having trouble calming down. I kept thinking, "I've got to back off and slow down and get off this train."

Two days later, I got to Indianapolis to play the Indiana Roof Ballroom. I was walking through the venue that afternoon with my son Cristopher and my assistant and road manager, Sue Main, to do the sound check. There was a step down to the dance floor but the place was totally unlit so I couldn't see it. I went down hard on my left shoulder and heard something crack. I knew right away I had broken it.

Sue Main: We called the paramedics immediately and put something under Burt's head and were careful not to move him. The paramedics came and Burt was pissed off because he was wearing one of his favorite T-shirts and they cut it off him. We ended up going to the hospital in the promoter's car because Burt didn't want to go in the ambulance.

We had never had to cancel a show before, but we only had a few more hours until this one was scheduled to start at eight o'clock. I spent a lot of time on the phone with our agent while Burt was in the examination room. I was seriously considering canceling the show but Burt kept saying, "No. Don't do anything yet. Just wait. Let's just wait."

They did X-rays but it still wasn't clear what had happened. Burt was asking the doctor if he could do any more damage to his

shoulder by performing that night. He said, "It's my left shoulder so I can't conduct, but I can play with my right arm." He somehow convinced the doctor that he was fine to do the show and the doctor gave him a shot for the pain and some additional pain pills and told Burt, "If it gets really bad, take these. But if you don't need them, don't take them."

We had been at the hospital for so long that we had to go straight back to the venue. We got Burt backstage, where he put on suit pants and a sweatshirt and off he went. No sound check. No rehearsal. Burt walked out and apologized to the audience for coming on almost an hour late and explained he'd had a little fall and had his arm in a sling. Everybody was very appreciative and he went on to do the show in what seemed like a state of euphoria.

Burt was having a great time. He was very funny, laughing and telling jokes. When I got him back to the hotel I said, "Wow. You were amazing. You didn't seem to be in any pain at all. You were so funny and just . . . so loose." And he said, "Well, it was that pain pill I took." It was just Burt being Burt and doing whatever it took to keep from canceling the show.

They sent the X-rays to Los Angeles. My orthopedist read them and said I had a fractured shoulder. Although it never occurred to me at the time, I had gone on and done the show just like Marlene did after she had broken her shoulder in Germany. Unlike her, I'd had some chemical help to get through the pain. Looking back on it now, I realize that it was an accident just waiting to happen.

I thought I could keep going and perform the next date, which was three concerts with the Milwaukee Symphony, but we had to cancel the rest of the tour. When I went for shoulder replacement surgery at the Kerlan-Jobe Orthopaedic Clinic, they inserted a titanium plate in the joint. I had never been injured like this before and the recovery took a lot longer than I thought it would. The pain was

so bad I had to keep taking Vicodin, and then I had to work really hard to get off the stuff. I was seventy-one at the time and for the first time in my life I felt old.

I eventually had to have the surgery redone because the muscle had fallen off the bone. It was a mess but they managed to fix it. In 2007, I was in Aspen around Christmastime when I slipped on some ice on the steps of my house and broke my other shoulder. I had to fly back to Los Angeles to have it replaced as well. I was in the hospital recovering from that surgery when I heard the news about Nikki.

Chapter

25

Nikki, It's You

Angie Dickinson: The first time I read about Asperger's was in *Newsweek*. My sister sent the article to me in July 2000 and said, "This sounds just like Nikki." I circled the last paragraph, where it said that an institution is the last place these people should ever be sent. I finally went to UCLA, and after a doctor there examined Nikki, he said she might have Asperger's. I said, "Doctor, she does have Asperger's." For Nikki, knowing what she had just didn't help at all. She still couldn't cope.

Nikki was thirty-four years old when we found out what was really wrong with her. Her inability to interact with other people, her total lack of empathy, and all the compulsive and obsessive behaviors Nikki had demonstrated ever since she was a kid were all symptoms of a form of autism known as Asperger's syndrome.

Back when Nikki was born, no one knew nearly as much about this disease as they do now. I never heard any of the doctors who treated Nikki even mention the word "Asperger's" or talk about autism. I know people who have problem kids but don't want to find out what is really wrong with them and so never have them

diagnosed. I did just the opposite with Nikki but it did us no good at all.

If only somebody had told me the truth, I could have dealt with that. Nikki spent ten years in that center and nobody ever said to me that this was an autistic child. You'd think someone would have seen it but no one ever did. And all the while, Nikki just kept getting worse.

After Jane and I had Oliver and Raleigh, Nikki would come to see us, but she had no patience at all for the kids. For her, they were an interruption, because she wanted to see this beautiful sunset and not be disturbed by them. The language she used was also hard for them to hear because she cursed all the time. By then I had really backed off trying have Nikki included in family gatherings, because for her my kids just got in the way and were a nuisance to her.

Angie Dickinson: I moved into a new house in 1994 and the helicopters drove Nikki crazy. Helicopters, lawn mowers, motorcycles, leaf blowers, and weed whackers were like a drill in her ear. She couldn't get the sounds out of her head and she was really suffering. I realized there was only one way to find real peace for Nikki and that was for me to stop doing all "the other things." Don't go to dinners or functions. Don't play poker. Just pretty much give it all up. So I did and it helped. Nikki and I did everything together. We traveled together and saw movies and my whole life was Nikki. I was completely dedicated to her, and she was my soul mate.

Not one percent of it was out of a sense of guilt. She needed it. After she came out of the center, Nikki said the worst thing I ever heard. She said, "They stole my brain." If she had been born now, they would have special classes and schools for her. They would also have a diagnosis, which they didn't have back then.

Nikki talked a lot about suicide. She was very open about it, even to people she didn't know well. She read *Final Exit*, a book

about planning suicide, and found out that asphyxiation was the most peaceful way she could do it—like going under anesthesia at the dentist. What could I do? I had promised Nikki that she would never, ever go into another hospital and I meant it. I wanted to make everything right for her but I couldn't. The obituaries in the *L.A. Times* were filled with people my age and Nikki just couldn't bear the thought of my death. I was her lifeline.

In 2006, we went to church services together on Christmas Eve. Nikki had always wanted to sing but she didn't, maybe because singing is so much about bringing out what's inside you and she couldn't cope with what was inside her. But that night Nikki just sang and sang. I'll never forget how much gusto she put into those Christmas carols. She was free and at peace at that point because she knew where she was going.

Angie knew it was coming and one of her friends had given Nikki a book about how to commit suicide, but I never believed she would do it. At the end, Nikki's sensitivity to sound was so acute that she kept saying she was going to kill herself because of it. And then it was "If my mother dies, I'm going to kill myself." Always her mother but never her father.

I'd had surgery on my shoulder and I was in the hospital when Jane and I found out that our son, Oliver, who was on the Aspen snowboard team and competed nationally, had ruptured his spleen while snowboarding on the mountain. Jane flew off to Aspen to be with him and I was scheduled to be discharged from the hospital when Sue Main came to see me.

Sue Main: I got to the hospital and Burt was sitting there with this physical therapist. I said, "Excuse me. I need to talk to Burt." Burt looked at me and said, "What's going on here, Sue? I'm supposed to be discharged and they're telling me they're holding up the papers.

I don't understand." I said, "I have something I need to tell you and it's really very sad. I'm so sorry I have to tell you this." And he said, "What? What is it?" And I said, "It's Nikki. She died. She committed suicide." Burt was completely stunned. He was on pain medication and a little bit out of it and he was looking at me like he couldn't believe it and I think he said, "How?"

It seemed like every time I would go up to Angie's house to bring her and Nikki lunch from the deli, I'd hear Nikki going on about the helicopters. "I'm going to kill myself!" Or if it wasn't the helicopters, it was the gardeners below with leaf blowers. "If they don't stop, I'm going to kill myself!" I never believed Nikki would do that, because there were too many things she liked and too many places she wanted to go and too much pleasure she wanted to have. So it was sort of like the boy who cried wolf. I always thought she would never actually do it, but then suddenly she did.

Sue Main: Nikki had gotten a DVD about how to commit suicide and it was in the video machine when she died. There was a bag over her head with a tube that fed nitrous oxide into it, and that was how they found her. She basically fell unconscious and died. She suffocated after knocking herself out with the nitrous.

Burt kind of pulled himself together and said, "How's Angie?" I said, "How could she be? What do you want to do, Burt?" And he said, "I think we should go to Angie's house." We still had to go through the discharge process and it took hours. His arm was in a sling and he was in pain but I got him in the car and we drove up to Angie's. We spent a couple of hours there because there were things that needed to be discussed, like donations in Nikki's name and an announcement for the newspapers.

The entire conversation was about Nikki and it was kind of like a wake. Burt was trying to understand what had happened. His son

Oliver had just had his spleen removed in Aspen and Burt was worried about that, and he had just come out of the hospital and was in no shape to go anywhere. It was an extraordinarily tough time.

Nikki died on Thursday, January 4, 2007. She was cremated and there was no service, but Angie made a memorial booklet for her with photographs and a long poem that began, "Nikki loved yellow and pink, and bright blue skies with white puffy clouds. She loved scuba diving, and pushing the limits. She loved glacial calving and the powerful sensation to her body of the earth shaking under and around her in an earthquake. She loved Steve Perry, and her father's music, and the sound of the kitties mewing and Pink Floyd." The last lines were "Nikki put on quite a show when she was here, on *this* earth. She was not understood by most, but loved and appreciated by a precious few. And now, she's finally happy. Her Mom."

Angie Dickinson: Nikki not only had Asperger's but she also had terrible vision from having been born three months prematurely. She also had water on the brain, which I did not know until I saw the coroner's report. That probably came from the prematurity as well. But she was great and it was a miracle she made it as long as she did, and I know that and I cherish it. I just wish I had done a million times more for her. In my view, I could have done so much more but it took me a long time to understand that for Nikki, there were no earthly solutions. Most people can fix what problems they have, but Nikki did not have that gift.

No matter how many times I would say to Nikki, "Please forgive me and Carole. We didn't know you had Asperger's. No one ever told us the truth so I ask your forgiveness," she just could not let that go. For her it was just one more thing to hold on to. She was stuck

on a wheel of three or four obsessions and she never did forgive me.

Before Nikki killed herself, she left me a note in a sealed envelope. I have never read the note because I can just imagine what she said in it. A couple of years later, before I was going out to dinner with Angie, she called me and said, "Do you still have the note Nikki left for you?" And I said, "Yeah, Angie, but I just don't know where it is. It's hidden somewhere." She said, "Do you think you could get your hands on it and bring it when we have dinner tonight? I'd like to read it." And I said, "Angie, I don't know where it is. Besides, it was made out to me."

Sue Main: I went to the mortuary to pick up Nikki's belongings for Angie because she didn't want to do that and they had already opened the envelope, so I saw the note. It's a couple of pages long and a very hateful thing. I was really surprised because in recent years, Burt had spent more time with Nikki. He would take her to dinner and go up and have lunch with her and Angie and sit with Nikki when she was in the pool. He was really making an effort to be in her life.

I mean, why would Angie want to read the note? Jane knew where the letter was but because she was being protective of me, she had stashed it somewhere. I already knew what the letter would say and I didn't want to hear it or read it. If there was something in there I should see, Jane would have shown it to me. The truth was that no matter how much I had tried to give Nikki, I had still wound up hitting the wall.

Jane Hanson Bacharach: I have read the note Nikki wrote and it's nothing Burt hasn't heard before. Nikki was who she was and couldn't control some of the hurtful things she would say to Burt when they were together. He would take her to dinner or have her

at our house, and at the very first opportunity, Nikki would lay into him and just get on that wheel. She wanted Burt's attention so she could beat him up because he had put her in the clinic in Minnesota.

I originally wrote "Nikki" as an instrumental that was later used as the theme for the ABC *Movie of the Week*. Then Hal wrote these terrific lyrics for it that were very touching. The way the chorus goes is "Nikki, it's you / Nikki, where can you be? / It's you, no one but you, for me / I've been so lonely since you went away / I won't spend a happy day / Till you're back in my arms."

Chapter
26

Night and Day

My lifelong battle with insomnia began when I was a teenager growing up in Forest Hills and my mother gave me my first sleeping pills. I stopped taking them when I went into the Army and I don't remember when I started again. But when I came off the road after having worked for Vic Damone and the Ames Brothers, my insomnia got really bad.

When I lived by myself in that apartment on East Sixty-First Street in New York, I had this kind of ritual so I could make sure I would get some rest. Before going to bed every night I would turn on a machine that made white noise, just like the one my mother had used in Forest Hills. Then I would close all the windows, get the air conditioner going with just the fan so it would be really loud, and put wax plugs in my ears to block out all the noise. I would also turn the clock around so I wouldn't see the hands. Then I would lie there thinking I had to get some sleep. Since that thought was also keeping me awake, it was a wicked cycle.

When I was out on the road with Marlene Dietrich, she always had a good supply of German suppositories I would take to go to sleep. Things really got out of control once I started going into the studio to make records. I would be fighting a deadline and I'd have

this recurring dream of not getting the arrangement done while all the string players were sitting in the studio getting paid by the minute. I'd heard a famous story about Quincy Jones writing an arrangement in his hotel room while the orchestra waited for him in the studio. I don't know if the story was true but that was my nightmare so I began bumping up the sleeping pills.

No matter what I did, I could still hear the music playing in my head at night. On some level that was a plus because it meant that I might be on to something really good. It was a costly trade-off but the fact that I kept hearing the music made me think the work had some significance. I was also playing the piano at night and writing music, and that energized me to the point where I felt like I could never get any rest.

When I was in London racing against the clock, trying to score *What's New Pussycat?*, I got myself into a situation that was really out of control. I was taking sleeping pills at two in the afternoon and then drinking coffee at three in the morning in order to wake up and start writing again after three or four hours' sleep. And then the same thing happened while I was working on *Casino Royale.*

When I was living with Carole, we discovered that we had two things in common—writing songs and not being able to sleep at night. We both had our own sleep machines and we would both take sleeping pills. In the morning, I'd say to her, "So, what'd you take last night? One of the yellow ones or one of the green ones?" It was a kind of competition between us to see who could get the most sleep. Six hours might win it all.

About sixteen years ago, I went to see a psychiatrist who put me on the antidepressant Paxil so I could taper off on the sleeping pills. The idea was to substitute one for the other, but it didn't work for me. The Paxil really dried me out and screwed me up so bad sexually that I couldn't even get an erection.

After I had been using Paxil for a couple of months, I was in a hotel outside Detroit getting ready to play a date with my band. I cut my lip while I was shaving and I couldn't get it to stop bleeding. I was friendly with Dr. Arnold Klein, Michael Jackson's dermatologist, so I called him in Los Angeles and said, "I just cut myself shaving, and I can't stop the bleeding." He said, "What kind of medication are you on?" When I told him I was on Paxil, he said, "You've got to stop taking that stuff right away and go to the emergency room to have stitches."

I went to the hospital and invited the nurse who sewed me up to come to the concert that night, where I thanked her from the stage for putting those stitches in my lip. After that, I gave up on Paxil. Even though the sleeping pills still didn't really work for me, I then went right back to taking them every single night. In the early days when Jane and I were together in Aspen, I was driving her crazy because she would have to teach skiing early in the morning and I would be up every fifteen minutes and walking around and then go back to bed and get up again. I was using both Restoril and Ambien, and some nights I would take three Restoril.

About seven or eight years ago, I played five dates in a row and then drove with Oliver and Raleigh to JFK so we could fly to Venice, where I had some shows to do. It was a long flight and I didn't get any sleep at all on the plane. I was already out of my head because I had done five concerts in a row. I was planning to have dinner that night with Jane, who was already in Italy with a girlfriend, so I knew I had to get some sleep.

I asked our nanny to take the kids out in the afternoon and I took a couple of sleeping pills and slept for about three hours. At dinner that night, I drank a lot of wine. I was getting up from the table when suddenly I was on my knees, about to pass out. I snapped out of it in a minute but the incident got Jane very concerned. I

knew she was right because I was seventy-five at the time and that was stupid stuff to do. I think I was lucky that I didn't wind up dead.

Not long after this happened, my internist suggested I start going to a very high-end outpatient clinic in Santa Monica called the Moonview Sanctuary, which was run by Gerald Levin, the former head of AOL–Time Warner. I went there mainly because of my sleep problem but also because I wanted to work on issues like lateness. I was always late, which was very bothersome to Jane. I was never late for a record date, because that was money and the musicians would be sitting there and I needed every minute I could get. But I didn't like hanging Jane up, because it upset her to always be waiting on me.

Although I was sure there were big stars walking in and out of Moonview with drug or alcohol problems, I never once saw another client while I was there. My internist worked out a program with a sleep specialist there and they decided to put me on an antidepressant called Remeron. I began taking one tablet at night as well as one milligram of Klonopin, an anticonvulsant and muscle relaxer. It took me a week to get used to them, because at first I wouldn't know who I was the next day. I was living in cobwebs and the dreams I was having were unbelievable.

I've been taking Remeron and Klonopin for about eight years now and although I can still hear the music at night, I am able to sleep. I've also tried to condition myself not to work after dinner, because if I start playing piano at ten-thirty or eleven o'clock at night, I get too stimulated. When I'm not on the road, I try to go to bed around twelve-fifteen. Sometimes I sleep for eight and a half hours and wake up just once or twice.

What I want to do now is try to get off the Remeron and the Klonopin. Am I getting sleep? Yes, but there is a price. I don't like the dreams because they are too vivid. Although I'm sleeping better

than I have since I was a child, would I like to have a sweet dream? Yes. Would I like to have something really pleasant to dream about? Yes. It happens once in a while but not often. I guess the best way to describe what I am still going through in terms of coping with my insomnia is that it's a work in progress.

Chapter
27

What the World Needs Now

In 2010, I went to Italy to play a huge outdoor concert in Milan's Piazza del Duomo about four or five days before Christmas. It was so cold there that I had to walk out onstage wearing thermal underwear, a ski jacket, and a ski hat. I was also wearing a pair of Sue Main's gloves, which were cut much tighter than mine so I could feel the piano keys.

Three months before I did the show, I had been having some issues with my back and had seen a doctor who told me I had a collapsed vertebra. He injected some kind of cement into the vertebra and said it was okay for me to go to Italy. After the show was over, we flew out of Milan as fast as we could to beat a snowstorm, stayed in a hotel at Heathrow Airport in London, and then got on a plane to L.A. It started to snow like crazy and they had to de-ice the plane, so we were in our seats for about four and a half hours before we ever left the gate.

It was the trip from hell and I hadn't been feeling that great to begin with. When I got back to Los Angeles, I was supposed to fly to Aspen to join my family for the Christmas holidays, but the pain in my back just kept getting worse. On Christmas night, my son Cristopher had dinner with me. I wasn't walking right and I wasn't

feeling right so I said, "Hey, Cris, I know you're going to Hawaii tomorrow but I'd really feel more secure if you were here with me tonight. Stay in Oliver's room and leave your cell phone on in case I need you."

I went to sleep, and when I woke up the next morning, I put my feet down and suddenly I was on the floor. My legs weren't working. The sheets were damp and I realized that what I was feeling in the bed was not perspiration. It was urine. I couldn't walk and I had also lost control of my urinary function.

I called Cris and he got in touch with Sue Main. She called my internist, who said they should get me to the nearest hospital, which was St. John's. When I got there, they didn't really know what the problem was. A therapist told me he thought I'd had a stroke and so they wanted to put me in rehab, which would have been the worst possible thing for me to have done.

I was there for five or six days, and after they discharged me, I went to UCLA Medical Center, where the doctor said, "Did they ever do a CT scan of your spine?" I told him they hadn't. After they did the scan the doctor looked at it and said, "You didn't have a stroke. You've suffered a compressed fracture of the vertebrae and it's impinging on your spine. You need to go into surgery right away." It was New Year's Eve and I was in surgery for seven hours. I remember Jane and Raleigh walking alongside the gurney as they wheeled me in for the operation.

What they think happened was that when I was coming out of my pool one day, a piece of the cement that had been injected into my back slipped out of place. At UCLA, they inserted a plate in the upper quadrant of my back so the top vertebra would be bolted securely in place. After I came out of the surgery, I was afraid to even put my foot down on the floor but I remember them touching my feet with feathers and I could feel it so that was a good sign.

I spent two weeks in the hospital at UCLA and then three weeks

in the rehab unit. They actually had to kick me out of there, because I had gotten so used to working with the therapists that I didn't want to leave. What I didn't realize at the time was that I could take the therapists home with me because they didn't work at UCLA every day. Once I got home, the rehab continued and a nurse slept in my room for months because I still couldn't get out of bed by myself.

I also had to wear a full-body plastic brace that wrapped around my chest and stomach from my armpits to the top of my butt. I could take it off only when I went to sleep. I started doing physical therapy six days a week with three different therapists who would take me to the beach and to Will Rogers Park to walk so I could relearn how to put my left foot in front of my right.

I spent the rest of the year just trying to get better. I wasn't writing any music and I decided I wasn't going to do any more concerts, because I really thought I was done. I had always worked out before I was hurt and even when I was on tour I would always make sure the hotel had a gym. I guess I was equally obsessive about the therapy, because I somehow managed to come back from the surgery stronger and in better shape than I had been before. I went back on tour in Europe in 2011 and did some shows in Australia in the spring of 2012.

My current routine is that I work with a trainer in the pool three days a week for an hour a day. When I'm alone in the pool, I use an Aqua Jogger, which lets me run without hitting the bottom. I also have a small gym at my house with a treadmill, a recumbent bike, an elliptical trainer, and weights, and I work out with another trainer there doing weights three days a week.

A long time ago Neil Simon told me, "You know, athletes peak at a certain time but as long as we're alive and creative, we can still write. That doesn't go away." That's his theory but maybe it does go away. What I do know is that you can't stay put. If somebody asked

me now to sit down and write a song like "Don't Make Me Over," I couldn't do it, because I don't live in that ballpark anymore. It's not a language I still speak. Having said that, I do feel really proud of the work I've done over the past ten years.

In 2003, Mo Ostin, who was the head of DreamWorks Records, called me with the idea of taking my standard repertoire and reinventing some of my trademark songs by doing them with Ron Isley, the former lead singer of the Isley Brothers. DreamWorks had a lot of money at the time and Ronnie would come to my house in a white stretch limo so we could work together. Then we went into the studio to cut an album called *Here I Am.*

Ronnie is a great, great singer but when he told me he wanted to do "Raindrops," I thought the idea was ridiculous until I played the opening chord for him. He sang one bar and I thought, "Oh, I see where I can go with this. I can make a very soulful, totally very different kind of interpretation of the song with him." At this stage of my life, I find it hard to write yet another arrangement of "The Look of Love" or "Make It Easy on Yourself" or "A House Is Not a Home," but Ronnie wound up singing all these songs so beautifully on *Here I Am.*

We went to cut the album in Capitol Studios, which has always been a very magical place for me. Vic Damone's managers took me there for the first time when I was just starting out so I could watch Sinatra record. I didn't get to meet him then but it was great just to see him work, and to this day there is no place in L.A. that sounds as good to me.

I put the string section in Studio B so they could see me conducting from the piano through a window. The first song we did was "Alfie." I was at the piano, Dean Parks played the intro on a classical guitar, and then Ronnie came in. As he was singing, I was calling out cues and saying stuff like "I'm not hearing enough piano. There's too much drums in my ear."

I didn't realize it at the time, but everything I was saying was also being recorded. Ronnie nailed the song on the very first take and they were able to edit out my remarks so we could use the track the way we had cut it that day. Ronnie Isley is one of the great natural singers. He doesn't have a bunch of ad libs stored in his closet. When Ronnie sings, he is totally free.

There was so much buzz and excitement about *Here I Am* before it was released that I really thought we had something. But the day the album came out, DreamWorks was taken over by Universal. They had artists like Dr. Dre and Eminem and this was just not their kind of music, so the album got no real promotion.

Ronnie and I did do a show together for PBS in Chicago and then we played a couple of showcases in theaters in L.A. and New York. Ronnie was absolutely fearless onstage and did some of the greatest singing I have ever heard in my life. I put him right up there with Luther Vandross as one of the great singers of all time, and I still love what we did together on that album. I don't know how many copies *Here I Am* has sold over the years but it has become a cult record. I also know Ronnie has never sung that kind of material before or since.

Two years later, I did an album called *At This Time*. Dr. Dre and I had talked about working together and he had given me six or seven drum loops that I wound up using, and Elvis Costello and Rufus Wainwright did some vocals for it as well. The more I got into the album, the more I realized how badly things were going in America and the world and the more angry and frustrated I became. So I decided to get involved in writing some of the lyrics with Tonio K., who was terrific and really easy for me to work with.

I took the heartbreak I felt about what had happened on September 11, 2001, and about all the young men and women who were getting killed in a useless war in Iraq and put it into some of the songs. On "Who Are These People?" one of the verses goes,

"Who are these people that keep telling us lies? / And how did these people who get control of our lives? / Who'll stop the violence because it's out of control? / Make them stop." Elvis Costello used the word "fucking" on the last line of the song, and although we had to take it out for the American release, you can hear him sing it if you download the import. I also did a song called "Where Did It Go?" which is about me riding the subway to Times Square on New Year's Eve back when I was a kid growing up in Forest Hills.

At This Time won a Grammy for Best Pop Instrumental album in 2006. As I was coming through the press line after receiving the award, someone asked me why I had chosen to make such a political album at this point in my career. I said, "Because I don't like being lied to. I don't like being lied to by a girlfriend, an agent, or my president." And so when Rahm Emanuel asked me if I would do some fund-raisers for the Obama campaign in 2008, I was happy to say yes.

The reality is that most composers sit in a room by themselves and nobody knows what they look like. People may have heard some of their songs but they never get to see them onstage or on television. I've been luckier than most because by performing and being on television, I get to make a direct connection with people. Whether it's just a handshake or being stopped on the street and asked for an autograph or having someone comment on a song I've written, that connection is really meaningful and powerful for me.

In 2009, I was given an honorary doctorate of music by the Berklee College of Music in Boston. Paula Cole sang five of my songs. To thank everyone, I took off my cap, robe, and hood and sat down at the piano to perform "Alfie." After the show was over, this guy I did not know who turned out to be a big fan of my music came up to me and said, "Burt, this will only take a second." And then he hugged me.

Whenever somebody takes the trouble to tell me how much my

music meant to them when they were going through a divorce or having chemotherapy, I think to myself, "Just take that to the bank and store it and remember it." Because it's so real, I never take that kind of thing lightly. After she'd had a few drinks, a good-looking woman who was sitting next to me on a plane once said she couldn't make love unless she put my music on. I thought that was pretty great, too.

When I was younger, I would dismiss that kind of adulation immediately. After getting a standing ovation at the end of a show, I would be back in some hotel room by myself an hour later, turning on the television to watch CNN and ordering room service. So it wasn't like I was sitting around and wondering, "Where did all the applause go?"

I remember playing the Greek Theatre in Los Angeles during one of my hot periods. We sold out the place five nights in a row and set the house record, which stood until Neil Diamond came in and broke it. I had never even thought about having a limo written into my contract, so I would drive myself to the show and after it was over every night, I would go to Du-par's and eat a melted cheese sandwich or some scrambled eggs by myself, which was really weird after having played in front of all these people. This was so long ago that no one even knew about egg whites.

What got me onstage in the first place was not that I could sing or tap-dance. It was the music I had written, and there is definitely a healing element to playing that music in public. Two weeks after the twin towers fell in Manhattan, I was booked to play a show in New Jersey. After I checked with the promoter to see if he really wanted to go ahead with the date, I canvassed my band and singers and crew and said, "How do you feel? Do you want to do this?"

They all said they did, and the last five songs we did that night were "Alfie," "A House Is Not a Home," "That's What Friends Are For," "The Windows of the World," and "What the World Needs

Now Is Love." Everybody in the band was crying, and so was I. For all of us as well as the people in the audience, it was a kind of real catharsis and a powerful emotional release.

I really don't think age has anything to do with how long someone can keep on performing. It's just a number, although I do find myself checking on people like Toots Thielemans, the great harmonica player. He's ninety and he's had a stroke but he's still playing in Antwerp and three nights later he's in Tokyo. Nobody ever said you have to stop making music at a certain time in your life and I can tell you from experience, doctors don't know about this, either. They really don't.

Everyone knows the record business is now dead, but I believe a musical called *Some Lovers*, which I've been working on with Steven Sater, who won two Tony Awards for *Spring Awakening*, is going to have a life. The show begins on Christmas Eve as a woman calls the songwriter with whom she used to be in love. Then it goes backward through their lives to look at their romance. There are lots of references to the classic O. Henry story "The Gift of the Magi" in the show and although we need to do some rewrites and another workshop, the audience really loved the show when we did it at the Old Globe in San Diego at the end of 2011, which is the most important thing. We'll get it into another regional theater and then hopefully bring it to Broadway at some point.

Mike Myers: I was at a table read of *Some Lovers* in New York sitting beside Elvis Costello, and about three songs in, we caught each other being transfixed by Burt's beautiful, beautiful songs. Elvis turned to me and said, "He's *here*!" By which he meant all of the yummy, quirky inversions Burt does, all of the satisfying "a-ha!" contrapuntal melodies with a healthy dose of what I call his "boom-stick-boom-boom" songs like "Walk on By." Burt was there, de facto conducting, and it was all in his body and his face. Every time it was satisfying and

yummy, he sent out sheer delight like a sonar ping. And when it was clear that it wasn't, the torture was there. It was so important to him.

Elvis Costello: I went to hear *Some Lovers* in New York at a reading, and the thing that touched me about it so much was despite the fact it was being done by actors who didn't have any props or costumes, no makeup or lighting, and were sitting around in a bright strip-lit rehearsal room with a pianist and a drummer, Burt was at the table looking straight at them and he was conducting. He was cueing and mouthing every word of every song, he was breathing with the singers, and it was just so inspiring to see. And the melodies were just incredible. At one hearing, there were five tunes that made you say, "I've got to hear that again." What really struck me was that the language of the music was vivid and the signatures of Burt's writing were there without it seeming like he had written all this before. There were still new permutations within the recognizable language he speaks in.

I was in New York for the workshop of *Some Lovers* and I hadn't talked to Mike Myers for a long time so I called him up and said, "I'm going to be here for two weeks, Mike, and I'd love to see you." We went downtown and had dinner that night and Mike said, "We're going to do Austin Powers onstage as a Broadway musical and you're going to write the music." I said, "Mike, what if I hadn't called you? Were you going to tell me?"

Mike Myers: I was going to call Burt about a week before we had dinner together in New York but instead I just sat there and wondered, "Gee, should I call him now? I don't want to bug him." Then he called and said he was in town and I thought, "Do I say something to him tonight? Do I go through his agents?" And then I was telling my friends, "This is a find. He could say no. I should

just ask him, right?" And after I told him, Burt said, "Yeah. Sounds great." And I went, "That was easy," and I was floating on air. I was just thrilled and twenty-five feet off the ground.

The concept is that these films were already musicals and I want the show to be a celebration of a time of music for which Burt is one of the major players, if not *the* major player. It's a celebration of Carnaby Street and also of England and it's about England swinging and Burt's part in that. I've already spoken to him about some aspects of it and I said, "It's the horns, it's the horns, it's the horns." I want this to be a celebration of the Burt Bacharach horns and I want at least one of the songs to be front and center and see what happens with that. And he said, "Ah, I love it, Mike. That's great, that's great. Send me the words."

Mike can sing and he's really musical so he'll probably end up writing half the lyrics with Elvis and me as we put together the score. Doing something for the stage is never as immediate as going in and making a record or doing a concert, but I'm really excited about working with Mike and Elvis, so that's where my writing energies are going to go.

I've also become very friendly with Chuck Lorre, who has created some of the most successful shows on television, like *Two and a Half Men*, *The Big Bang Theory*, and *Mike & Molly*. I got to know Chuck through Grant Geissman, the guitarist who does the music for *Two and a Half Men*. Then Chuck called me because he'd had this idea for eight years about *Painted from Memory* and had decided there was a musical in this album.

Chuck has a story and is writing the book with Steven Sater. Chuck is very, very good and his instincts are terrific. Elvis and I could see that we didn't want to restrict the plot line by being faithful to the album and just using the songs that are on it. So if five or six new songs are needed, we will write them.

I've also just worked with Bernie Taupin, who wrote the words for all those great songs by Elton John. Bernie and I tried to write a song for a picture years ago but it didn't work out. From out of the blue, he reached out to me and sent me a couple of lyrics that I thought were really special.

I have also worked with Carole again. We wrote a three-way song, which was something I always liked to do with her. The other person involved was Babyface, Kenny Edmonds, a great musician, songwriter, and producer who has worked with many talented artists. I also feel really positive about the fact that I am now on good terms with all three of my ex-wives, and I've taken Angie out to dinner seven or eight times since Nikki passed away.

In the spring of 2012 I did a tour of Australia, working with five symphony orchestras, and it went really well. In the fall, I did five concerts in three days with my band and my singers at the Tokyo Jazz Festival. We played in a huge concert hall and did two shows a night at a place called Billboard Live, a five- or six-hundred-seat venue where they serve drinks.

It was interesting being in Japan this time. I had been there seven times before and the audiences were always appreciative but very polite. When people applauded, it was almost like someone in the audience would signal "Cut!" and then everyone would suddenly stop clapping at the same time. This time, however, the reception was really wild, and I kept thinking, "Does this have something to do with everything they've all been through here in the last year with the tidal wave and the meltdown at the nuclear plant?" I'd never seen Japanese people act like this before.

Long after I was done playing at the concert hall, a beautiful young girl saw me and started to sob uncontrollably, so I went over to her. She could hardly speak so I just put my arms around her. Her reaction touched me so much that I thought, "Boy, if I can make music that can make her feel like that, well, that's really something."

Before each show at Billboard Live I had to come through the house. As I did I was shaking hands all the way to the stage. When I came offstage, people were grabbing me and I had never experienced anything like that in Japan. My son Oliver was running security for me and he found the girl from the concert hall trying to get through the crowd to give me a present along with a note. She wrote very good English and said my music meant so much to her that she hoped one day I would return to Japan. She never gave me an e-mail address or a way to contact her, so I've never been able to tell her how much she really touched me.

The fact that people still care enough about my music to want me to play onstage is a blessing. Getting to write new songs with Elvis and Bernie Taupin and Carole and Kenny Edmonds is also a blessing. I mean, how lucky can you be? It's a gift, and when I look at what is now happening in my life, I'm extremely grateful.

Chapter
28

The Gershwin Prize

One day during the summer of 2011 I got a message from Sue Main telling me I should be near my home phone to get an important call from Dr. James Billington. Sue never told me who he was, and when I asked her what the call was about, she said, "You'll find out." When Dr. Billington got on the line, he introduced himself as the Librarian of Congress and told me that Hal and I had been given the 2012 Gershwin Prize for Popular Song, an award that had only been won before by Paul Simon, Stevie Wonder, and Paul McCartney.

I had never in my life dreamed I would win the Gershwin Prize, so it was incredible news. Because the Library of Congress had given another award to someone who had talked to the press about it before the official announcement, Dr. Billington also told me, "You cannot tell anyone about this."

When someone says something like that to me, I'm very good about it. Although I did tell Jane, I also really wanted to tell my son Oliver, who was about to go off on a trip to India, but I couldn't do it. Dr. Billington had told me he was going to call Hal, so I did get in touch with him right away. When the Library of Congress made its announcement at the end of September, I was finally able to tell Oliver.

The award was going to be presented at a luncheon at the Library of Congress on May 7, 2012. I had been in Australia doing concerts with symphony orchestras for nearly three weeks and then I flew back to Los Angeles. I was there for about two days and then I flew to Washington with my daughter Raleigh and Sue Main. Jane was going to meet me there the next day after stopping off in Ohio to pick up her mother and her two sisters, and Cristopher and Oliver were going to fly in on their own.

The first night we were in Washington, Jane arranged a great dinner at a French restaurant right across from our hotel. Her family was there, along with some friends who had flown in from all over the country. It was a wonderful evening. Although I didn't know it at the time, all the artists who were scheduled to perform at the Library of Congress and then the White House were also staying in the Ritz-Carlton, but I never ran into any of them. I knew Phil Ramone was producing the shows but I didn't know who would be appearing because the only person I had asked to be there was Mike Myers.

At eleven-thirty the next morning, we were driven to the Library of Congress on East Capitol Street for a congressional lunch in the Members Room for about eighty people. It was hosted by Buffy Cafritz, a terrific person who is a member of the board of the Kennedy Center. I had never been to the Library of Congress before, but it is so large that you would really have to spend five or six days there to see it all. The place was really overwhelming.

I was sitting with Raleigh and Oliver and Jane when Nancy Pelosi, the former Speaker of the House of Representatives, came in and spoke. I was very happy to see her because the two of us had met four years earlier when I had taken Oliver and Raleigh on a tour of the House.

Dr. Billington also spoke at the luncheon, and then he presented me with the certificate for the Gershwin Award. Later on I was also

given an engraved box holding an American flag that had actually flown over the Capitol, which I thought was stunning. The only sad part about the luncheon was that about six weeks earlier, Hal had gone into the hospital for surgery and had then suffered a stroke. He couldn't come to Washington for the ceremony, so his wife, Eunice, was there to accept the award in his name.

After the luncheon, Mark Horowitz, the senior music specialist at the Music Division of the Library of Congress, took us all downstairs. Set out on a long table for us to look at were original scores and music manuscripts by Beethoven, Hoagy Carmichael, George Gershwin, Bernard Herrmann, Mozart, and Richard Rodgers. There was also an arrangement Benny Carter had done of "Alfie" from the Ella Fitzgerald Collection and original compositions by my three great teachers, Darius Milhaud, Henry Cowell, and Bohuslav Martinů.

I also got to look at the sheet music for what they told me was my first copyrighted composition, a song called "A Soldier's Prayer," which I had written with William Stephen Quigley when I was in the Army in 1951. I was clueless when I first saw it but then I remembered that Bill Quigley had been a chaplain and I must have written the song with him when I was playing piano on Governors Island. We were on a pretty tight schedule so it wasn't like I had enough time to pick something up and say, "Let me see what's going on in the fifth bar here." I just had to keep on moving.

Jane and I were then escorted to the Capitol, where we were to meet John Boehner, the Speaker of the House of Representatives, in his office. He smelled from cigarette smoke just like Hal used to do in our office in the Brill Building, but much worse. I was there for about fifteen minutes but we didn't really talk about much. Boehner was trying to make a connection to the world of music so he asked me if I knew Tom Snow, who wrote "Let's Hear It for the Boy" from *Footloose* as well as some other good songs. Tom Snow's family

is Republican so I guess that was how Boehner knew him. It was all very pleasant but I made sure to steer clear of any talk about politics.

I was still really jet-lagged but I was also energized by what was going on because Jane and my three kids were there to share the whole experience with me. That made everything so much more powerful for me than if I had flown in to accept the award on my own.

We were then taken back to the hotel so I could get ready for the show that night at the Coolidge Auditorium in the Thomas Jefferson Building at the Library of Congress. Before we left, Jane ordered up some champagne so we could all have a toast in my suite. Then there was a small reception for us in Dr. Billington's office, where we all had some more champagne and hors d'oeuvres. Once everyone had been seated in the theater, we were taken inside.

The auditorium holds 485 people, and there were lots of dignitaries there that night as well as friends that Hal and I had invited. Jerry Moss and his wife, Anne, were there, and my cousin Frank Binswanger and his family came from Philadelphia. Phil Ramone and Sue Main had put the show together but they had kept it all so quiet that all I knew was that I was going to introduce Dionne to close the show.

Mike Myers opened by doing "What's New Pussycat?" and ended the number by standing there in a white Elvis Presley jumpsuit with my first name in big letters on a rhinestone belt buckle. After introducing Stevie Wonder, Mike walked off the stage, only to be told Stevie was in the bathroom. Coming back out, Mike had five minutes to kill so he started doing improv and he was brilliant.

Then Stevie came out and did "Alfie." Sheryl Crow sang "Walk on By," Lyle Lovett did "Always Something There to Remind Me," and Diana Krall played and sang "The Look of Love." Michael Feinstein did "Close to You," Rumer performed "A House Is Not a Home," Sheryl Crow and Lyle Lovett did "I'll Never Fall in Love

Again," and Shelea sang "Anyone Who Had a Heart." Stevie came back on with Arturo Sandoval and did an up-tempo kind of reggae version of "Make It Easy on Yourself." Then Mike introduced me, and I got up from my seat and walked onstage.

I hadn't made any notes or written anything down but I thanked everyone and said that while I had been on tour in Australia, a journalist from the *Washington Post* had called to ask what this award meant to me and how would I compare it to other awards I had received. I told him that with the Academy Award, someone opens an envelope and pulls out a card with your name on it and that sends a spike up your spine that is an unbelievable feeling. But the Academy Award is for just one song or one score. This award was for all of my work, and so for me, it was the best of all awards possible, and I meant that with all my heart.

After people stopped applauding, I said, "I'm standing up here alone. I should be up here with Hal David and it's so sad that Hal was unable to make this trip. You wait for something like this all your life and get one shot and then you don't get to come to the dance and it's sad. So it's with a heavy heart that I feel kind of lonely up here tonight by myself. Hal is a great lyricist and he wrote great, great lyrics. And for Hal to write a lyric like 'What's it all about, Alfie? / Is it just for the moment we live? / What's it all about when you sort it out, Alfie? / Are we meant to take more than we give? / Or are we meant to be kind?'—that's one of the best lyrics anyone has ever written."

I talked about the different ways Hal and I had written songs together and how all I ever wanted in the beginning was for him to give me a word that would sound good on the note and how we were never very quick, except when it came to "I'll Never Fall in Love Again." Then I said, "I salute you, Hal. I was very careful on my Australian tour with every step and every shower I took because I was determined that one of us had to get here. I am deeply hon-

ored by this award, as Hal will be, and it is great to have my wife and my three kids here to share this with me."

Then they showed a short video with Paul Williams talking about Hal and an interview with Hal in which he said being a songwriter was the happiest thing anyone could do in the world. When the video ended, I introduced Dionne, who talked about having just seen Hal in Los Angeles and how strong he seemed. Then she closed the show with "This Girl's in Love with You" and "What the World Needs Now Is Love."

All the artists then joined the invited guests for dinner upstairs in the Great Hall of the Library of Congress, which looked spectacular with tables set all the way around. I sat with my family but I was up a lot and visiting people at different tables. After dinner ended, an elaborate dessert buffet was set up in the center of the room downstairs. They opened up the Reading Room so we could all go in there and take photographs. We were basically given the run of the place, which was pretty amazing.

The next day, I went back to the Library of Congress at twelve-thirty so I could be interviewed by Mark Horowitz. We talked for about forty-five minutes on camera and tape and the interview went into the Library of Congress archives, where it will be accessible to anyone who might ever want to do research on me. Then Sue and I got into a black sedan that had been security-swept because we had to go to the White House so I could rehearse for the show that was being taped that night for PBS.

The car dropped us off on Pennsylvania Avenue, and we had to get out and walk up to security so we could let them know we had an appointment. That was when I saw Robin Roberts, the ABC TV journalist, coming the other way. There was a lot of tension in the air and I knew something important was happening. I later learned she had just done the interview with President Obama in which he had come out in favor of gay marriage.

We went through security and then down the stairs into a room in the West Wing right below the residence. I only had about ten minutes to rehearse with the band before I had to go back to the hotel to get ready for the performance. Chairs had been set up so close to the stage that I knew it was going to be like playing a private show. I had played a lot of privates in my life but not with the president of the United States sitting right there in front of me. The setting felt a lot more intimate than when Carole and I had played for President Reagan.

The show began at seven, so we had to leave the hotel at five-forty-five because it takes quite a long time to get into the White House. Cristopher, Oliver, Raleigh, Jane, and Sue and I were all in a van. After we had come up Pennsylvania Avenue and parked, they opened up the doors so the dogs could sniff everywhere while the guards swiped underneath the van.

After they had cleared us, we went up to the gate and got out of the van and walked through security with our IDs. We were then taken into the White House through the main entrance and walked along the corridor beside the Rose Garden, where there were lots of photographs of President and Michelle Obama with their kids and their dog, Bo. Since we have Alfie, who is also a Portuguese water dog, we all had to look at those.

We were then taken into the Men's and Ladies' Reading Rooms, which are very elegant and beautiful and filled with books that anyone from the residence or the staff can take out. Then we went upstairs into another holding area where there was a reception for the artists. We were all drinking champagne and the Marine sentries were there in their dress uniforms with white pants. Everyone was milling around and talking to one another and then they pulled me away to put a little powder on my nose so I wouldn't look shiny at the show.

We then went upstairs, where everyone was given a card so they

could have their photograph taken with the president. Jane and I and the kids went in first. President Obama and Michelle were standing there and we all shook hands. The president was charming. I congratulated him on his decision to come out in favor of gay marriage, and then we had our picture taken together.

As the next group started to come in, the president said, "You stay here with me. You're in all the pictures." And that was really a kick, man. Standing next to the president of the United States for picture after picture. The two of us really couldn't talk to one another while this was going on, because it was all happening so fast.

After we were done taking photographs, I walked with my family into the room with the stage. Jane and I sat down in the first row and the announcer said, "Ladies and gentlemen, the President of the United States." We all stood up as President and Mrs. Obama walked in. When they sat down, I realized I was sitting right next to the president. That created a nervous energy in me that lasted all through the show.

The artists had all felt comfortable the night before while performing in front of the audience in a big theater, but this was completely different. I don't think I've ever seen Mike Myers so nervous. He was two feet away from the president and Michelle as he did his bumps and grinds but they loved it. Sheryl Crow was also really nervous, and when Diana Krall came on to do "The Look of Love," I could see her hands shaking before she started to play. Once she got her fingers on the keyboard, the music pacified her because that was a place of comfort for her.

When Stevie Wonder came onstage, he said, "I feel like I'm a regular here," because he'd been to the White House so often. He started and stopped "Make It Easy on Yourself" three times because he didn't like the way it was feeling. The night before at the Library of Congress, he had just gone straight through the song, but Stevie knew this was all going on tape and he didn't like it so he

started again. That was when the president leaned over to me and said in my ear, "He's done this before." And I said, "Yeah."

The great thing about the president was his body language. The fact that he was sitting next to me and reacting so physically to my music was overwhelming. That was when I said to him, "I'd really like to work for you and record you." The president just smiled but I do think he can really sing.

The show went really well and then the president got up to speak. He said, "Like the Gershwin brothers, Burt and Hal have never been limited to one genre, or one generation. Burt once said that all he looks for in writing a good melody is 'to write something I like.' Hal agreed, saying, 'We just tried to write with as much integrity as we could.' Above all, they stayed true to themselves. And with an unmistakable authenticity, they captured the emotions of our daily lives—the good times, the bad times, and everything in between. They have lived their lives on their own terms, and they've taught Americans of all ages to embrace their individual stories, even as we move forward together. So tonight, on behalf of a grateful nation, it is my privilege to present the nation's highest prize for popular music to two kings of songwriting, Burt Bacharach and Hal David."

There was no way I was going to top that. When I accepted the award, I got really choked up and repeated what I had said the night before about this being the greatest award I had ever received. Then I sat down at the piano and led everyone in "What the World Needs Now." It wasn't until I settled in at the piano that I finally felt comfortable.

After the show was over, the president and the First Lady got up onstage and went around and talked to every single musician. The president shook everybody's hand and thanked all the staff. After they left, we all went to a champagne reception. President and Mrs. Obama could not attend because it was late, and the reason their daughters had not been at the show was that it was a school night.

When we left the White House, it was pouring rain. We got back into the van and went to dinner. Then Jane and I went off for a little vacation in Puerto Rico. I had been to the White House before with Carole to play for President Reagan, but for me this experience was on an entirely different level.

During the George W. Bush era, I had played a charity event in a hotel ballroom in Dallas. I was backstage waiting to go on when Laura Bush came back to see me with Cherie Blair, the wife of Tony Blair, the prime minister of England, and another woman who was a friend of theirs. The three of them started singing my songs to me like they were the Andrews Sisters and I thought that was wonderful.

Less than a year later, I went to Washington for the Kennedy Center Honors, where Elizabeth Taylor was being honored, and I was going to play piano for Dionne as she sang "That's What Friends Are For." As we went into the White House to meet President and Mrs. Bush, I was telling Jane, "Laura Bush was singing my songs to me in Dallas so I know she'll be happy to see me." We were all standing in line and when she came up to me, Laura Bush didn't have a clue who I was but the president said, "I like your music."

A couple of months after the Gershwin Prize ceremony, I went to a small fund-raiser in Los Angeles for President Obama, thrown by Ryan Murphy, who did the television show *Nip/Tuck*. There were about eighty people at Ryan's house and I said to Jane, "We're going to get our picture taken again with the president." I was sitting there eating dinner and just before the president started to speak, I realized my knife had been taken away. Because the president had just come in the room, everyone's knives suddenly disappeared.

When the time came for Jane and me to have our picture taken with the president, I said to her, "Do you think he'll remember me?" She said, "Of course he will." We went back to see him and

the president couldn't have been nicer. He gave me a big hug and said, "How's Hal? Is he out of the hospital?" I thought that was incredible. The man has great charisma and all I can say is that I am kind of in love with the guy.

A couple of weeks after Jane and I came back from Puerto Rico, I talked to Hal on the phone. Then I did a benefit show at the Geffen Playhouse in Westwood with five other composers, J. D. Souther, Sergio Mendes, and Kenny "Babyface" Edmonds among them, for the Fulfillment Fund, a charity that helps about two thousand disadvantaged kids a year. I walked in and someone told me Hal was there. I went over and told him how happy I was that he was out of the hospital. Hal didn't look that great but he could speak in short sentences, so I could communicate with him. When I got up onstage, I talked a lot about him before I sang "Alfie."

About a week and a half later, Jane and I were in the car on our way to Hollywood Park when I got a call from Dionne in London. Chuck Jackson had just gotten in touch with her because he'd heard Hal had died. I got on the phone right away and called Eunice, but I couldn't even get through to her voice mail.

I was now very concerned, so I called Phil Ramone on the west coast and asked him if he knew anything about it and he said he was going to try to find out. When I got in the car with Jane after leaving the track, the phone rang and it was Eunice. I was expecting really bad news but she said, "Hal and I were out at the Ahmanson Theater seeing *Follies*."

Not long after that, in June, Hal was in New York at the Songwriters Hall of Fame dinner. I talked to him and Eunice again after I came back from playing a show in Louisville, Kentucky, and she told me they were going there the following week for an eight-day boat cruise up the Ohio River. As it turned out, Hal never got to make that trip. Instead he got an infection and had to go into the hospital. He came back out, but was then hospitalized again.

Hal was ninety-one years old when he died on September 1, 2012. I knew it was coming, so it wasn't a sudden shock. I just felt really sad. I also thought Hal got the worst break possible because he had been able to go to that event at the Geffen Playhouse two weeks after the Gershwin Prize ceremony but he couldn't be there in Washington for the greatest honor he had ever been given. I just thought that was so cruel.

I got a lot of condolence calls from people who said to me, "You lost your partner." The truth was that it had been a long time since Hal and I had sat down in a room to write a song together. I had written with other people and so had he. But even though we were no longer partners, the real truth is that the guy was simply brilliant.

I was down in Del Mar when I heard the news on Saturday. Then the *Los Angeles Times* asked me if I would write a piece about Hal. I wrote it in longhand on a yellow pad the next day, and my son Oliver typed it up for me. The piece had to run on Monday, so I didn't have that much time to get it done. The last line was "Hal, we had a great run and I'm so grateful we ever met." And that's the way I still feel about him.

Epilogue
Happy

It's hard for me to describe how much I appreciate having a family at this time in my life. It is a little bit unusual for someone my age to have two children who are still teenagers and sometimes somebody will say something to me about my "grandkids." When I say, "No, that's my son and that's my daughter," they think they have to apologize.

I'm very proud of my son Cristopher, who is a fine young man working really hard to make it on his own. Cris is now twenty-six years old and lives in Los Angeles. He worked for a couple of years up in Seattle for the Seattle Sounders and the Seattle Seahawks, and then came back to Southern California. He worked at Warner-Chappell just to get a taste of what that the music publishing business is like. He didn't love it so now he's over at Warner Bros. Television.

I'm also lucky enough to have been able to take both Raleigh and Oliver out on the road with me. Raleigh was fourteen when we went through Italy together a couple of years ago. She has the kind of intensity about getting things done perfectly that reminds me of myself when I used to go into the studio to cut a record. She can also be a little shy, but not when she gets on a horse.

Oliver was eighteen when I took him on the road in Europe and he worked for me on the tour. We stayed together in castles in Italy and I got the kind of connection with him I would never have had in any other way. Oliver is so outgoing that he was like the mayor of whatever town we were in. At the end of the tour I said to him, "You know, I would have done this for no money just because of what I've gotten from you." And he said he felt the same way.

The band I play with now didn't even exist in my mind until Jane came up with the idea for me to get people together who could really sing and play my songs so they sound the way I want them to, instead of my just going out there to perform them by myself. On my own, I would never have thought of this, so that was all Jane's doing.

Jane and Oliver and Raleigh and I were on a little vacation this past summer on the Greek isle of Mykonos and I was late getting ready. I certainly don't get dressed as quickly as I used to because of my back, but I kept everybody waiting. They were all pissed off but nobody said anything. When we walked into the restaurant I kind of fell apart. I was in tears at the table, and I said, "You don't know how much you all mean to me, and I can't stand disappointing you."

It was a full-out confession of my love for them, and I'm really glad I said it because, thanks to Cristopher, Jane, Oliver, and Raleigh, I am now finally truly happy.

Acknowledgments

Thanks to Eric Lax, who did the initial interviews with Burt and was kind enough to make them available for use in this book.

Thanks to "The Doc" at www.oldtimetv.pizco.com for copies of Burt's television specials.

Thanks to Paula Stewart for her personal photographs and the copy of the sheet music for "Night Plane to Heaven." Thanks to Carole Bayer Sager and Mike Myers for photographs from their personal collections as well.

Thanks to Joel Selvin for providing us with the manuscript of his forthcoming book, *Here Comes the Night: The Dark Soul of Bert Berns and the Dirty Business of Rhythm and Blues*, published by Counterpoint Press.

Thanks to Amy Schiffman, Brian Lipson, and Joel Gotler at the Intellectual Property Group. Thanks to Jonathan Burnham, Claire Wachtel, and Elizabeth Perrella at HarperCollins.

Thanks to Paul Conroy and Richard Havers for finding Paul Jones. Thanks to Jeff Ayeroff and Ryan Null for helping us look for a cover photograph for this book. Thanks to David Riva for his help with interior photographs.

Thanks to Herb Alpert, Jane Hanson Bacharach, Frank Binswanger, Slim Brandy, Elvis Costello, Hal David, Angie Dickinson, Lee Grant, Paul Jones, Mike Myers, Richard Kirschman, Jerry Moss, Phil Ramone, Carole Bayer Sager, Joel Selvin, Gary Smith, Paula Stewart, and Dionne Warwick for finding the time to talk about Burt.

Thanks to Sue Main, without whose never-ending help this book would not have been possible.

Sources

Much of what Angie Dickinson says about Nikki in this book comes from an article titled "Autism: A Struggle in Black and White," by Angie Dickinson as told to Ed Leibowitz, which appeared in *Los Angeles* magazine on September 1, 2010. Many thanks to Ed Leibowitz for his kind permission to quote from it at length here.

Marlene Dietrich's comments about Burt come from her autobiography, *Marlene*, which was published by Grove Press in 1989.

Cilla Black's comments about Burt come from her autobiography, *What's It All About?*, which was published by Ebury Press in 2004, as well as the 1996 BBC documentary about Burt titled *This Is Now*.

Hal David's comments about "Anyone Who Had a Heart" come from an interview he did with Johnny Walker of BBC Radio in 2000, as quoted in *Burt Bacharach: Song by Song*, by Serene Dominic, published by Schirmer Books in 2003.

The comments by Richard Carpenter and Noel Gallagher come from *This Is Now* as well as a 2001 A&E biography of Burt. The material from all the other speakers comes from original interviews done with them for this book.

Index

About the Author

Raised in Forest Hills, New York, Burt Bacharach is a classically trained pianist, whose songs have been recorded by the most influential artists of the twentieth century. He has written more than seventy Top 40 hits, and has received the Grammy, Oscar, and Emmy awards for his work. The father of three children, he lives in Los Angeles, California.